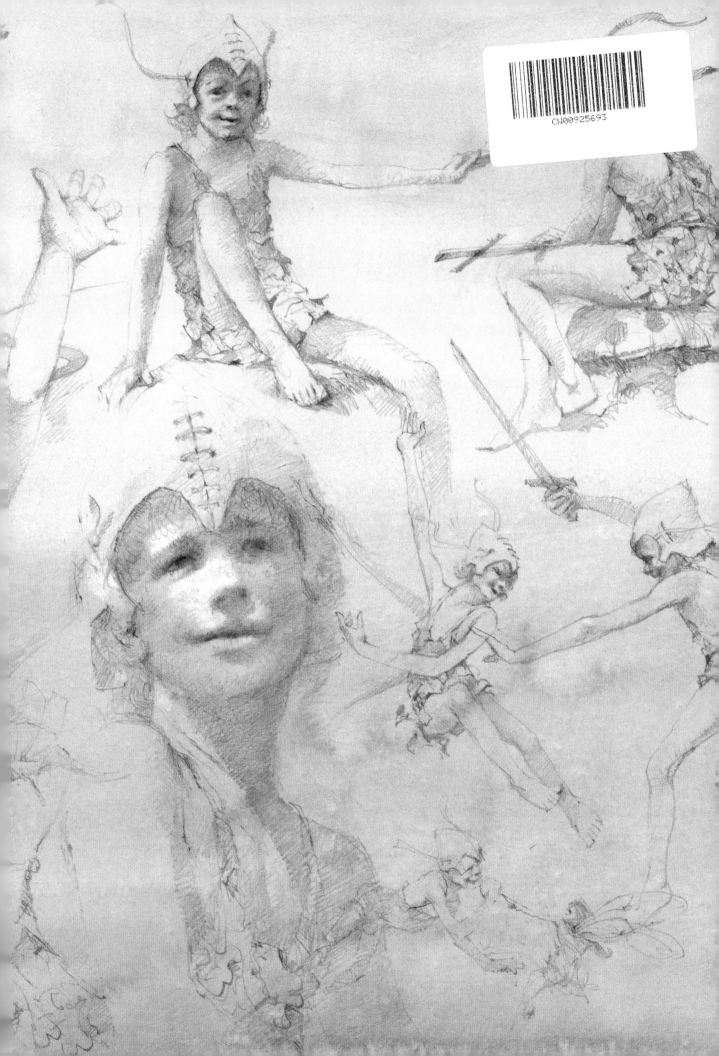

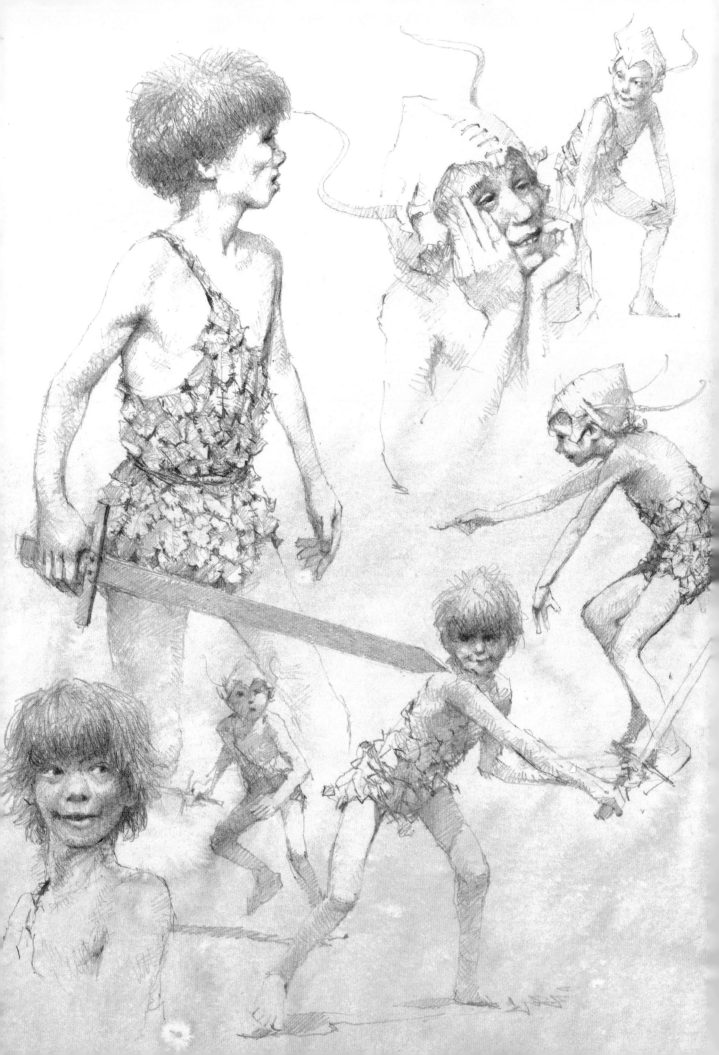

WONDERLANDS

The Illustration Art of Robert Ingpen

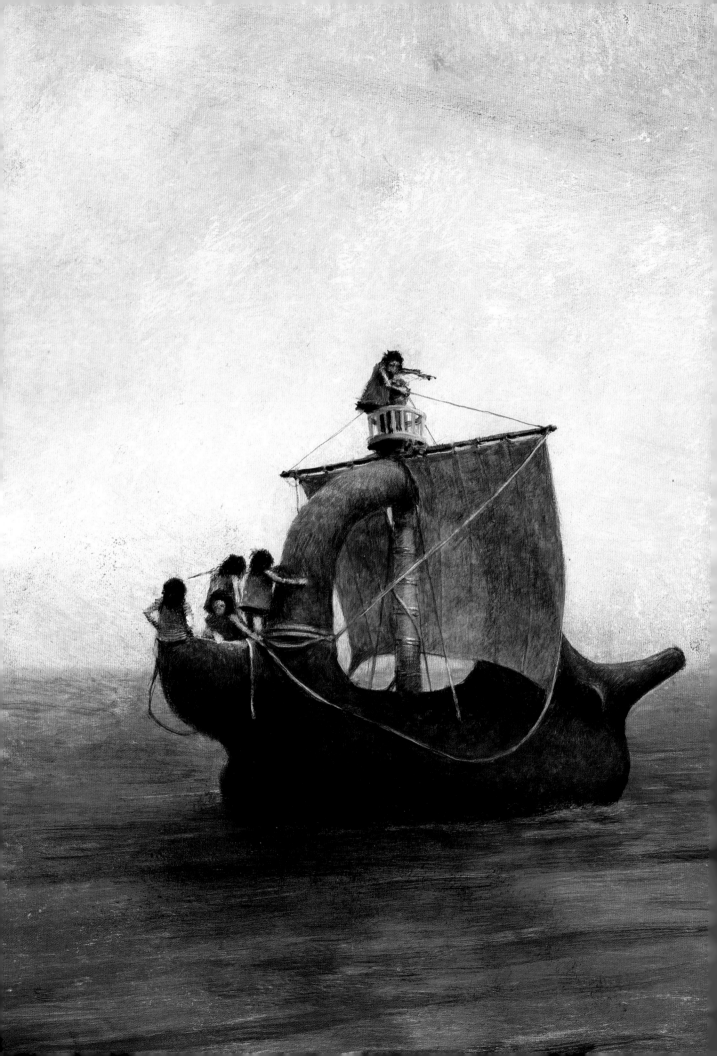

WONDERLANDS

The Illustration Art of
Robert Ingpen

PALAZZO

This book is dedicated to publishers Colin and Pamela Webb
in gratitude for the opportunity to design and illustrate the
fourteen titles in the Children's Classic Series of books.
Robert and Angela Ingpen

This edition first published in 2016 by
Palazzo Editions Ltd
15 Church Road
London SW13 9HE
www.palazzoeditions.com

Text and illustrations © 2016 Robert Ingpen
Introduction © 2016 Elizabeth Hammill

Publisher: Colin Webb
Managing Editor: Victoria Walters
Art Director: Bernard Higton

A CIP catalogue record for this book is available
from the British Library.

ISBN: 978-1-78675-003-7

Printed and bound in China by Imago

Endpapers:
Studies for *Peter Pan*, 2004.
Previous pages:
The 'Poppykettle' with its crew of Hairy Peruvians sails
towards a new Wonderland and adventures, 2016.
Opposite:
George Merry remains as sentinel, from *Treasure Island,* 2011.

CONTENTS

✦

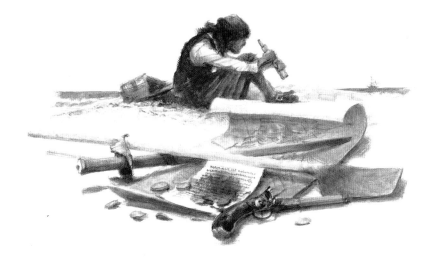

INTRODUCTION

Robert Ingpen is a keeper of the imagination. That is the potent impression that I take away from two intense and absorbing interviews – first in 2009 and now in 2016 – with this Australian giant amongst illustrators whose work over the past 50 years has displayed a rare and engrossing discipline, craftsmanship and singularity of vision. The importance of keeping the imagination alive and healthy – be it his or his readers' – weaves in and out of our discussions. So, too, does his exploration, as an illustrator, of how to build 'imaginative spaces' between 'the idea that the words convey and the image that the pictures give you' for the reader to 'play in… colour in for themselves' and make a story their own. So, too, does his commitment to revitalising and passing on our imaginative heritage – be it myths, legends, folktales or literature and art. The dreamer in Robert Ingpen is always present and the dreams feel compellingly real.

Born in 1936, Robert's childhood was spent in the coastal city of Geelong, Victoria, Australia, where his father ran the Ingpen family wholesale grocery business and his mother, a trained milliner, sewed endlessly, danced and played the piano. It was a happy time filled with storytelling, books and drawing. A neighbour and portrait photographer Marjorie Wood introduced him to stories; apparently 'reading' from a 'very large red book' called *Tim Pippin in Giant Land*, but actually 'making the stories up… I thought this was the most wonderful thing possible… She taught me… how to use my imagination without fear', how to pursue a thought that was 'lateral and novel… and that was my beginning.'

As a young teller of tales, Robert's approach to narrative during his school years was already outside the box. He believed that by creating 'a fictional outer wrapper' for a truth or a fact that spoke to readers' imaginations, 'people would understand more about the facts (and themselves) as a result of unwrapping them through story'. Robert saw art as a craft – the 'servant' of story and a bridge to the imagination.

Moving to the Royal Melbourne Institute of Technology (1955–58), Robert studied design and illustration. Here, he 'made it a project' to learn about everything that went into creating a book from paper making, book printing and editing, to the 'intellectual rehearsal time' and manual skills he needed to tell stories visually. Evenings spent working for a lithographic printer versed him in the technical aspects of offset printing. The book, he now knew, was 'an art form… but there was no museum for displaying that art… Instead, it could be found in a library, in a book store… or in someone's possession.'

Recruited by CSIRO (Commonwealth Scientific and Industrial Research Organisation) as a communications designer, Robert turned his storytelling skills to a practical purpose: the transmission of new scientific discoveries to an unscientific public – farmers and fishermen – who needed to understand science in order to apply it to use in industrial practice. Finding pictorial means to explain concepts of conservation, environment, ecology and 'man's role within nature, not beyond it' became a fresh artistic challenge. He experimented with imaginative ways of 'packaging' scientific research in layers for people to discover for themselves new 'ways of looking at our landscape in terms of understanding its protection, its delicacy…' To do this he drew upon the imaginative power of local lore and 'old tales', reframing these to communicate the latest research – a technique he was to use in the early 1970s in Mexico and Peru with the United Nations.

A continuing passion for environmental and heritage conservation has run parallel to Robert's work as a children's writer and illustrator. It is visible in commissioned murals, tapestries and sculpture throughout Victoria and nationally in commemorative postage stamps and nonfiction books, and in his work for the Australian Conservation Foundation and as a design consultant. It is there, too, in his first prize-winning illustrations for the modern Australian children's classic – Colin Thiele's *Storm Boy* (1974). In this story of an isolated beachcomber's son and an orphaned pelican, Storm Boy learns to 'read' the landscape of the 'wild strip' where he lives between the Coorong and the sea – 'the strange scribbly writing on the sandhills and beaches…' This vast, bleak setting for the story's action is what Robert characteristically chooses to picture – not the action itself.

'You never lose sight of the landscape,' Robert notes – be it the new landscape of Australia or the older landscapes of world myths and classics. How Australians, a 'displaced' people, 'engage with the Aboriginal people, the Dreamtime, the animals and the whole of this land – big cultural issues that are equally as important as water or lack of it' – is an ongoing concern. Sometimes he invites us to consider the 'poetry' of the bush. In *Looking for Clancy* (2013), for instance, he explores in words, pictures and the ballads of folk poet A.B. 'Banjo' Paterson, the creation of the legendary and inspirational hero Clancy, a free-spirit, a stockman and shearer, a battler in whom Paterson summed up the essence of the enduring Australian outlook.

Or, sometimes, he invites us to consider the hidden, secret history of a land inhabited by an ancient magic: in his illustrations for Patricia Wrightson's *The Nargun and the Stars* (1988) – a 'spiritual investigation of the land, of the Aboriginal people and imagination', and, in his modern folktale *The Voyage of the Poppykettle* (1980) about a race of miniature Peruvian fishermen – 'boat people' – who flee Spanish persecution in a clay teapot, sail the Pacific Ocean and discover Australia, and the subsequent occupation of their new home in *The Unchosen Land* (1981) – an 'uncompleted saga'.

As Robert journeys abroad into the wonderlands of the classics – Neverland, the Riverbank, the Wild Wood, Oz, Alice's Wonderland, the Secret Garden, the Mississippi riverside, or the Land of Toys, he also journeys into the landscapes of their creators' minds. Using that 'fearless imagination, I can believe these authors can come to stay with me, sit with me as I'm designing, planning and illustrating their story...' This is typical Ingpen: an apt wrapping of fact with fiction to describe the rehearsal or dreamtime spent getting to 'know' authors and their characters, understand a text's 'messages' and 'balladry', and experiment with design and illustration to 'enhance and align' these, giving readers 'extra information for the imagination to play with' and imaginative spaces between the words and pictures to inhabit.

Of course, having authors as 'house guests' or perhaps, mind guests isn't always straightforward.

How do you 'avoid being tricked by Lewis Carroll into venturing too deeply' into his dreamworlds?, Robert muses. How do you cope with Charles Dickens's 'impossible curiosity' about your life which 'gets outrageously in the way' of your work? What happens when you 'question the ego of Mark Twain who ignores future illustrators by having his best story bits happen at night or in darkness' or Rudyard Kipling when he arrives with all of his animal creatures? Such visits are always illuminating but unexpectedly so sometimes.

Nonetheless, it is this close attention to authorial intent, to character psychology, to place and to the sensibilities and expectations of modern readers raised on video and cinematography that gives Robert's classic revisionings their power, immediacy and energy. Look at his Alice and her 'amazed' yet 'apprehensive' body language when faced with decisions about 'unknown substances' inviting her to 'Eat me' or 'Drink me'. Look at his portraits in *Treasure Island* – some cropped and close-up, textured, filled with the 'beautiful hidden detail that Rembrandt leaves you to imagine'... the wrinkles, the lines around the eyes, the eyes themselves, or a 'shadow thrown over them' – all 'part of engaging people in exploring'. Look at his aerial shots of the classic landscapes or the carefully researched scenes of Shakespeare's plays and Dickens's London, which seem to draw upon the 'whimsy, fun and social commentary' of a Bruegel where you are 'compelled to go into the picture and search for someone you need to find'. Always, for this Hans Christian Andersen Award-winning illustrator, his craft – his use of perspective, composition, psychological focus, surprise and mystery – is directed at capturing young readers' imaginations with the stories he chooses to illustrate and transporting them to go beyond words and pictures to become dreamers themselves and live in the 'unfinished spaces' between them.

Elizabeth Hammill

Elizabeth Hammill, OBE is the initiator and co-founder of Seven Stories, Britain's National Centre for Children's Books. Currently a Founder Patron and Collection Trust trustee, she continues to write critically and is the editor of *Over the Hills and Far Away: A Treasury of Nursery Rhymes from around the World* (2014).

Finding Wonderlands
AUSTRALIA

Storm Boy

By Colin Tiele and Robert Ingpen

'Storm Boy lived between the Coorong and the sea. His home was the long, long snout of sandhill and scrub that curves away south-eastwards from the Murray mouth… Storm Boy lived with Hide-Away Tom, his father. Their home was a rough little humpy made of wood and brush and flattened sheets of iron…'

Colin Thiele, *Storm Boy*, 1974

Around Robe

With my wife Angela and our young family we would travel to Robe in the south-east of South Australia for many summer holidays in the 1960s and 70s. In the mornings and late afternoons we swam and played with friends on 'Long Beach', and while the four children rested at our hotel in the heat of midday, I went out to draw and paint the old buildings of the pioneer town and its surrounding farm buildings. Over the years these drawings were bought and collected, and became the pictures for one of my early books, *Robe: A Portrait of the Past* (1975).

One year at Robe I made the drawings for Colin Thiele's story *Storm Boy* and its success began my life as a book illustrator and occasional author. To make the drawings for the book I travelled along beaches, through sandhills, among pelicans and into the Coorong – a wonderful wilderness region that inspired Thiele's classic story, and later a famous Australian film. The illustration on this page depicts Storm Boy's home and was done for the title page of the book.

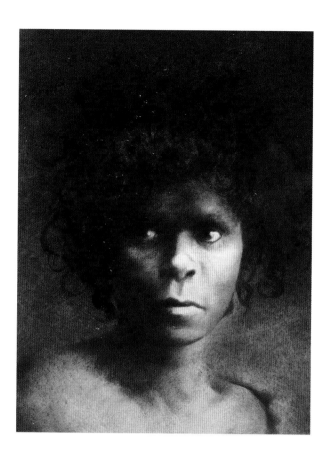

The Drover's Boy

By Ted Egan and Robert Ingpen

The Australian folklorist Ted Egan wrote *The Drover's Boy* (1997) as a fictional ballad, although it was based on historical fact, in recognition of the many Aboriginal women who worked as drovers in years past. As women they were not permitted to do such work, so they would conceal their identity, dressing as boys and often working without pay to move cattle all over Australia. In some cases, as the song suggests, hidden relationships existed between the drovers' 'boys' and their white bosses.

Clancy of the Overflow

The revered Australian folk poet A.B. 'Banjo' Paterson first published his ballad 'Clancy of the Overflow' in 1889. The verse achieved immediate popularity and with the creation of his legendary character Clancy, a free-spirited stockman (above, from my 1982 edition), Paterson had embodied the essence of the Australian outlook.

To mark the 150th birthday of Banjo Paterson in 2014, I took a journey into the Australian outback, exploring the myth of Clancy through words and drawings to find what it is that has made Clancy such an enduring figure in Australian folklore. The result was my book *Looking for Clancy*.

Around Lincoln's Place

In the early 1970s we moved to live on a small farm on the Bellarine Peninsula not far from Geelong. We designed and built a home and studio on a hill with views in every direction. As I did at Robe, I began drawing and painting the old farms and homes in that district, which was first settled in the 1850s. The place that most attracted me was Lincoln's dairy farm with its old cheese factory not far from Portarlington. Once more, I combined with Colin Thiele to make *Lincoln's Place* (1978), and to tell the story of Mrs Lincoln who lived alone on the farm with her ponies, chooks and dog. She often sat with me when I was drawing to help 'colour in' some of the history of her home.

I call the tempera painting shown here 'Johnny Grigg' – a pitchfork treasured by Mrs Lincoln, who was in her nineties when I knew her. I didn't ask her who Johnny Grigg was or why he reminded her of the farm tool that stood silently and faithfully just inside the pony stable door.

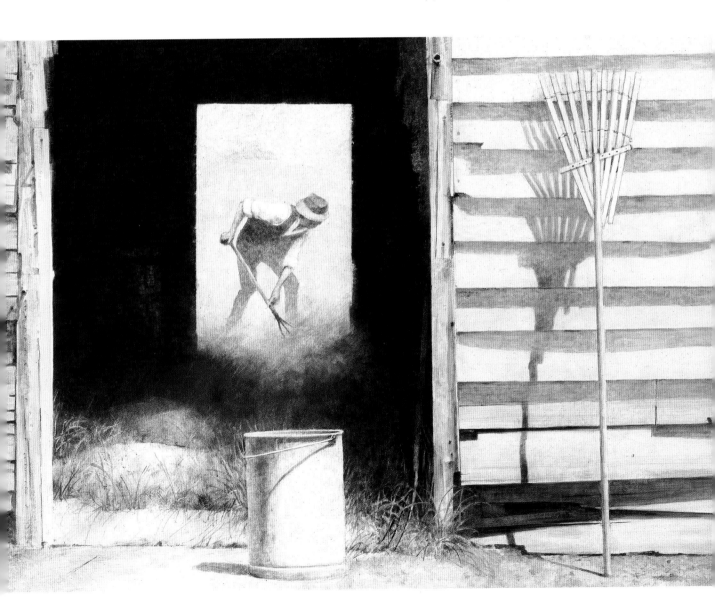

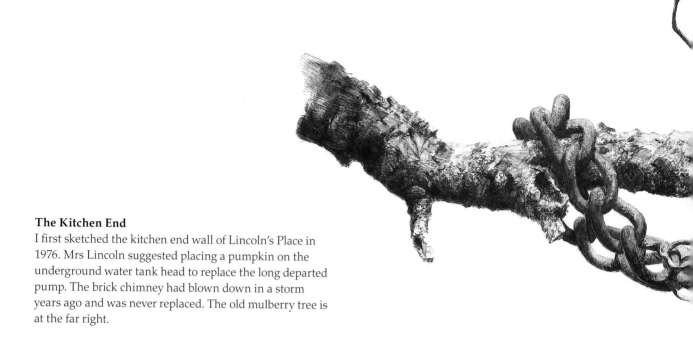

The Kitchen End

I first sketched the kitchen end wall of Lincoln's Place in 1976. Mrs Lincoln suggested placing a pumpkin on the underground water tank head to replace the long departed pump. The brick chimney had blown down in a storm years ago and was never replaced. The old mulberry tree is at the far right.

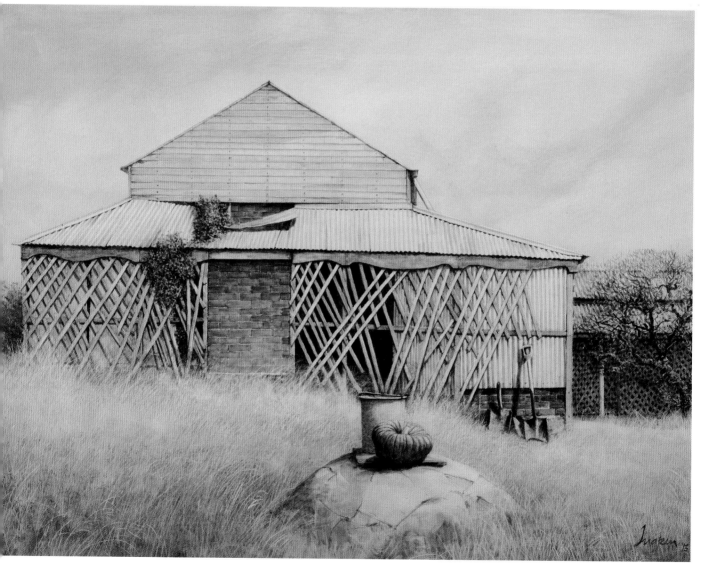

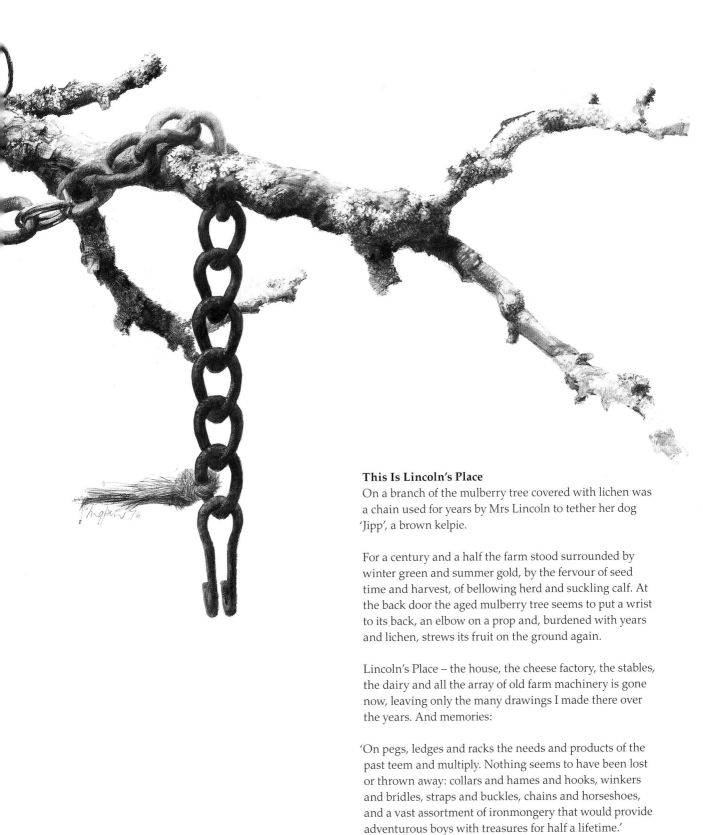

This Is Lincoln's Place

On a branch of the mulberry tree covered with lichen was a chain used for years by Mrs Lincoln to tether her dog 'Jipp', a brown kelpie.

For a century and a half the farm stood surrounded by winter green and summer gold, by the fervour of seed time and harvest, of bellowing herd and suckling calf. At the back door the aged mulberry tree seems to put a wrist to its back, an elbow on a prop and, burdened with years and lichen, strews its fruit on the ground again.

Lincoln's Place – the house, the cheese factory, the stables, the dairy and all the array of old farm machinery is gone now, leaving only the many drawings I made there over the years. And memories:

'On pegs, ledges and racks the needs and products of the past teem and multiply. Nothing seems to have been lost or thrown away: collars and hames and hooks, winkers and bridles, straps and buckles, chains and horseshoes, and a vast assortment of ironmongery that would provide adventurous boys with treasures for half a lifetime.'
Colin Thiele, *Lincoln's Place*, 1978

THE VOYAGE OF THE POPPYKETTLE

By Robert Ingpen

In the early 1970s I was working in Peru for the United Nations (FAO/UNDP). I was part of a team that had been recruited to study the influence of an El Niño episode on the massive commercial anchovy fishery of Peru. Part of my work was to develop communication within the fishing industry and I researched old stories relating to the fishing tradition, which had been passed down since the time of the Inca civilisation. I found a story that seemed to have been told by pelicans, which concerned the sea-god El Niño. My modern retelling of this story, to include new science and conservation ideas, proved useful among local fishing families.

Years later, back in Australia, I further adapted the tale to become the opening of my book *The Voyage of the Poppykettle* (1980). The 'Poppykettle' is the name of a sacred Incan teapot. When it is converted into a boat, a crew of miniature Hairy Peruvian dolls sail away in it, to find a new home. After four adventurous years at sea they land in Australia. The illustration opposite shows an encounter early in their journey, with dragons in the form of iguanas.

My hometown of Geelong was, so the story goes, the landing place for the expedition some 400 years ago. To mark this the community of Geelong did two things. They built a fountain on the waterfront, which was popular for many years with families and children, until it was replaced with a car park. They also created a children's arts festival, aiming to ignite the imaginations of local school children, and called it 'Poppykettle Day'. This has remained an annual event in the Geelong district for 35 years. During this time I have been amazed at the progress of this 'folktale', knowing that the story is composed of a mixture of facts, unexplained events and pure fiction – a combination that drives the enchantment in many enduring folktales. After all these years there still remains much to be discovered by new readers, and sufficient space for imaginative people to make adjustments to the story to suit the occasion and the audience, and so maintain the wonder of storytelling.

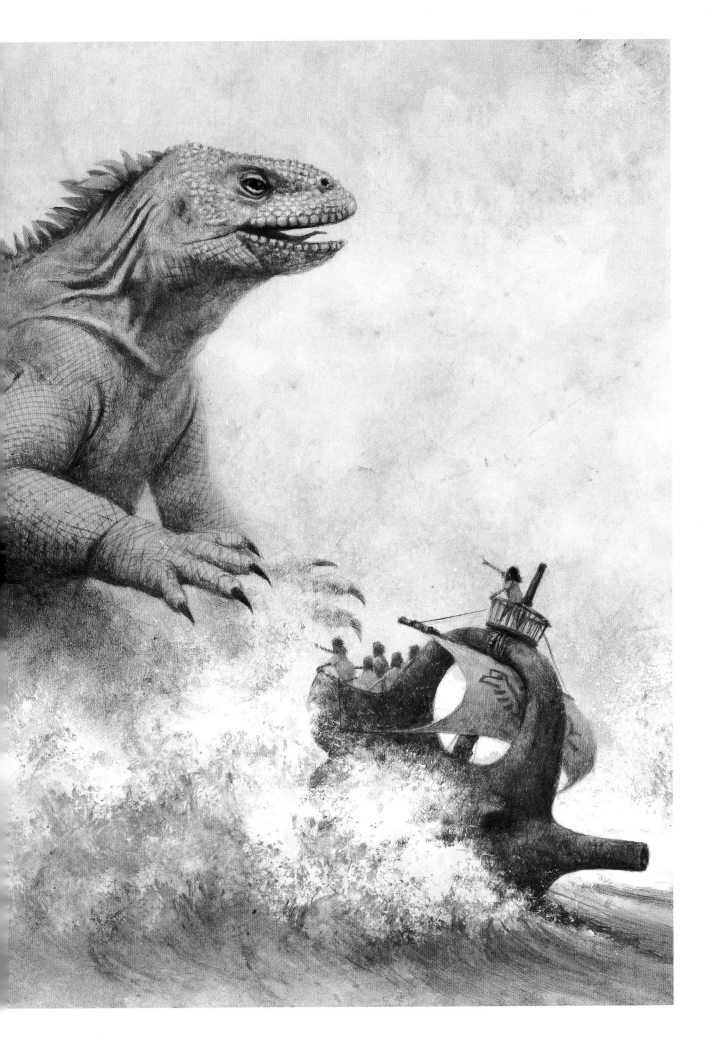

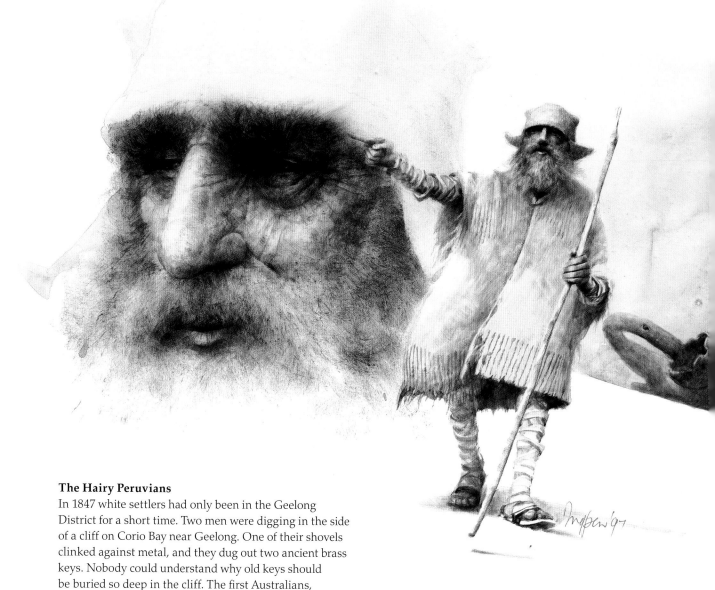

The Hairy Peruvians

In 1847 white settlers had only been in the Geelong
District for a short time. Two men were digging in the side
of a cliff on Corio Bay near Geelong. One of their shovels
clinked against metal, and they dug out two ancient brass
keys. Nobody could understand why old keys should
be buried so deep in the cliff. The first Australians,
the Aboriginal people, had never needed keys. The
Governor of the Colony, Charles La Trobe, visited the
spot, now called Limeburner's Point, and took the keys
for safekeeping, then he lost them. The newspapers wrote
about the keys at the time but nobody could explain them.
Could they have been the ballast keys that fell out of the
'Poppykettle'? And what happened to the 'boat people' of
the story, the Hairy Peruvians?

The Hairy Peruvians were tiny dolls made of driftwood, pieces of woven cloth and human hair. They looked nothing like the Inca people of Peru who made them long ago, but they had enough hair to give them some of the special human attributes of their makers. In reality, I first saw these dolls in a museum in Lima, Peru, when I was searching for stories. At the time they seemed not to be important, but much later when I needed a crew of 'refugees' to flee the tyranny of invading Spaniards they became my Hairy Peruvians.

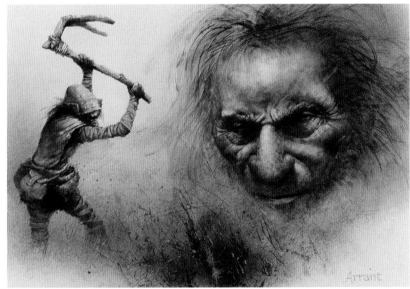

The voyage of the 'Poppykettle' from Peru to Australia took about four years. Following many adventures, including being shipwrecked, they were rescued by a dolphin who delivered six Hairy Peruvians to Australia.(Andante was lost overboard in the great storm.) The men were: Don Avante the leader (*opposite*), Aloof the lookout (*top right*), Arrant the plant keeper (*centre right*) and Astute the negotiator. And there were two women to make up the expedition: Arnica the future teller, and Arnago the cook and healer (*bottom right*).

The account of their adventures and life after landing in Australia – the unchosen land – is told by the Areca, the unseen spirit who was given to the expedition of refugees as a good omen by the sea-god El Niño shortly after the 'Poppykettle' left Peru.

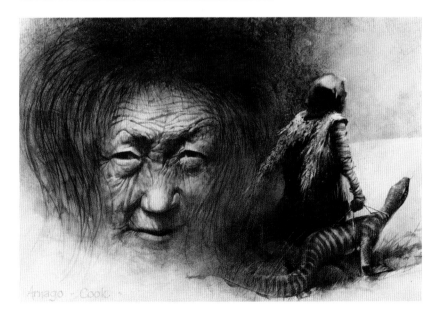

Strange Parallels

There are parallels between my story people from Peru who found their way to Australia 400 years ago and the real 'boat people' who came to Australia – from Britain as convicts in 1788; from Vietnam in the 1970s; and from Afghanistan and other such places in recent times. These boat people became 'non-persons': the convicts because the English could not cure their social evils except by shipping the results out of sight and out of mind; the Middle and Far Eastern boat people because they are 'politically undesirable' and set adrift because of military disasters.

With each era of arrivals of 'boat people', Australian people are challenged to decide whether their homeland is part of the world, capable of accepting the responsibilities of nationhood, including that of succouring the helpless, or whether they will turn inwards to chauvinism and inhumanity.

Ziba Came on a Boat

Written by Liz Lofthouse and based on real events, *Ziba Came on a Boat* (2007) is a moving story full of love, warm memories and hope for the future even in a time of fear. It remains among the most challenging and memorable books that I have been asked to illustrate. Sitting in a crowded hull, Ziba, an Afghan child, remembers all that she has left behind. She and her mother hope to find peace and safety in a new land, but where will their journey end, and what will they find when they arrive?

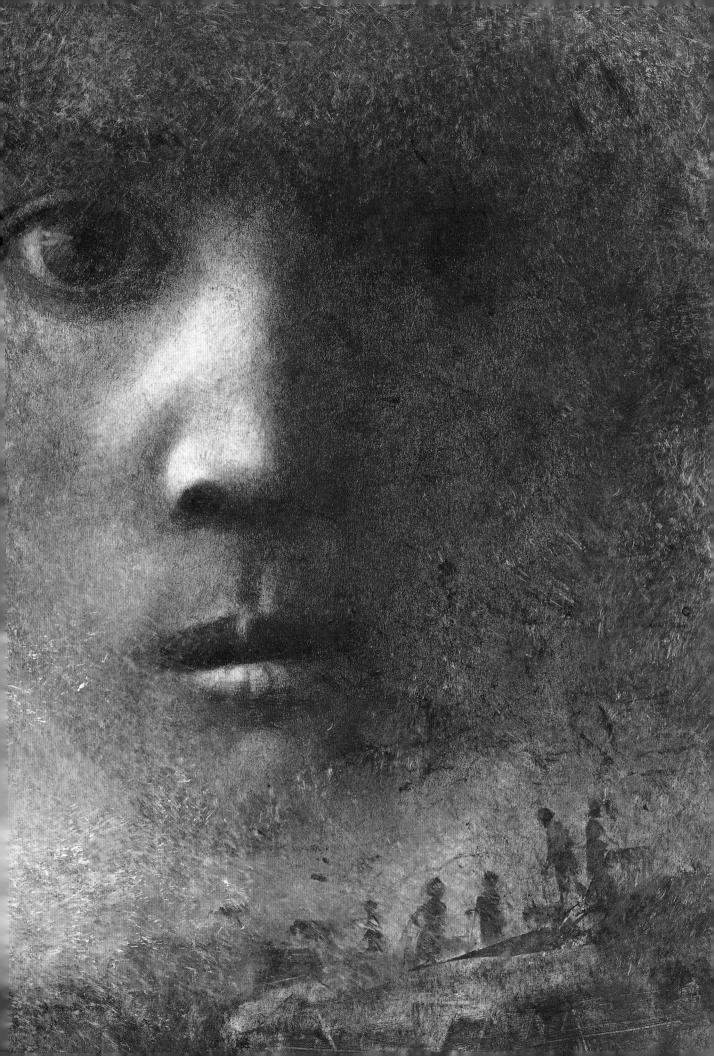

OUTBACK AUSTRALIA

In 2014 and 2016 the National Library of Australia published two books for children that I illustrated. At the heart of each fictional story was a vital but little-known real event that was filed deep in the archives of the NLA in Canberra. The books are *Tea and Sugar Christmas* and *Radio Rescue*, both written by Jane Jolly. Each is designed to illustrate, with words, pictures and fold-out diagrams, a story that occurred in remote parts of Australia that changed the Australian way of life.

Tea and Sugar Christmas
By Jane Jolly and Robert Ingpen

Kathleen is a part-Aboriginal child who lives with her parents in a railway settlement somewhere on the line that crossed the vast Australian desert. She is waiting for Father Christmas to arrive to give her a gift. For 81 years, from 1915 to 1996, the 'Tea and Sugar Train' travelled once a week from Port Augusta to Kalgoorlie to service the settlements with essential supplies, mail, food, and water to rail workers and their families.

'Kathleen grabbed the wheelbarrow and started running with it. Her feet pounded on the hot track, searing like scones on a griddle. She could hear the screeching of the train as it pulled into the siding. As she ran, others emerged from their tin castles, cheering and calling out across the shimmering landscape.'

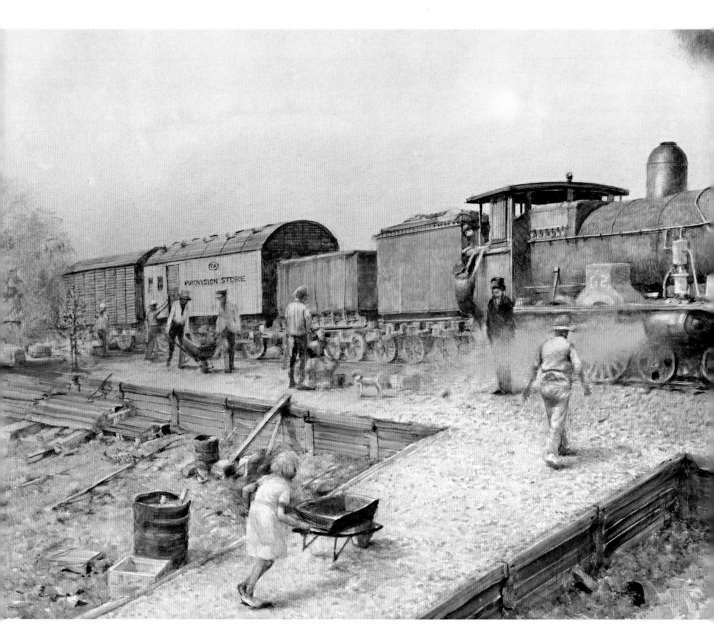

Radio Rescue

By Jane Jolly and Robert Ingpen

Young Jim lives with his parents on Four Wells, a lonely sheep station in the Australian outback. He loves hunting rabbits, exploring with his dog Bluey, chasing goannas and helping Dad with his sheep. But sometimes he is lonely. He is waiting for the 'new fangled' pedal radio to arrive to change things for the better.

In 1925 Adelaide telephone engineer Alf Traeger met the Reverend John Flynn, superintendent of the Australian Inland Mission. They began a partnership that was to change forever the way people in inland Australia communicated. In those times Morse code messages needed hand-driven generators to transmit effectively, which was not practical. By 1928 Traeger had invented his pedal wireless – an odd-looking contraption consisting of a radio on a table, under which sat a small, easy-to-operate, low-cost and durable pedal-operated generator. He travelled to outback areas, installing these sets and teaching the users Morse code and how to use their radios. He found, however, that many struggled with Morse code, so in 1933 Traeger invented a Morse typewriter, enabling outback users to type their messages and have them transmitted in Morse. With this came the establishment of the Australian Inland Mission Medical Service, and later the School of the Air to bring education to the inland.

LOOKING FOR CLANCY
By Robert Ingpen

For most Australians, droving is no more than a rather remote footnote in their past – a time before road, rail and air transport. A time romanticised by poets like Banjo Paterson and Henry Lawson.

Paterson wrote as though nothing else mattered other than Australia. His ballads, 'Clancy of the Overflow', 'The Man from Snowy River' and 'Waltzing Matilda', could not have been written for anywhere else as they centred around the romantic life of the bush. In truth, there was little romance out there in those remote places, in a land as harsh and a climate as fickle as the outback. Also, in truth, no pastoral station or distant township could operate without the Clancy-like characters of shearers, drovers and horsemen and women, even today.

In pictures and words, and supported by Paterson's verse, my book *Looking for Clancy* (2013) tries to point to a way of looking for the legendary drover in what I think of as 'that place between' with its three dimensions – time, place and in the marginal zone where truth and fiction intermingle.

The fictional Clancy occupies a wonderland, and lives in our imaginations remaining ever useful, both in town and country, if only as inspiration in our hearts and dreams.

'In my wild erratic fancy
visions come to me of Clancy
Gone a-droving "down the Cooper"
where the Western drovers go;
As the stock are slowly stringing,
Clancy rides behind them singing,
For the drover's life has pleasures
that the townsfolk never know.'
Banjo Paterson, 'Clancy of the Overflow', 1899

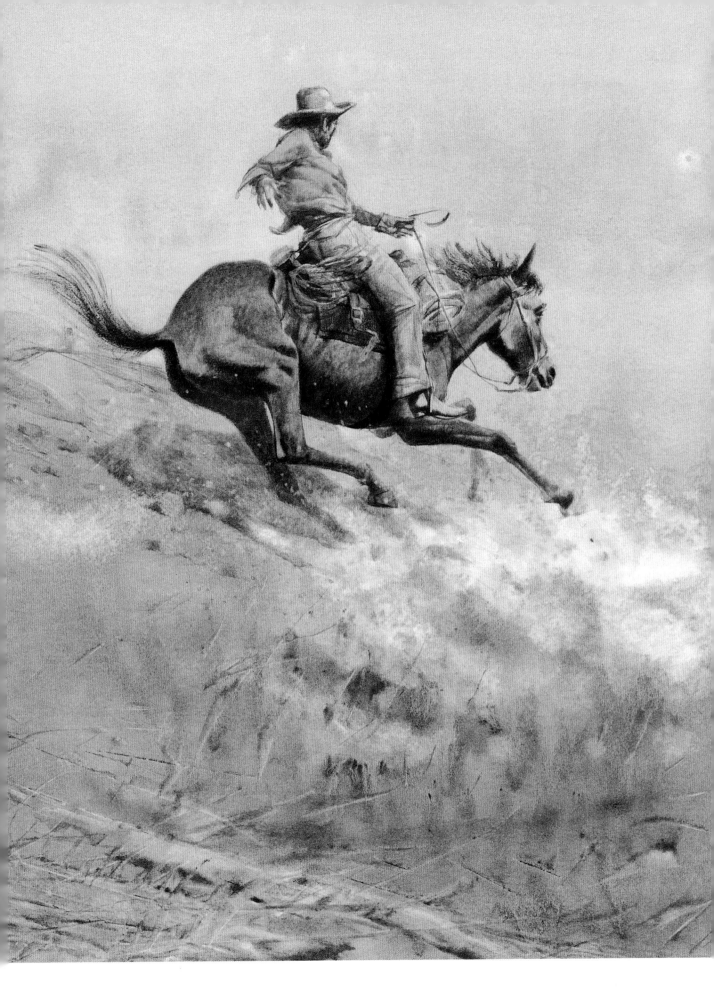

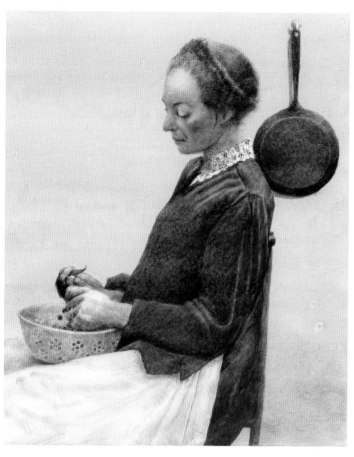

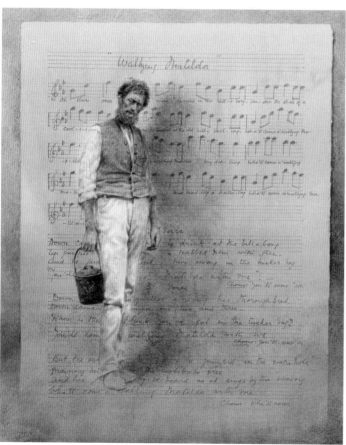

The Battlers

The term 'battler' refers to an Australian who generally has few natural advantages but earns respect by working doggedly on, with uncertain prospect of reward; who accepts the chanciness of the struggle for a living, and shows courage in doing so. Battlers may be characterised by their resourcefulness, as C.E. Bean noted in 1910 in his book *On the Wool Track*:

'The genius of the Australian is that he can make something out of nothing… he has had to make do without the best things, because they don't exist there. So he has made the next best do, and where even they did not exist themselves he manufactured them out of things one would have thought impossible for any use at all.'

Bean was mostly speaking of the people of the 'back country' – people like Clancy and the real stockmen, drovers, shearers, cooks and even swagmen. In 1895, in southern Queensland, Banjo Paterson heard a sad story about a recent suicide of a shearer. Based on this story, he composed 'Waltzing Matilda', about a forlorn battler who steals sheep to eat and is caught by a station owner and three policemen. Faced with arrest and the loss of his swagman's cherished freedom, he drowns himself. The song became a national treasure and is frequently being proposed as the alternative Australian national anthem.

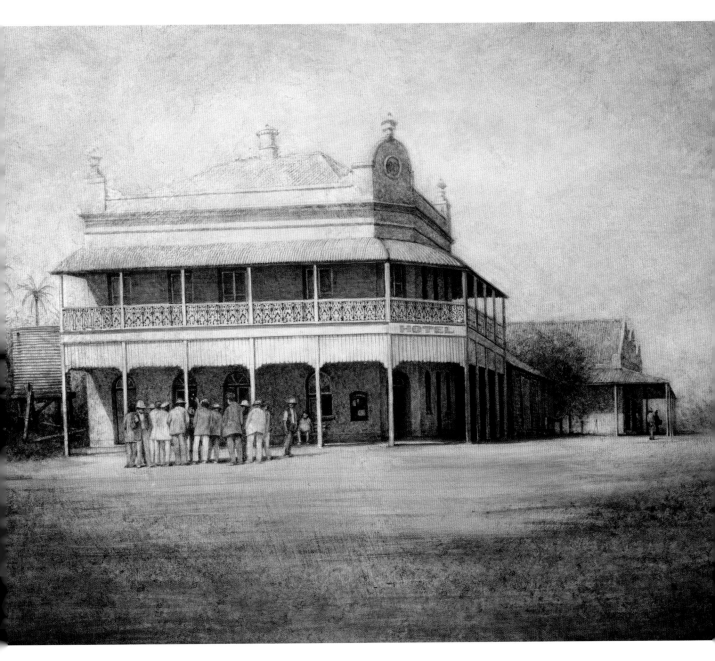

Tully the Cook
'I tell the customers in the bar of the Silkwood pub I'd never have got a job as cook in the Lachlan sheds down south if I had not met a bloke called Clancy at Wilcannia on the Darling back in the twenties. I didn't really, but it's the sort of thing that keeps the customers happy.'

The Shearing Shed

The woolshed here was probably built in the 1880s, close to the Lachlan River in western New South Wales. It was made of cypress pine with drop-log infill panels, and the interior would have resembled a long factory equipped to shear sheep, class the wool and bale the fleeces.

In 1937 *Walkabout* published a journalist's observation of the typical shearing scene:

'In the shed, throughout the shearing, the air is hot and heavy, and rich with the smell of wool… Everywhere there is an ordered rush and bustle. On the board, fleeces fall to the floor in beautiful, snow-white folds, to be whisked away to the wool room as each shearer finishes his sheep.'

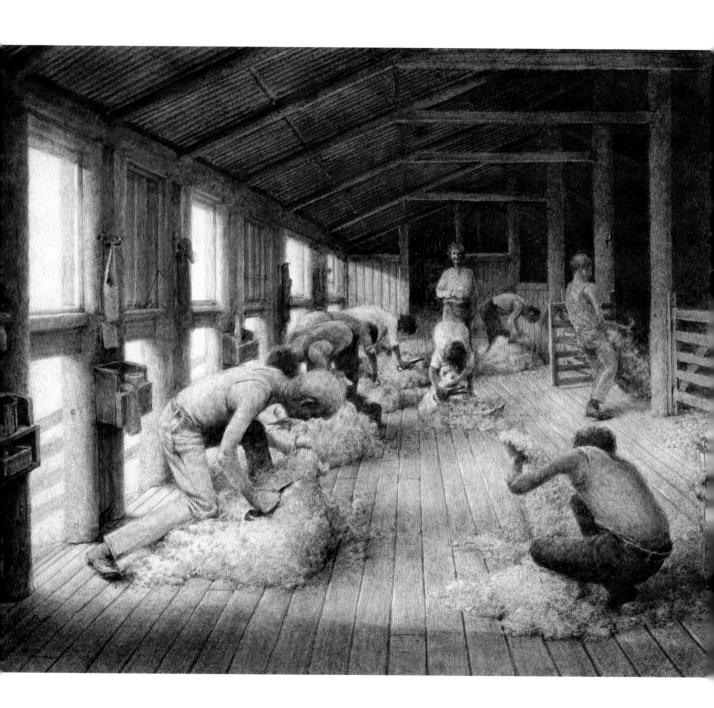

TASMANIAN WILDERNESS

Far away from the inland landscapes and places of
Clancy and other battlers, I have spent time drawing and
painting in Tasmania. Here in the rugged wilderness of the
southwest of the island there are high windy places where
one can sit by a lake and look into the misty distance and
seem to feel the movement of the world. By ceasing to think
of oneself, the sound – a strange and unexpected music –
can be sensed in the air.

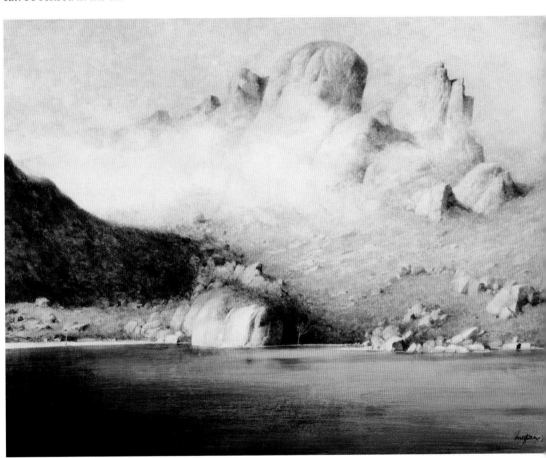

The Crags of Capella above Lake Cygnus,
Western Arthur Range, tempera painting on board, 2012

Finding Wonderlands
CLASSIC STORIES

CHAUCER'S PILGRIMS

An illustrator usually tries to build enough space into pictures that, while sufficient detail about the setting and casting of a story is included, there is still the possibility for readers to use their imaginations and make the story their own. Some time ago I illustrated most of the characters Geoffrey Chaucer describes in his prologue to *The Canterbury Tales* as they gathered at the Tabard Inn in 1390 before they set out on their pilgrimage. I also illustrated the Host – 'His eyes were bright, his girth a little wide'.

The Host (*right*)
This illustration shows that the Host has lost a tooth, possibly in a fight. By including this detail the reader is invited to look further into the story not entirely supplied by Chaucer, who created these colourful characters. Through careful research I began to think about the reasons for Chaucer not taking his pilgrims all the way to Canterbury, or bringing them back again. I don't think this was an accident, or that he tired of the story. I think he knew his readers could do that for themselves with the help of 'space' left for their own imagination.

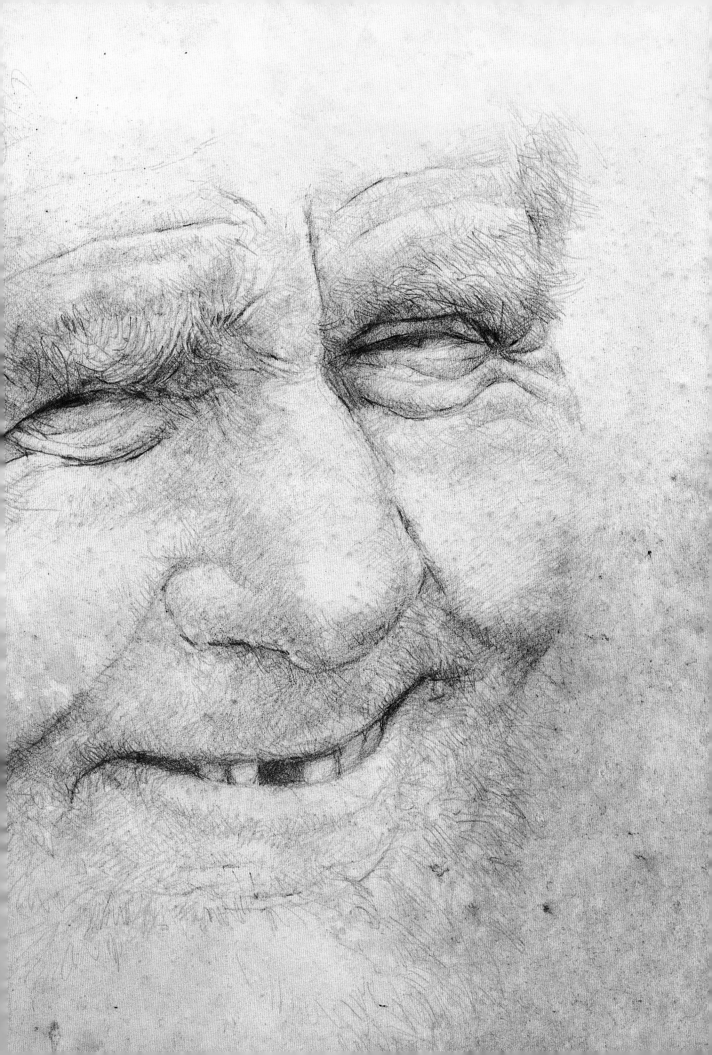

Chaucer's Prologue is a concise portrait of an entire nation, and it is generally agreed that nothing in classic literature resembles it. He presents word pictures of the high and low, old and young, male and female, lay and clerical, learned and ignorant, rogue and righteous of fourteenth-century England.

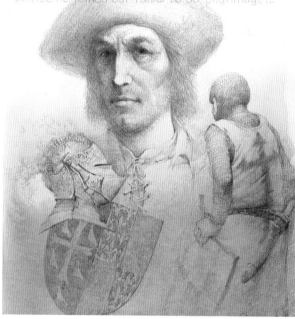

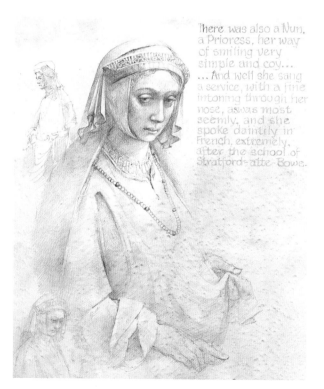

The Knight (*left*)
'There was a Knight, a most distinguished man…
And though so much distinguished, he was wise
And in his bearing modest as a maid.
He ne'er yet a boorish thing had said
In all his life to any, come what might;
He was a true, a perfect gentle-knight…
He wore a fustian tunic stained and dark
With smudges where his armour had left mark;
Just home from service, he had joined our ranks
To do this pilgrimage and render thanks.'

The Nun (*bottom left*)
'There was also a Nun, a Prioress,
Her way of smiling very simple and coy…
And well she sang a service, with a fine
Intoning through her nose, as was most seemly,
and she spoke daintily in French…'

The Friar (*opposite, top left*)
'There was a Friar, a wanton one and merry,
A Limiter, Friar, a very festive fellow.
In all Four Orders there was none so mellow,
So glib with gallant phrase and well-turned speech.'

The Monk (*opposite, top right*)
'A Monk there was, one of the finest sort
Who rode the country; hunting was his sport.
A manly man, to be an Abbott able;
Many a dainty horse he had in stable…
Greyhounds he had, as swift as birds, to course.'

The Miller (*opposite, bottom left*)
'The Miller was a chap of sixteen stone,
A great stout fellow big in brawn and bone…
His mighty mouth was like a furnace door.
A wrangler and buffoon, he had a store
Of tavern stories, filthy in the main.'

The Wife of Bath (*opposite, bottom right*)
'A worthy woman from beside Bath city
Was with us, somewhat deaf, which was a pity.
In making cloth she showed a great bent.
She bettered those of Ypres and of Ghent…
A worthy woman all her life, what's more
She'd had five husbands, all at the church door.'

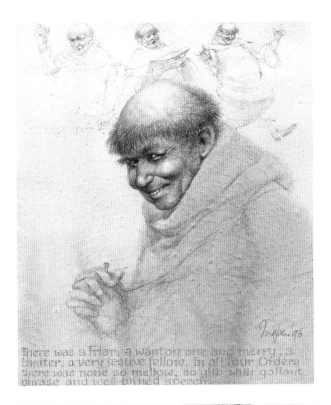

There was a friar, a wanton one and merry, a limiter, a very festive fellow. In all four Orders there was none so mellow, so glib with gallant phrase and well turned speech.

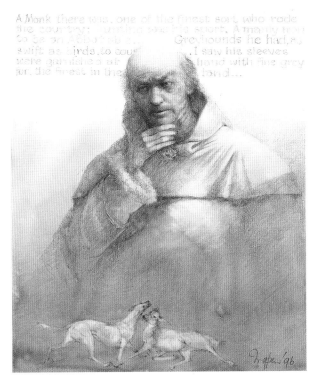

A Monk there was, one of the finest sort who rode the country; hunting was his sport. A manly man to be an Abbot able... Greyhounds he had, as swift as birds, to course... I saw his sleeves were garnished at the hand with fine grey fur, the finest in the land...

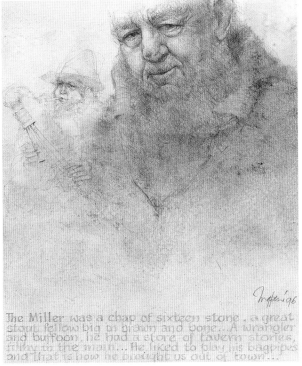

The Miller was a chap of sixteen stone, a great stout fellow big in brawn and bone... A wrangler and buffoon, he had a store of tavern stories, filthy in the main... He liked to play his bagpipes and that is how he brought us out of town...

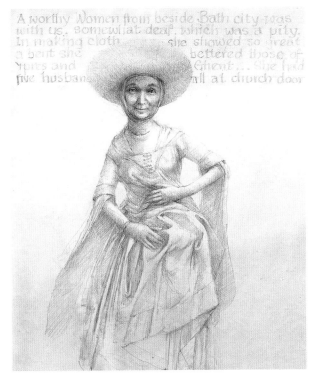

A worthy Women from beside Bath city was with us, somewhat deaf, which was a pity. In making cloth she showed so great a bent she bettered those of Ypres and Ghent... She had five husbands all at church door

HAMELIN TOWN

Long ago in ancient Germany, at a time just on the brink of modern civilisation, something terrible happened in Hamelin Town. While details of the events have been lost, the impact it had on the people of Hamelin and Europe as a whole was devastating. For, somehow, during those days of crusades, continental wars and the horror of the Black Plague, the children of Hamelin were lost forever.

With no real explanation of what happened, and no modern grief counselling to call upon, people turned to storytelling to ease the pain and help come to terms with something they couldn't understand. They invented a story about a stranger known as 'the Pied Piper', who promised the elders of Hamelin that he would use his magical pipe-playing to rid the town of a plague of rats. He was as good as his word, but when he asked for payment the town elders refused, and sent the mysterious stranger away empty-handed.

The next day the streets of Hamelin were silent, except for the wailing of bereaved and bewildered parents. Without the laughter and joy of children, the town was plunged into despair – the piper had taken them all, except for one crippled boy.

The piper had walked through the streets playing the most beautiful music the children had ever heard and they had followed him as he led them up the hill and far away

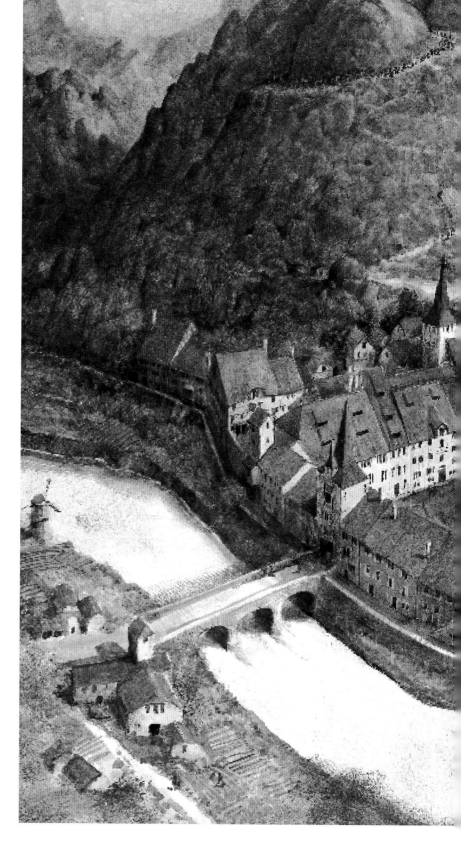

from Hamelin. But because one little boy had only one good leg, he fell behind until he could no longer see them, and he turned back to the town to tell his story. The story of the Pied Piper has

become a folktale. The modern town of Hamelin in Westphalia is much changed since those times in 1284, as above, when the children were lost, but the Rattenfangerhaus (or Rat-catcher's House) is preserved.

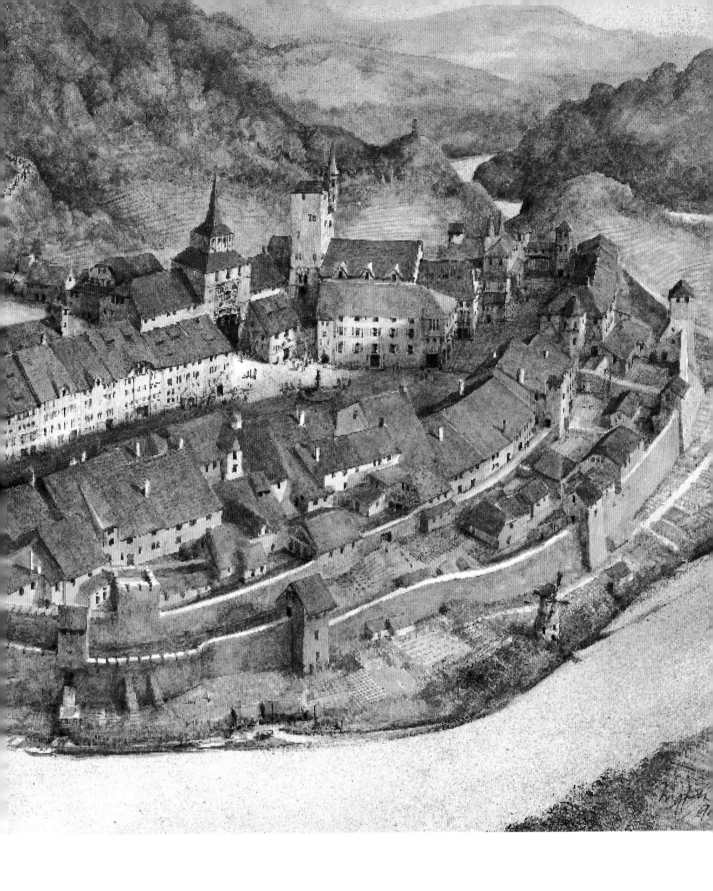

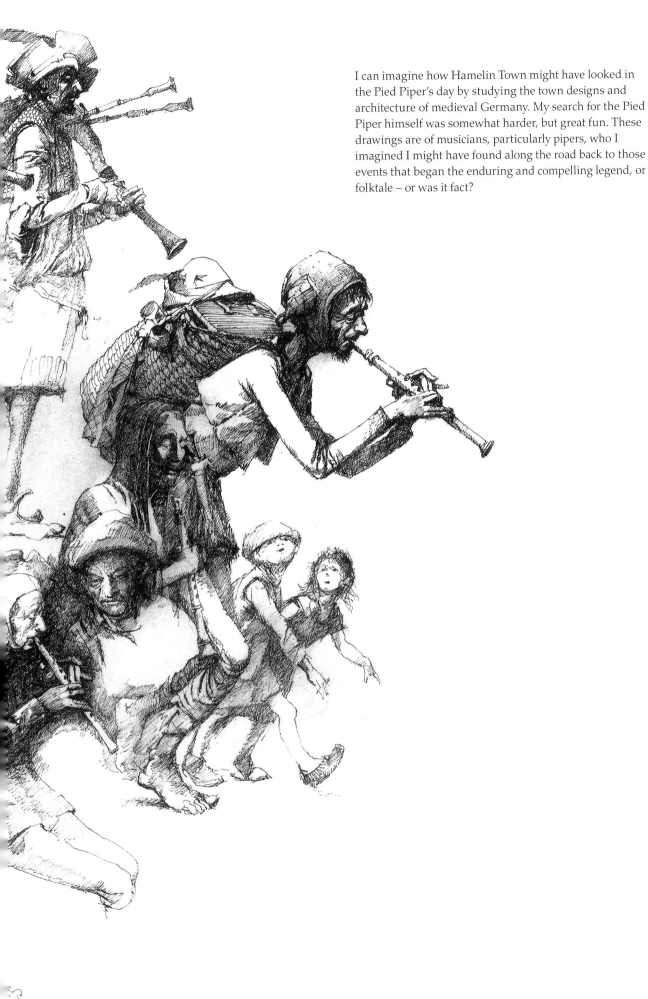

I can imagine how Hamelin Town might have looked in the Pied Piper's day by studying the town designs and architecture of medieval Germany. My search for the Pied Piper himself was somewhat harder, but great fun. These drawings are of musicians, particularly pipers, who I imagined I might have found along the road back to those events that began the enduring and compelling legend, or folktale – or was it fact?

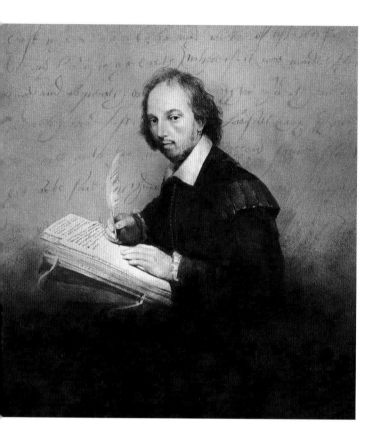

SHAKESPEARE AT WORK

In 2003 I collaborated with British writer Michael Rosen to make a book on the work and world of William Shakespeare. The publishers wanted this work for teenagers who would be expected to have read one of his plays at school.

To illustrate Shakespeare's stories is an experience unlike that of making pictures for most other authors like Chaucer, Dickens and Stevenson. His language is similar, but his purpose and impact has a special power. He didn't really write books, he wrote scripts – scenes and speeches for people to say aloud and act out in front of other people in theatres and playhouses in the late sixteenth century.

He wrote an incredible set of stories, full of action, poetry, tension, love, death, fun, music, dance, war, rebellion, conspiracy and betrayal. Sometimes they are about politics, at other times about how people get on together as man and woman, parent and child, friend and friend. In Shakespeare's plays we meet the people of London and visitors from far-off places who he drew upon for his characters. He lived here (*top right*) beside the Thames near London Bridge and close to The Globe and other theatres.

Juliet's Soliloquy (*opposite*)
In real life, people don't often make speeches out loud when they are on their own, but in Shakespeare's plays we find ourselves hearing about the workings of the mind. In my illustration Juliet is talking to herself and to us.

'Come, night; come, Romeo; come, thou day in night;
For thou wilt lie upon the wings of night
Whiter than new snow on a raven's back.
Come, gentle night, come, loving, black-brow'd night,
Give me my Romeo; and, when he shall die,
Take him and cut him out in little stars…'
William Shakespeare, *Romeo and Juliet*, Act 3, Scene 2

Overleaf:
A reconstruction of the imagined scene at Shakespeare's birthplace Stratford-upon-Avon over four hundred years ago. Somewhere in the crowded marketplace a young William Shakespeare watches travelling players perform tales he would later recreate as plots for his plays.

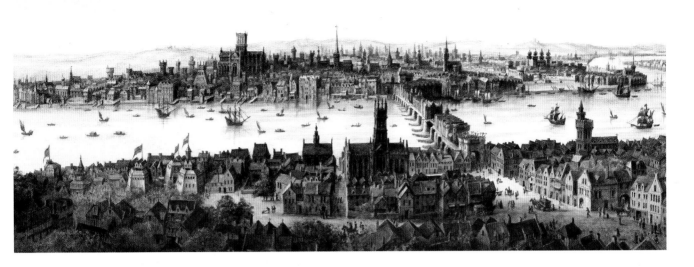

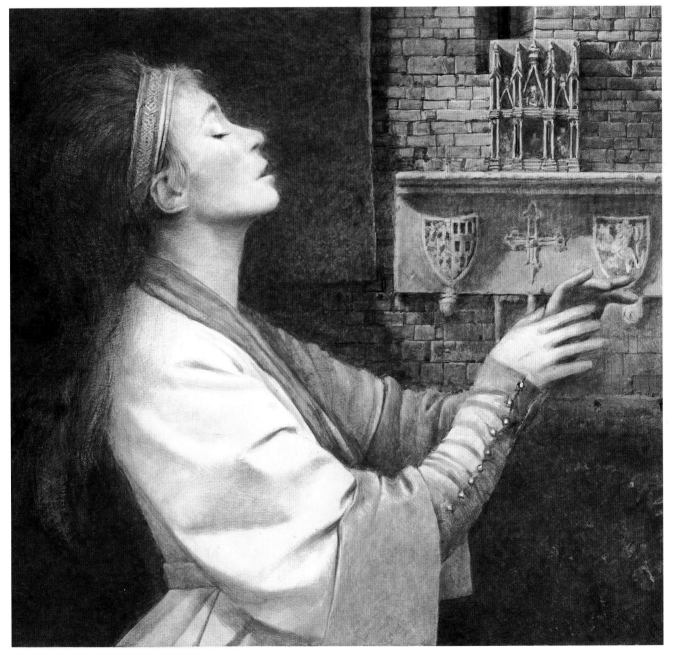

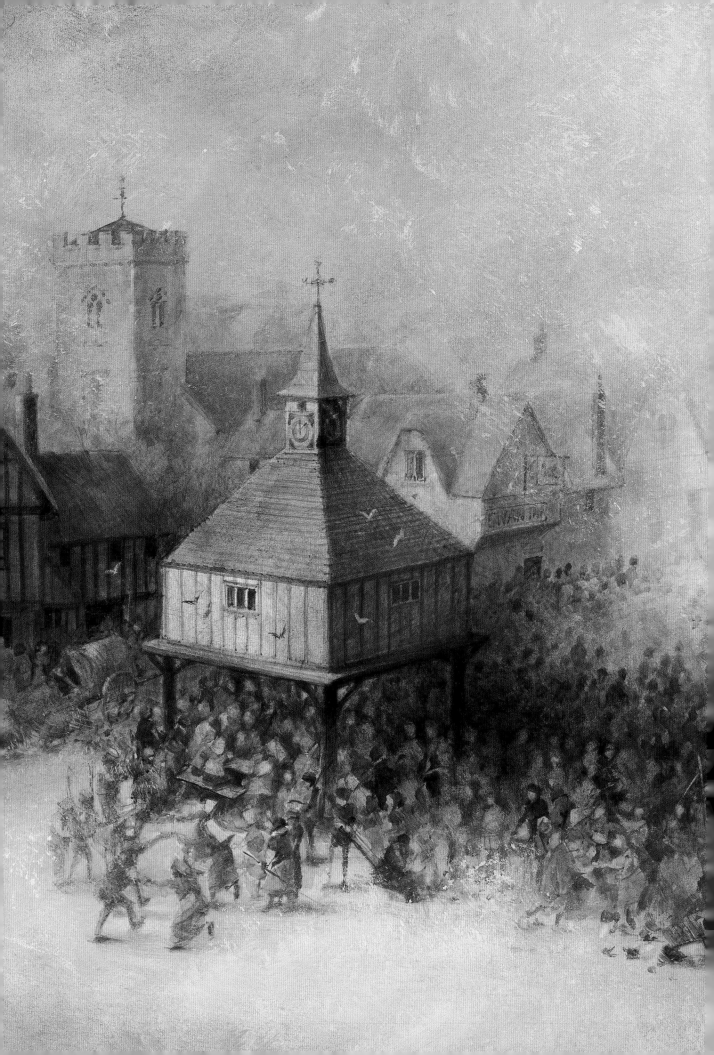

'Give Me Some Light!'

In *Hamlet*, Shakespeare sets the scene for an illustrator's wonderland. Well into the play Prince Hamlet arranges for a group of travelling players to put on a play that acts out the murder of his father. It is performed in front of Claudius, the new king, the one who actually did the murder. At the moment when the play shows a man poisoning a king, just as Claudius had murdered Hamlet's father, the real Claudius can't bear it any longer and rushes out shouting, 'Give me some light, away!'

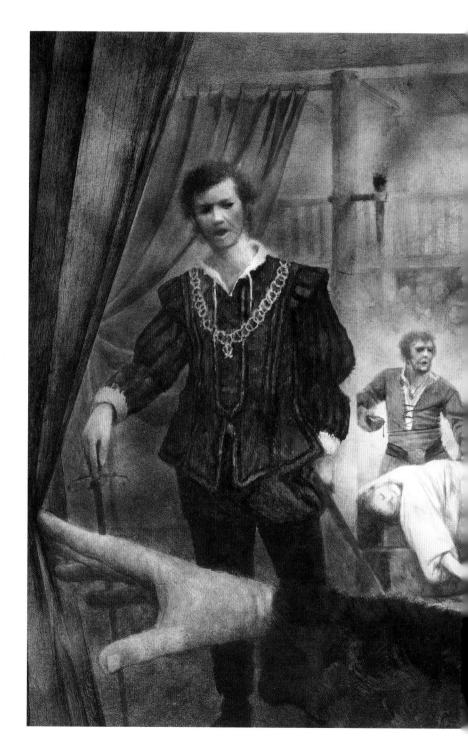

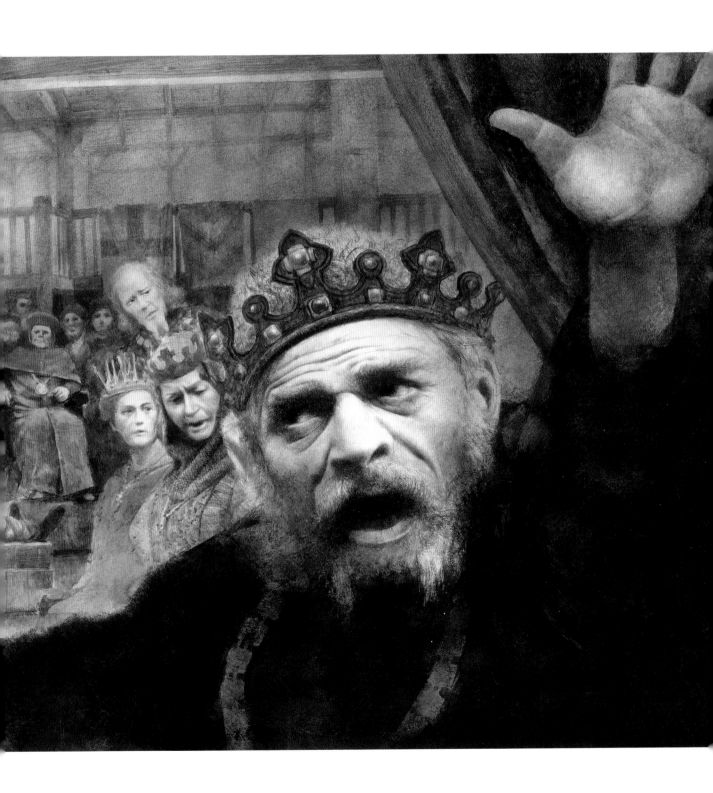

Charles Dickens left a legacy that still shapes our language and literature today, introducing us to characters like Ebeneezer Scrooge, Little Nell, Oliver Twist, and practically reinventing Christmas. The two characters I particularly enjoyed 'meeting' as an illustrator were Pip and Miss Havisham who are in perhaps Dickens's greatest work, *Great Expectations*, published in 1861.

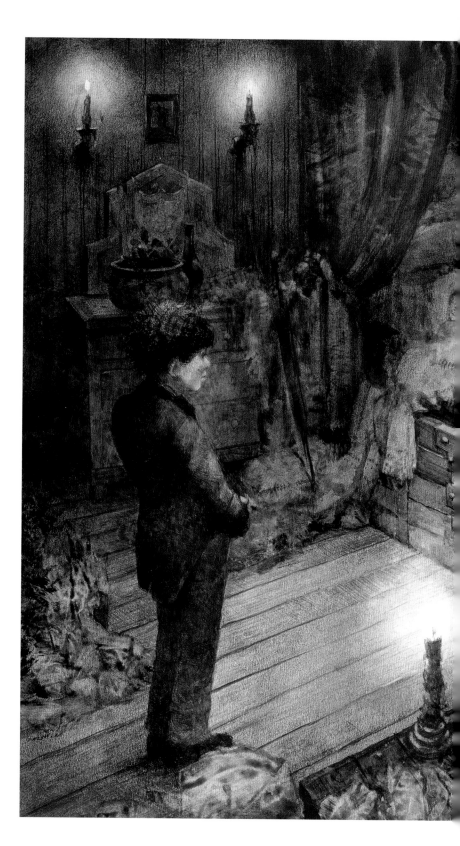

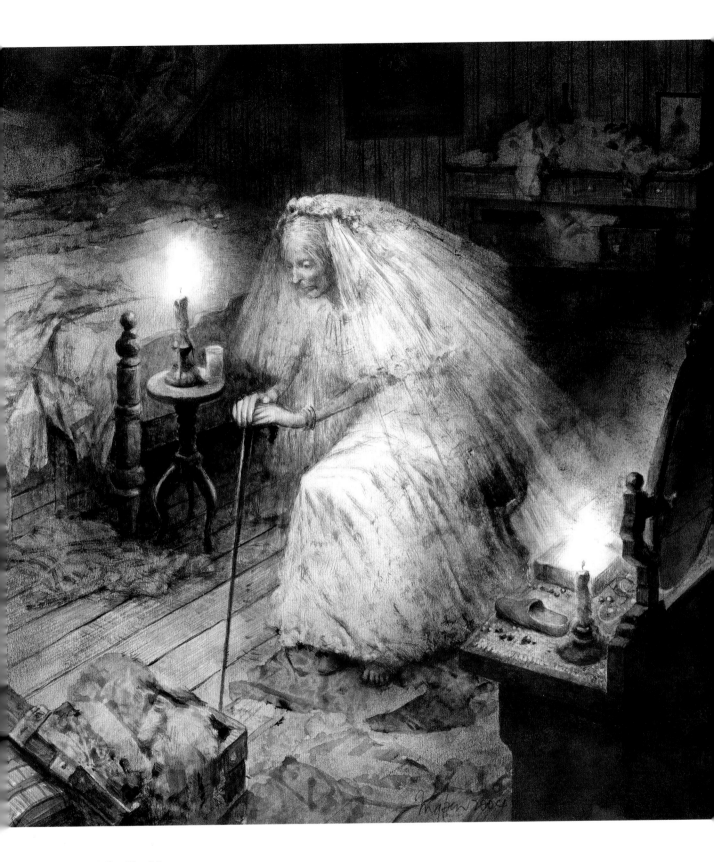

Pip Meets Miss Havisham

'It was not in the first moments that I saw all these things, though I saw more of them in the first moments that might be supposed. But I saw that everything within my view which ought to be white, had been white long ago, and had lost its lustre and was faded and yellow. I saw that the bride within the bridal dress had withered like the dress, and like the flowers, and had no brightness left but the brightness of her sunken eyes.'

Charles Dickens, *Great Expectations*, 1861

During the 1850s Dickens's stories appeared in serials, week by week or month by month in popular magazines called 'chapbooks'. Because his stories were so good they became books, and everybody wanted to read them. Dickens was who he was through living and taking part in everything going on around him. In his own journal, *Household Words*, he writes:

'Umbrellas to mend, and chairs to mend, and clocks to mend, are called in all our streets daily. [But] who shall count up the numbers of thousands of children to mend, in and about those same streets, whose voice of ignorance cries aloud as the voice of wisdom once did, and is as little regarded; who go to pieces for the want of mending and die unrepaired!'

Charles Dickens, 'Boys to Mend' in *Household Words*, 11 September 1852

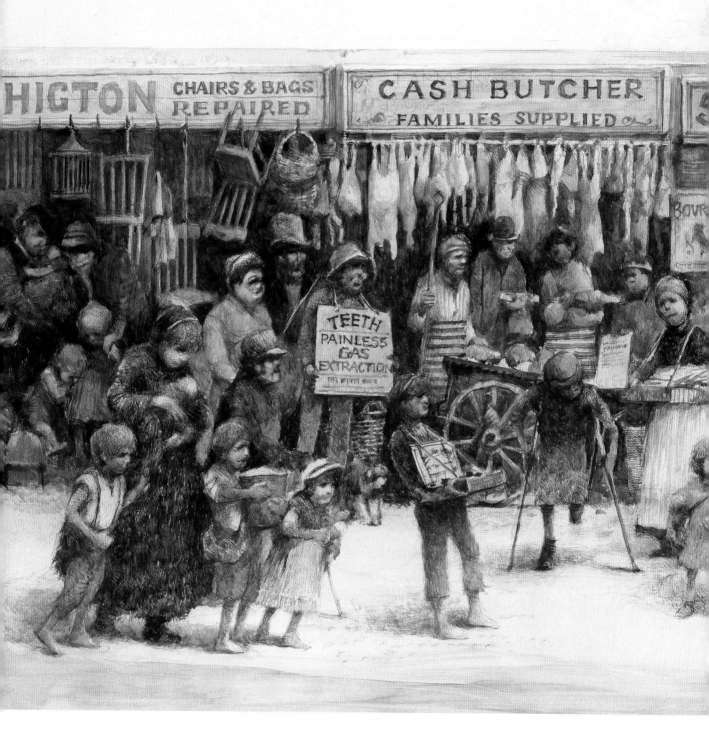

Working Plans

Here are my first ideas for a book about Charles Dickens's child characters. Although this book was never published it was to be titled *The Children of Dickens*. Over the following pages the process I use for preparing a book is displayed – from 'flat plan', to sketchbook, to final illustration.

The 'flat plan' is like a storyboard often used by filmmakers in their sequence resolution for filming. I lay out, at a much-reduced size, the pages and sequence of how the book might look. Illustrations are placed where they would be best in balance with the text narrative. Once done, these plans are reviewed by the publishing team and the writer of the text (if available) for refining and production costing. I retain a photocopy of this plan to refer to as I work on the final illustrations to ensure the context and size are realistic.

During the years that brought about my series of Children's Classics, the art of 'flat planning' was refined to serve also as a preliminary marketing opportunity to attract possible co-edition publishers, often in other languages.

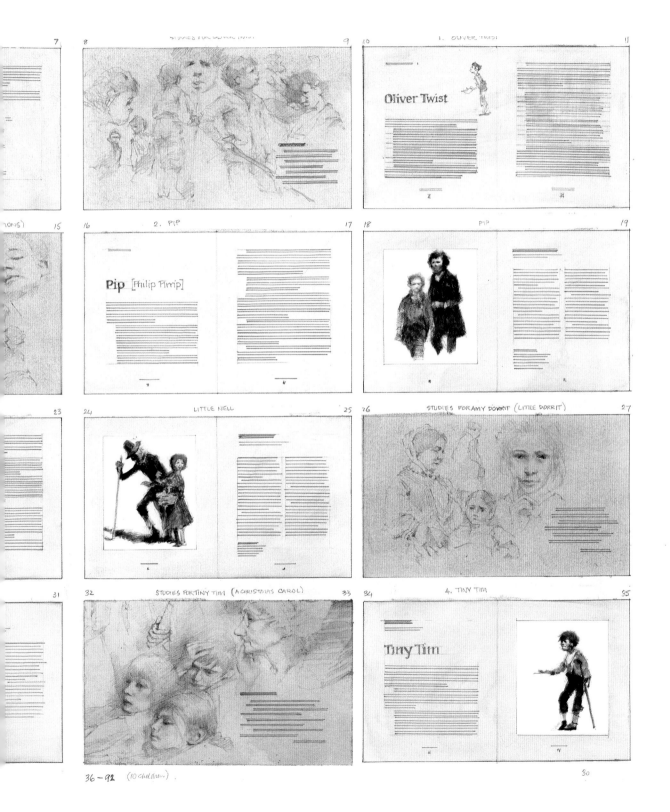

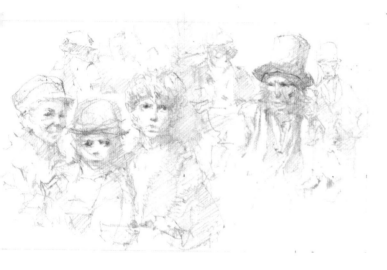

The Old Curiosity Shop

Chapter 12 Little Nell and Grandfather . (p 103)

'Which way' said the child.
The old man looked irresolutely and helplessly, first
her, then to the right and left, and shook his head
plain that she was henceforth his guide and le
the child felt it, but had no doubts or misgiv
Putting her hand in his, led him gently away.
It was the beginning of a day in June

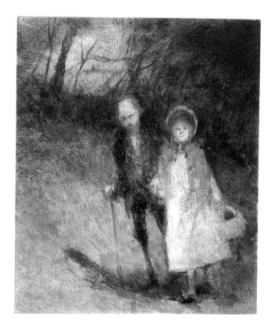

Chap 13
He awoke refreshed, and they continued
their journey. The road was pleasant, lying
between beautiful pastures and fields of corn,
above which, poised high in the clear sky,
the larks trilled out a happy song. The air came
laden with the fragrance it caught upon its way,
and the bees, upborne upon its scented breath,
humming forth their drowsy satisfaction as
they floated by . . .

Dickens — Household Words
Sat. Sept 11 1852

Boys to mend —
Umbrellas to mend, and chairs to mend, and clocks
to mend, are called on all our sheets daily. Who shall
count up the numbers of thousands of children to mend,
in and about those same sheets, whose voice of
ignorance cries aloud as the voice of wisdom once did,
and is as little regarded; who go to pieces for the want
of mending, and die unrepaired!

double-spread for introductory text to 'The Children of Dickens'

Sketchbook Habit

Here is a sheet from the sketchbook I used in the planning of *The Children of Dickens*. Pencil notes and rough drawings are done, often many times, over such sheets to refine the work approved in the flat plan. For example, the sketchbook page opposite shows a rough picture of Little Nell leading her grandfather from London:

'"Which way?" said the child. The old man looked, irresolutely and helplessly, first at her, then to the right and left, then at her again, and shook his head. It was plain that she was henceforth his guide and leader.'
Charles Dickens, *The Old Curiosity Shop*, 1840

The final version of this illustration ready for printing appears overleaf. The other rough ideas on this sheet are preparation for the illustration titled 'Boys to Mend', reproduced on pages 44–45.

Little Nell and Her Grandfather

'He awoke refreshed and they continued their journey.
The road was pleasant, lying between beautiful pastures
and fields of corn about which, poised high in the clear
blue sky, the lark trilled out her happy song. The air came
laden with the fragrance it caught upon its way, and the
bees, upborne upon its scented breath hummed forth their
drowsy satisfaction as they floated by.'

Charles Dickens, *The Old Curiosity Shop*, 1840

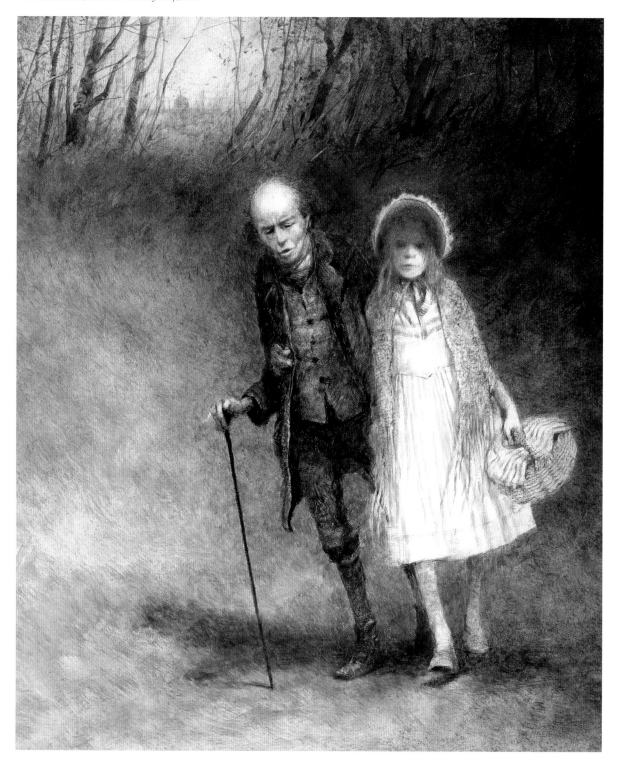

A CHRISTMAS CAROL

By Charles Dickens, 1843

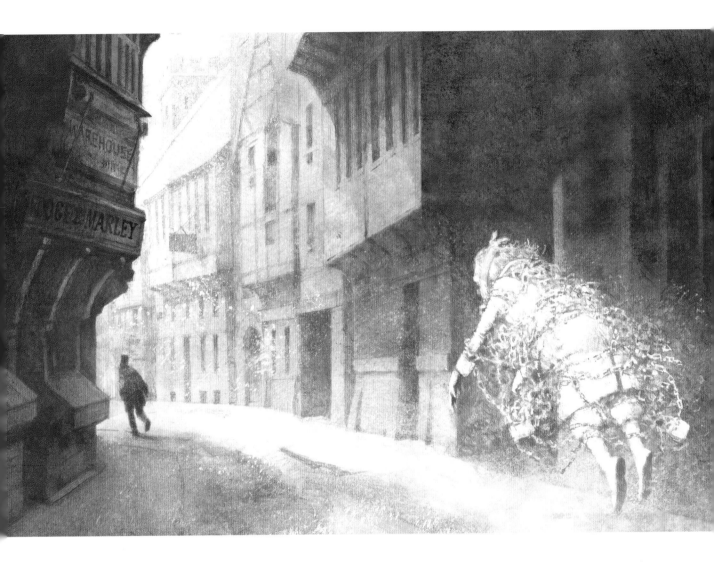

Early in 1843, as a response to a government report on the abuse of child labourers in mines and factories, Dickens vowed he would strike a 'sledgehammer blow… on behalf of the Poor Man's Child'. In December that year, he wrote one of his most popular works, *A Christmas Carol*. Through the story of the solitary miser, Ebenezer Scrooge, who is taught the true meaning of Christmas by a series of ghostly visitors, Dickens vividly defined the message of goodwill towards mankind. Above is Marley's ghost from my edition published in 2008.

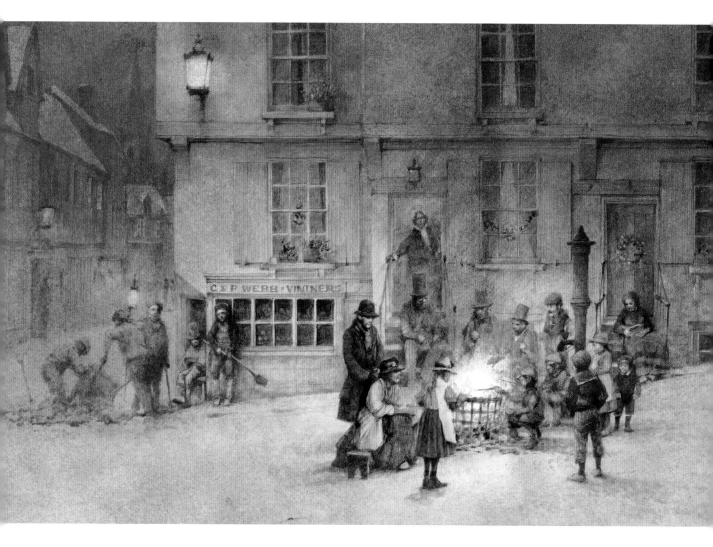

'The cold became intense. In the main street, at the corner
of the court, some labourers were repairing gas pipes, and
had lighted a great fire in a brazier, round which a party of
ragged men and boys were gathered warming their hands
and winking their eyes before the blaze in rapture…'

Charles Dickens, *A Christmas Carol*, 1843

'He went to church, and walked about the streets, and watched the people hurrying to and fro, and patted children on the head, and questioned beggars, and looked down into kitchens of houses, and up to the windows: and found that everything could yield him pleasure.'
Charles Dickens, *A Christmas Carol*

THE NIGHT BEFORE CHRISTMAS

By Clement C. Moore
First published circa 1823
Illustrated by Robert ingpen, 2010

''Twas the night before Christmas,
 when all through the house
 Not a creature was stirring,
 not even a mouse.'

This opening to the poem evokes the wonder of a
magical time of the year. The events that follow mark the
beginning of the tradition of Santa Claus and the joy that
he brings to children on Christmas Eve.

Some of my illustrations for this book got me into trouble.
I followed the author's words for the poem literally – I
gave Santa Claus a pipe! Some of the publishers felt that
it was inappropriate now that smoking is banned to show
children a pipe-smoking Santa:

'The stump of a pipe
 he held tight in his teeth.
 And the smoke it encircled
 his head like a wreath.'

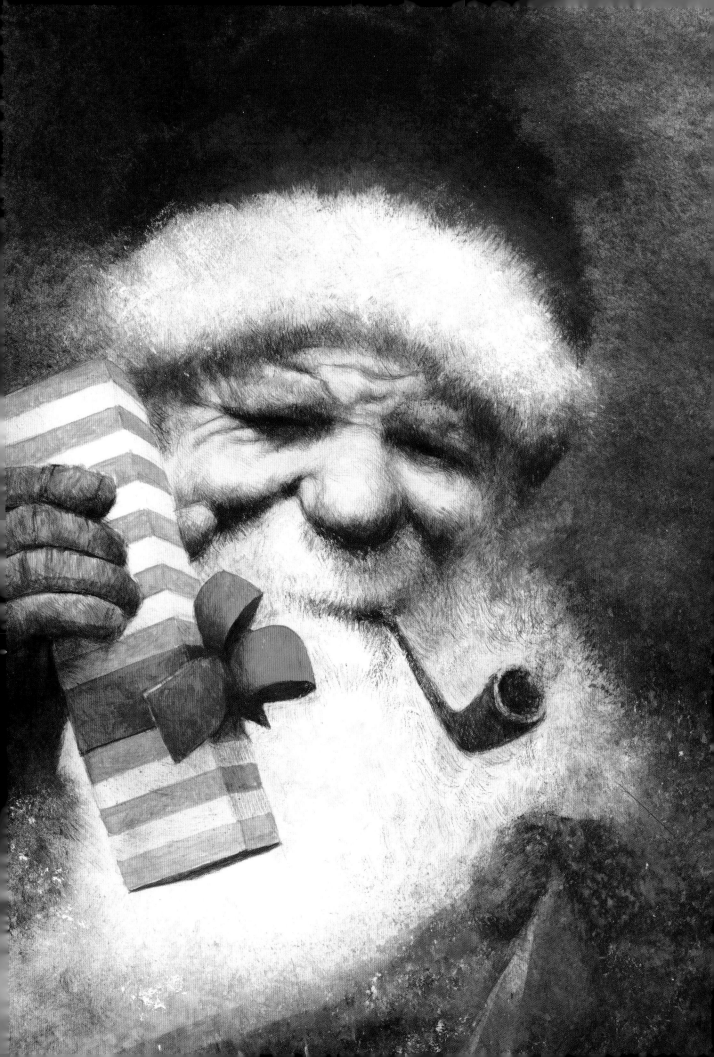

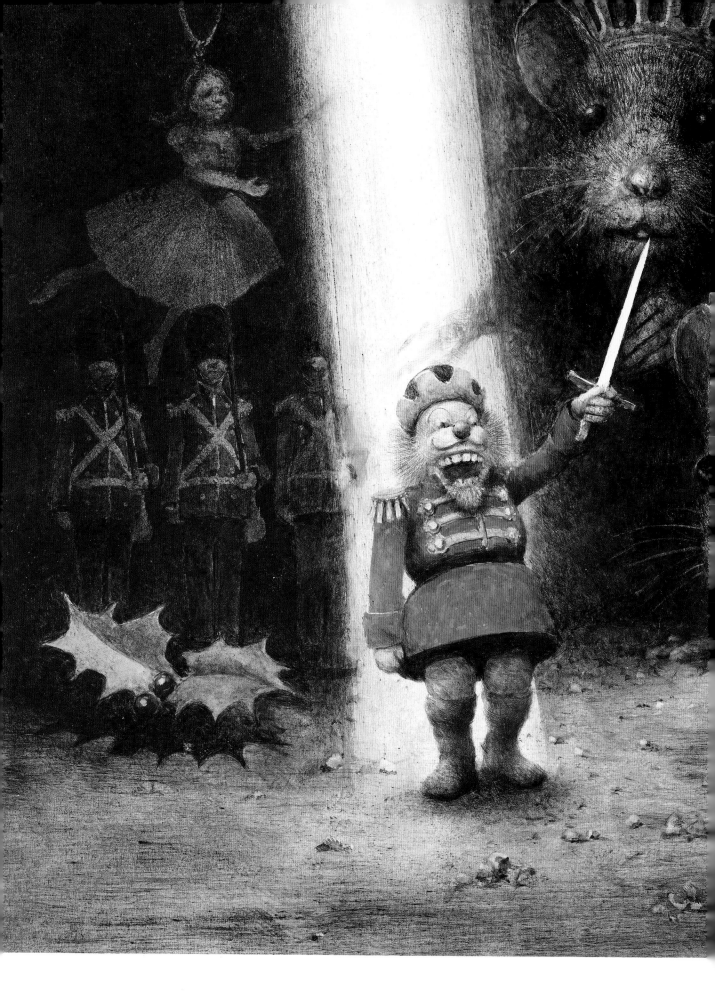

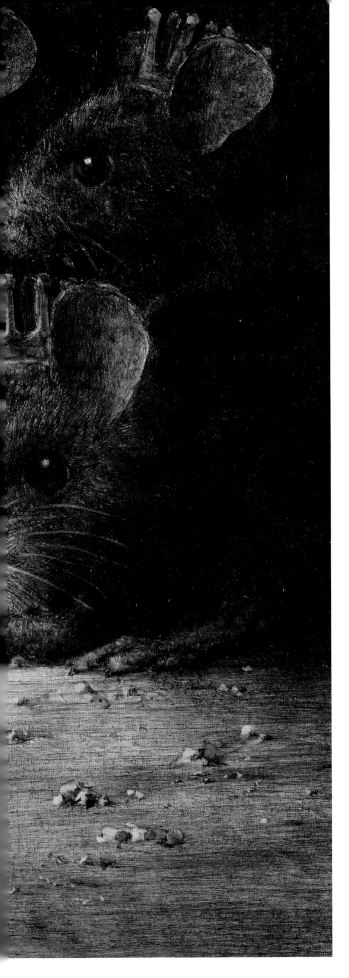

THE NUTCRACKER

By E.T.A. Hoffmann
First published 1816

This story was written in Germany two hundred years ago, and is now best known as the inspiration for Tchaikovsky's famous ballet which is regularly performed at Christmas time around the world. Hoffmann's story is rarely translated in its original form as we have done in this, the fourteenth and final title in my Children's Classics series. It tells the tale of Marie, a gentle young girl and her love for an enchanted Nutcracker – who leads her toys in a dramatic battle against a seven-headed Mouse King.

In my planning for the illustrations of this book (published 2016) I needed two attempts. My first 'flat plan' missed, in my view, the essence of the complex and slightly gothic fantasy told by Hoffmann. After some months I tried a different approach with a fresh plan. Had I been able to consult with Hoffmann to assist me with the events that needed illustrating, my job might have been much easier, but I don't speak German, added to which he has been dead for two hundred years!

The Mouse King (left)

'"And give me your marzipan, little girl, too – or Nutcracker's dead, for I'll bite him in two!" So squealed the Mouse King, chattering his teeth in a very nasty way'

The Vassal Drummer (below)

'"Strike up our military march, my faithful vassal Drummer!" cried Nutcracker in a very loud voice, and the drummer immediately beat a drum roll in the most expert way, making the panes in the glass-fronted cupboard clink and ring.'

Drosselmeier and the Astronomer (opposite, top)

'Drosselmeier had consulted with the astronomer for three days and three nights without stopping, and the King was just sitting down to luncheon on Saturday when Drosselmeier, who was to be beheaded early on Sunday morning, hurried in full of joy and jubilation, to announce that he had found the means of restoring Princess Pirlipat's lost beauty.'

The Battle (opposite, bottom)

'With banners flying and bands playing, regiment after regiment marched past Nutcracker and massed in the middle of the room. Fritz's artillery came clanking past. A few moments later the guns were going boom boom. Marie saw sugar balls landing in the serried ranks of mice, who were splattered with white powder. But the worst damage was done by a battery of heavy guns set upon Mama's footstool, which fired jawbreakers at the mice, many of whom were laid low.'

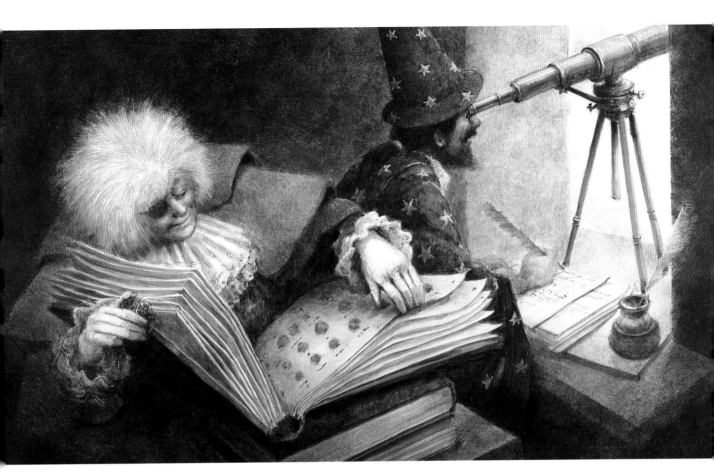

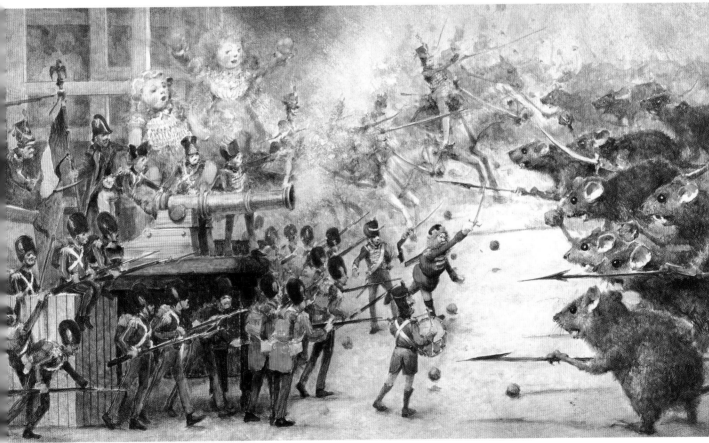

SILENT NIGHT, HOLY NIGHT

By Joseph Mohr and Franz Xaver Gruber
First performed on Christmas Eve 1818

Millions of people know the melody, some know the verses, but few are aware of the origins of the famous carol. Few know anything of its mysterious birth, the seed of its magic, its role in history, and the source of its power.

To tell this fuller story Austrian publisher Michael Neugebauer commissioned author and historian Werner Thuswaldner and myself as illustrator to visit the town of Oberndorf on the river Salzach in Austria.

'At Christmas time, early in the nineteenth century, two friends, one a curate, Joseph Mohr, the other a teacher and organist, Franz Zaver Gruber, were living in Oberndorf. War had been raging in the area, the bridge collapsed, cannonballs wrecked houses, stifling smoke filled the streets… The winter seemed as if cold would never end and any spark of hope almost died among the people…'

The two friends decided to give the sorely tried villagers of Oberndorf a Christmas present: a song, to rouse them from the misery of despair. In the village church the organ was broken, so the two decided to perform their song at the end of midnight Mass, with a guitar accompaniment. Immediately the congregation began to join in the refrain as if they had always known this newly created hymn: 'Silent night, holy night, all is calm, all is bright…'

A hundred years later:

'One Christmas season during the World War I, in the most dreadful days of all, between a thousand and a thousand deaths, men walked toward each other. Enemies, wondering, sharing "the air of an old Austrian song," and coming closer, saw, not enemies, but themselves, in that redeeming dawn.'

My long-term friend and mentor, Patricia Crampton, wrote the above caption to the picture reproduced here and in the book published in 2005.

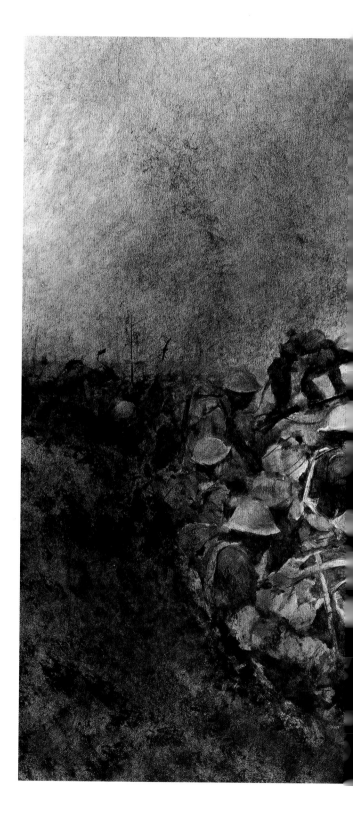

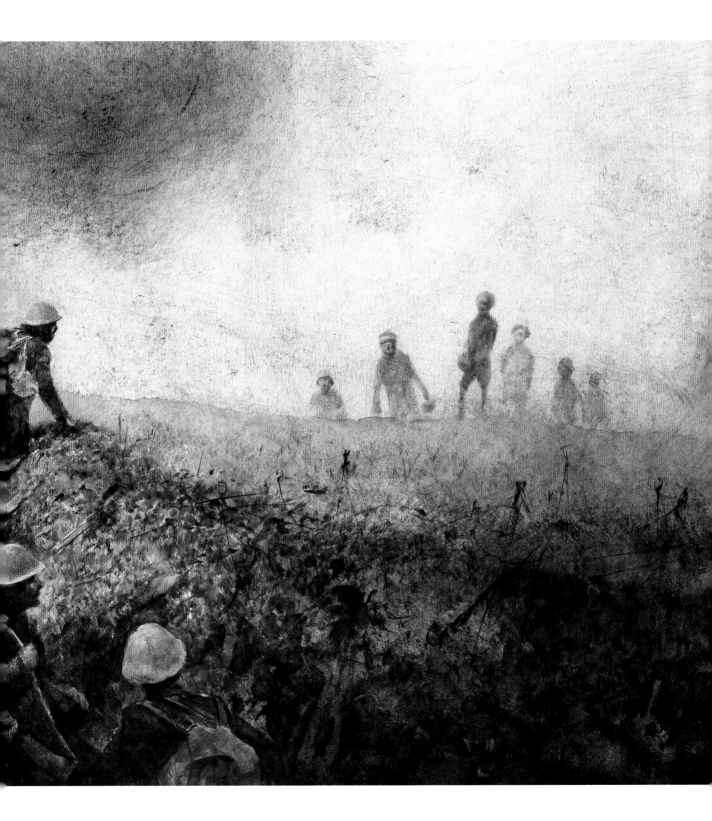

THE UGLY DUCKLING

By Hans Christian Andersen
First published in 1843

In 2005, past winners of the Hans Christian Andersen Medal were offered an opportunity to illustrate his works, to celebrate 200 years since his birth. I was given *The Ugly Duckling*. I had already worked on a book about Hans Christian Andersen's life, with a Danish publisher, so I was well aware of his curious habits. He made many paper cut-outs to amuse himself and friends. I chose to experiment with a technique that included cut-out paper shapes with my normal watercolour work. The effect can just be seen in the illustration above.

ROBINSON CRUSOE

By Daniel Defoe
First published in 1719

Possibly basing his story on fact, Daniel Defoe proposed that Robinson Crusoe lived mostly alone for twenty-eight years on an island in the Atlantic. As a sole survivor of a shipwreck, and with great ingenuity, he managed to survive and to protect himself against occasional cannibals and marooned seafarers. This is my version of Crusoe published in 2002.

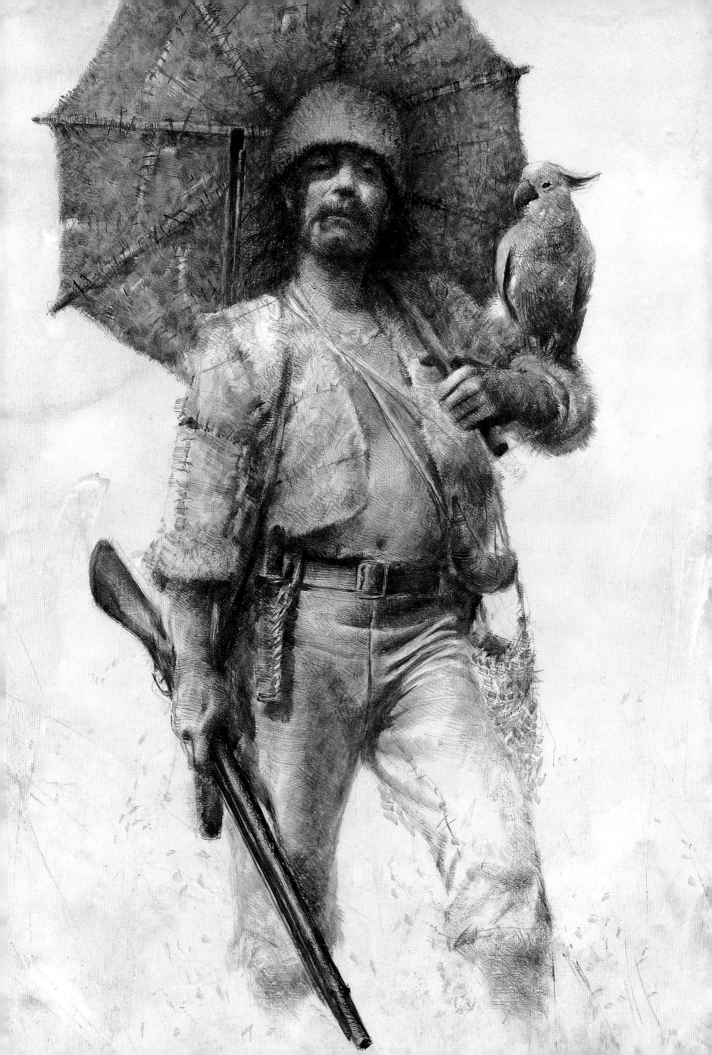

PETER PAN AND WENDY
By J.M. Barrie
First performed in 1904

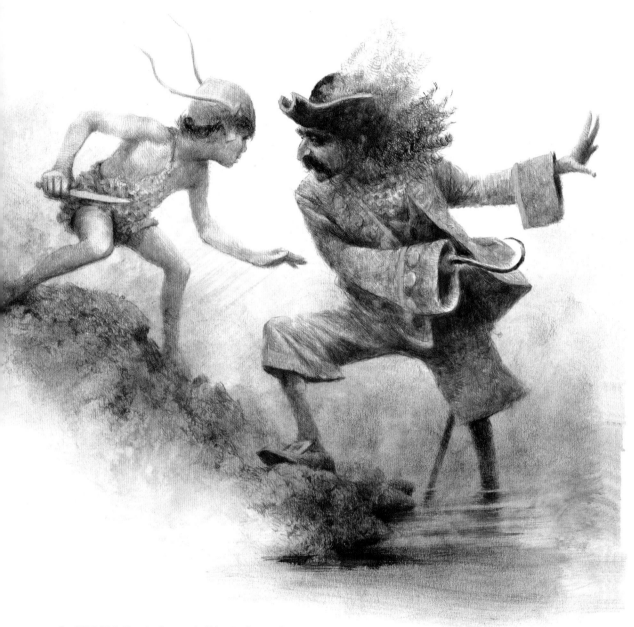

In 1929 J.M. Barrie donated all his rights to *Peter Pan* to
Great Ormond Street Hospital for Children, London. In
1988 a unique Act of Parliament extended the rights to
royalties to the hospital in perpetuity. To celebrate the
centenary of this book in 2004, I was invited to illustrate
a special edition which launched my illustrated editions
of Children's Classics.

I first attempted illustrating this classic tale when I was
seven years old (see reproduction on page 173) as a frieze
showing Peter at the end of Wendy's bed, the Tree House,
and Captain Hook's ship.

'Come Away, Come Away!' (*opposite*)
'A moment after the fairy's entrance the window was
blown open by the breathing of the little stars, and Peter
dropped in. He had carried Tinker Bell part of the way,
and his hand was still messy with fairy dust.'
J.M. Barrie, *Peter Pan and Wendy*

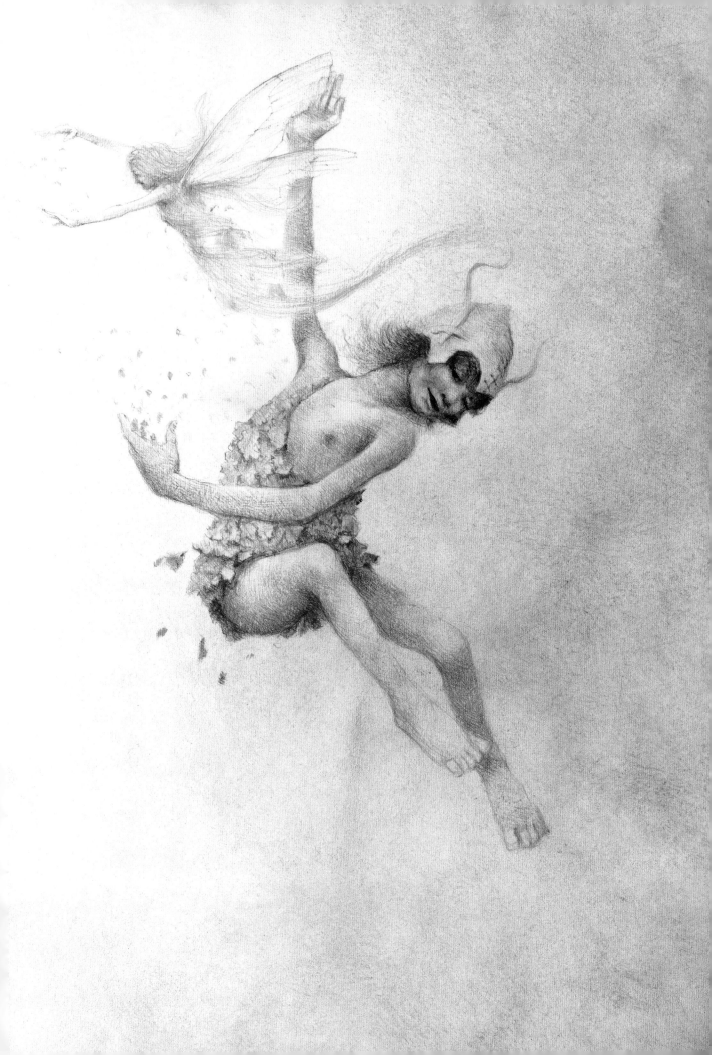

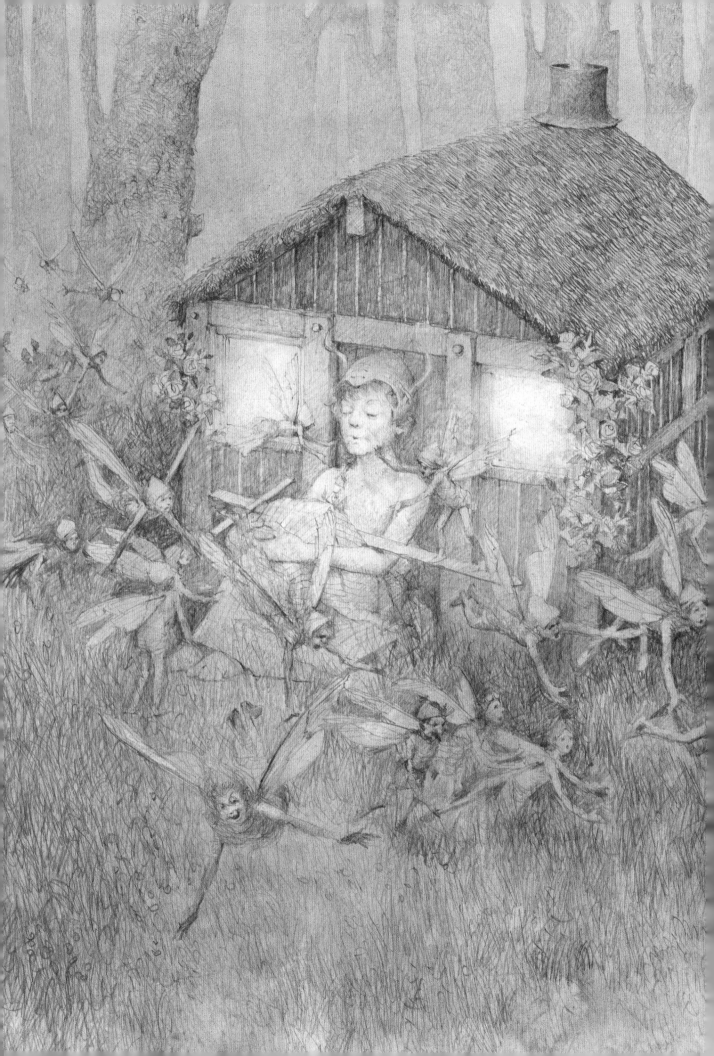

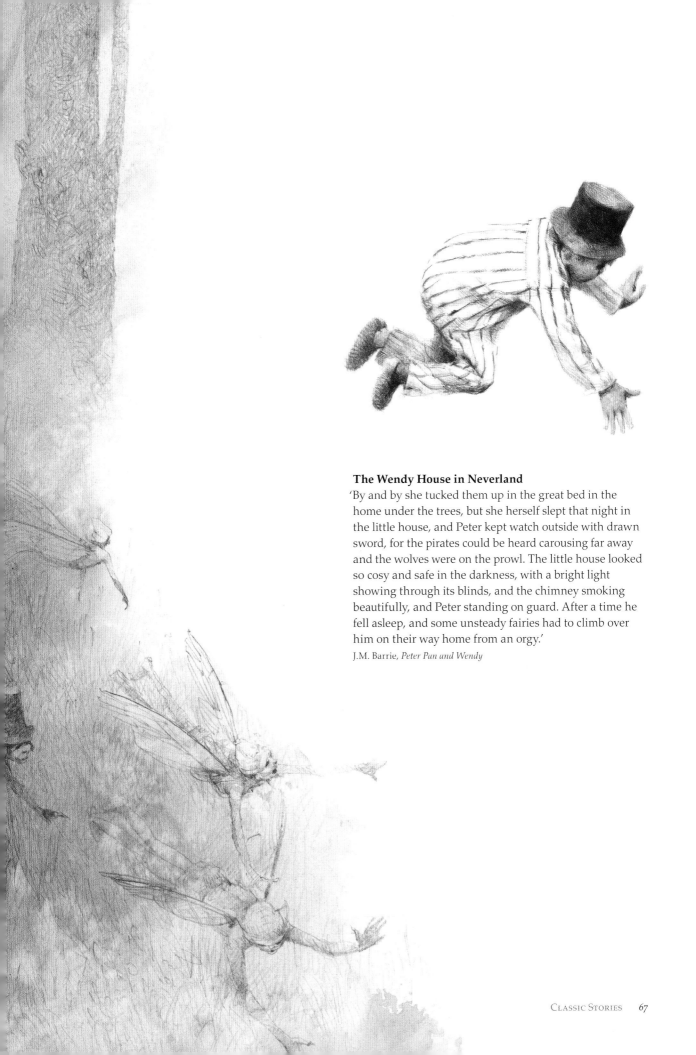

The Wendy House in Neverland

'By and by she tucked them up in the great bed in the
home under the trees, but she herself slept that night in
the little house, and Peter kept watch outside with drawn
sword, for the pirates could be heard carousing far away
and the wolves were on the prowl. The little house looked
so cosy and safe in the darkness, with a bright light
showing through its blinds, and the chimney smoking
beautifully, and Peter standing on guard. After a time he
fell asleep, and some unsteady fairies had to climb over
him on their way home from an orgy.'

J.M. Barrie, *Peter Pan and Wendy*

Captain Hook's Pirates

'A more villainous-looking lot never hung in a row on
Execution dock. Here, a little in advance, ever and again
with his head to the ground listening, his great arms bare,
pieces of eight in his ears as ornaments, is the handsome
Italian Cecco, who cut his name in letters of blood on the
back of the governor of the prison at Gao. That gigantic
black behind him has had many names since he dropped
the one with which dusky mothers still terrify their
children on the banks of the Guadjomo. Here is Bill Jukes,
every inch of him tattooed, the same Bill Jukes who got six
dozen on the Walrus from Flint before he would drop the
bag of moidores; and Cookson, said to be Black Murphy's
brother (but this was never proved); and Gentleman
Starkey, once an usher in a public school and still dainty
in his ways of killing; and Skylights (Morgan's Skylights);
and the Irish bo'sun Smee, an oddly genial man who
stabbed, so to speak, without offence, and was the only
Nonconformist in Hook's crew; and Noodler, whose
hands were fixed on backwards...'

J.M. Barrie, *Peter Pan and Wendy*

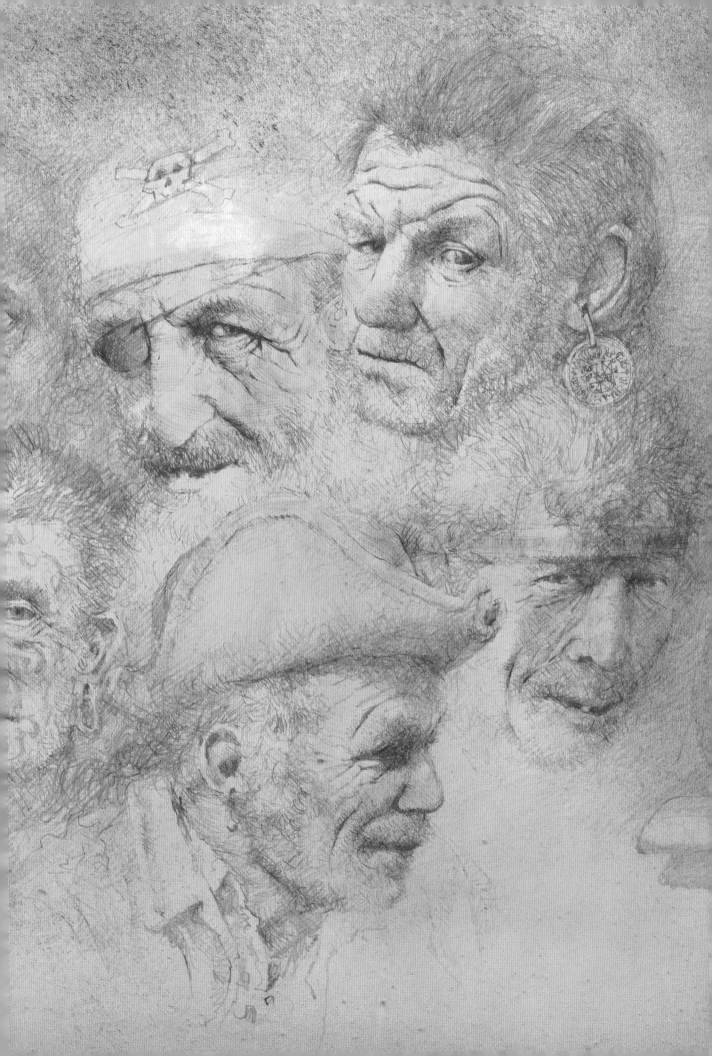

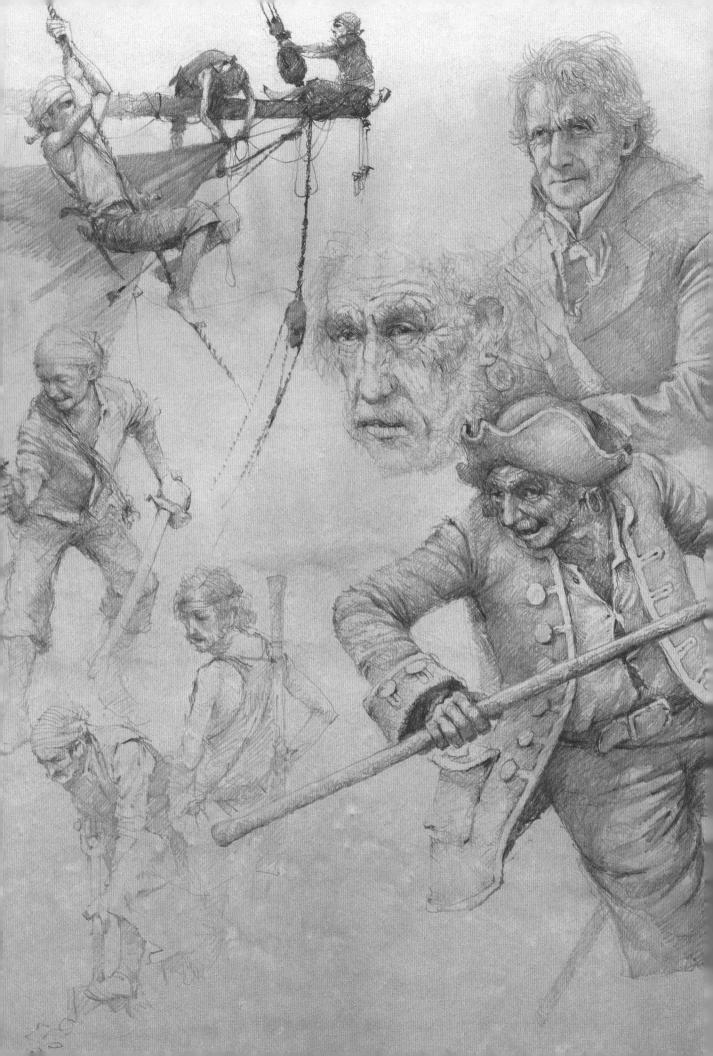

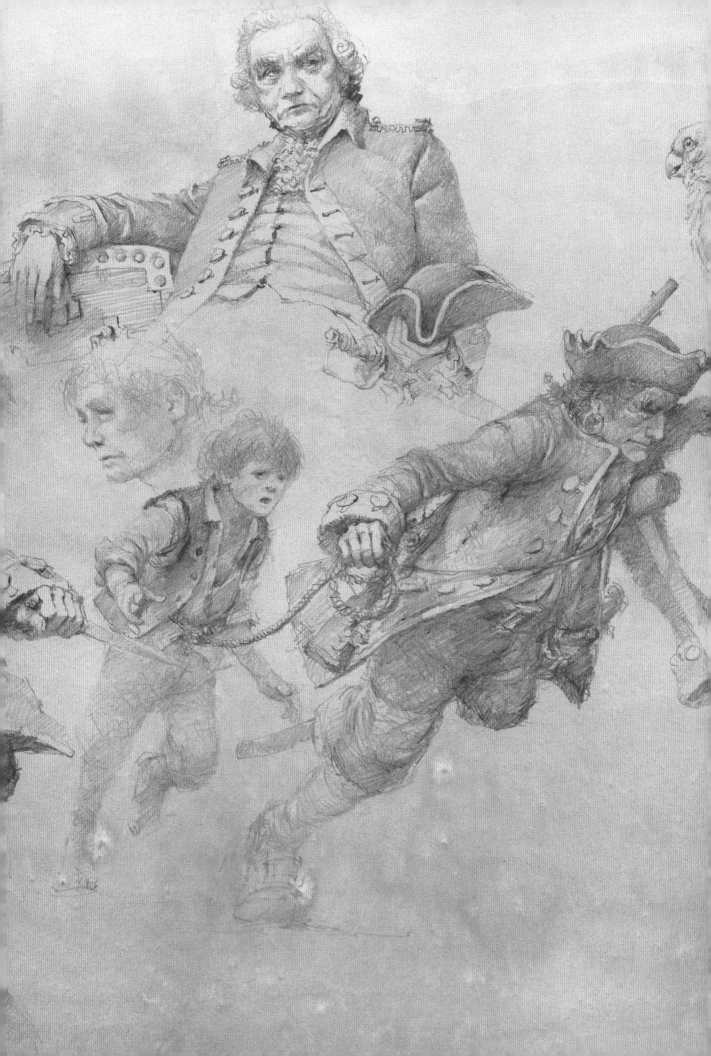

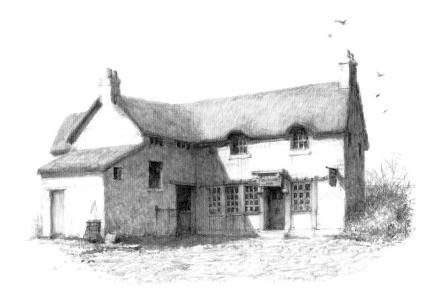

TREASURE ISLAND

By Robert Louis Stevenson
First published in 1883

Previous pages:
The Classics Series Endpapers
Each of the fourteen books in the
Children's Classics series is defined
with distinctive 'endpapers'. They are
pencil and wash sketches of characters
and details that I included in the full-
coloured final illustrations on the text
pages of the book.

Shown here are the endpapers
for *Treasure Island*. Technically, an
endpaper is defined as: 'Either of two
paper leaves at the front and back of a
book pasted to the inside of the board
covers and the first leaf of the book.'

There are some stories and characters that transcend the
original inspiration of their authors and take on a life of
their own. They become classics against which all future
books are measured. *Treasure Island* is, without doubt, one
of these stories. Long John Silver, the sea-cook, is one of
these characters, along with Jim Hawkins, Blind Pew and
Ben Gunn.

The early chapters of *Treasure Island* remain among the
most compelling reading in all adventure literature. It is
said by experts in literature for children that if a child can
read and feel the drama of the happenings at the Admiral
Benbow Inn as imagined by Stevenson, and narrated by
Jim Hawkins, then they will be readers forever.

The Last of the Blind Man
In chapter five Blind Pew is deserted by his pirate
companions at night on the road outside the Admiral
Benbow Inn (*top*), and observed by Jim Hawkins:

'Him they had deserted, whether in sheer panic or out of
revenge for his ill words and blows I know not; but there
he remained behind, tapping up and down the road in a
frenzy, and groping and calling for his comrades. Finally
he took the wrong turn and ran a few steps past me,
towards the hamlet, crying, "Johnny, Black Dog, Dirk,"
and other names, "you won't leave old Pew, mates – not
old Pew!"
 Just then the noise of horses topped the rise, and four or
five riders came in sight in the moonlight and swept at full
gallop down the slope.
 At this Pew saw his error…'
Robert Louis Stevenson, *Treasure Island*

In my belief the greatest illustrated edition of *Treasure
Island* is the 1911 one which includes N.C. Wyeth's
depiction of the death of Blind Pew. From my earliest years
this picture has haunted me, and when my turn came in
2005 to illustrate this event the result clearly draws upon
Wyeth as inspiration.

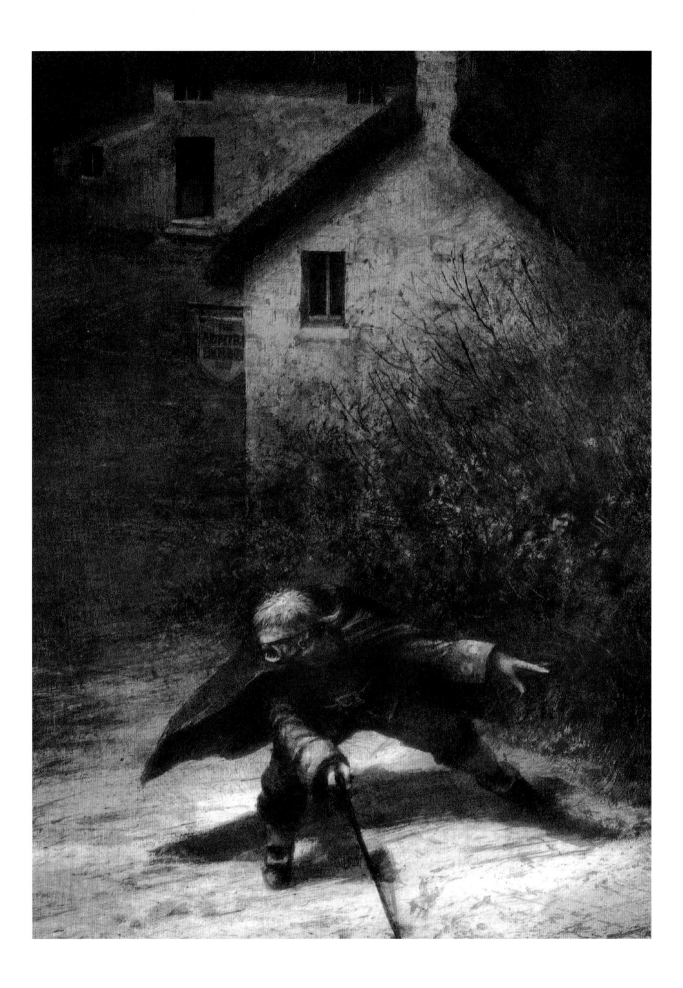

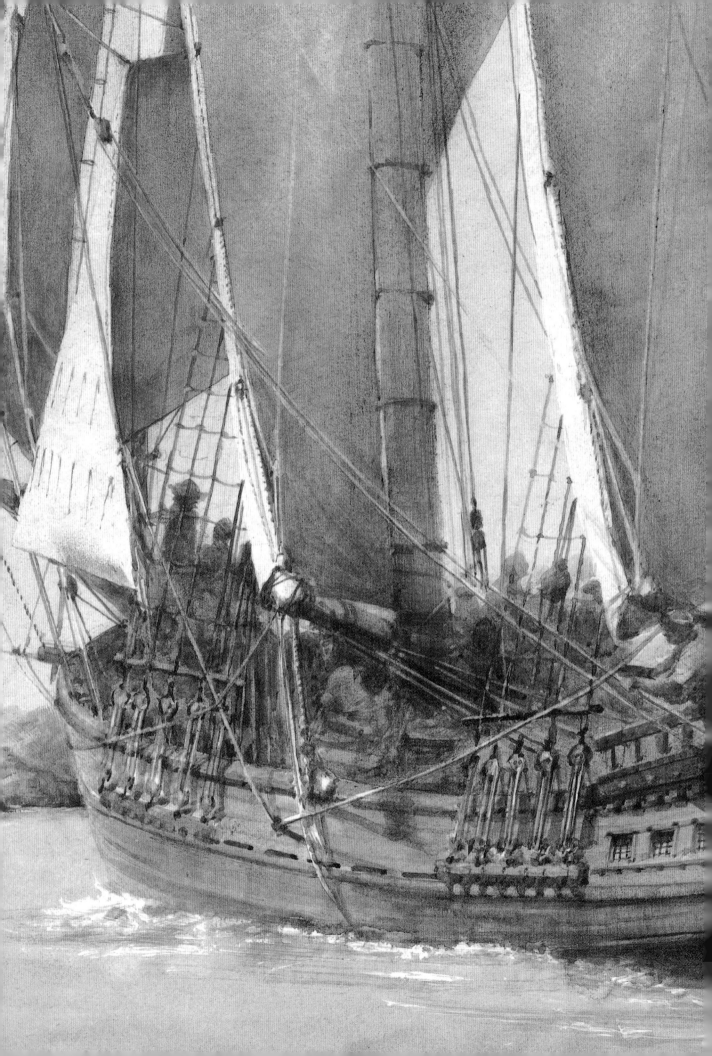

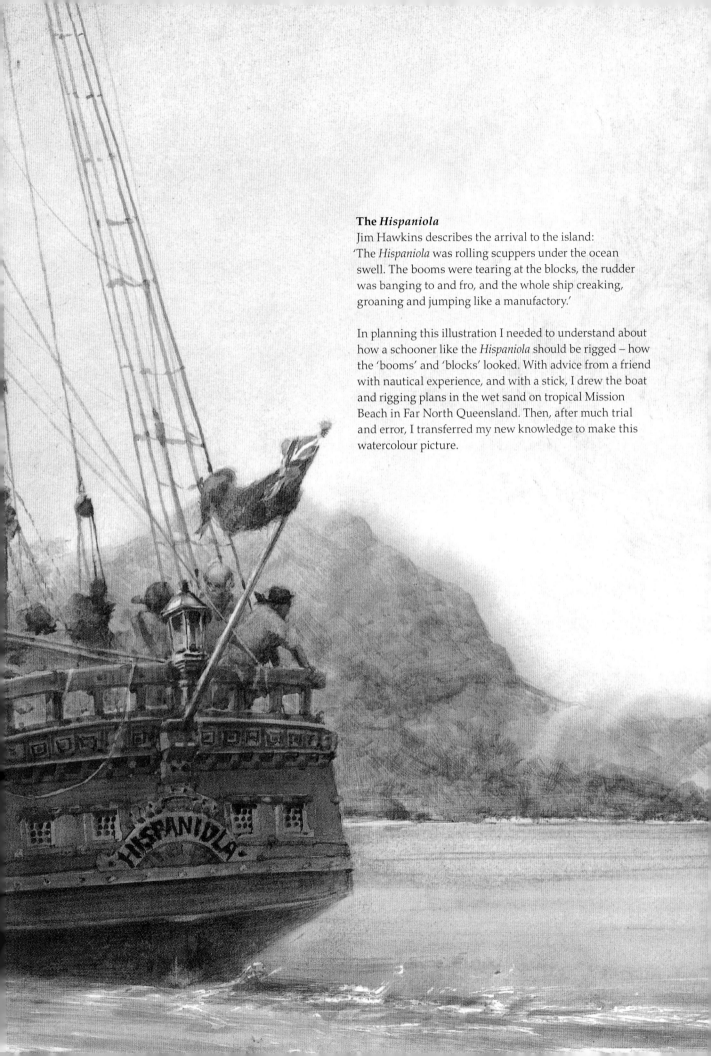

The *Hispaniola*

Jim Hawkins describes the arrival to the island:
'The *Hispaniola* was rolling scuppers under the ocean swell. The booms were tearing at the blocks, the rudder was banging to and fro, and the whole ship creaking, groaning and jumping like a manufactory.'

In planning this illustration I needed to understand about how a schooner like the *Hispaniola* should be rigged – how the 'booms' and 'blocks' looked. With advice from a friend with nautical experience, and with a stick, I drew the boat and rigging plans in the wet sand on tropical Mission Beach in Far North Queensland. Then, after much trial and error, I transferred my new knowledge to make this watercolour picture.

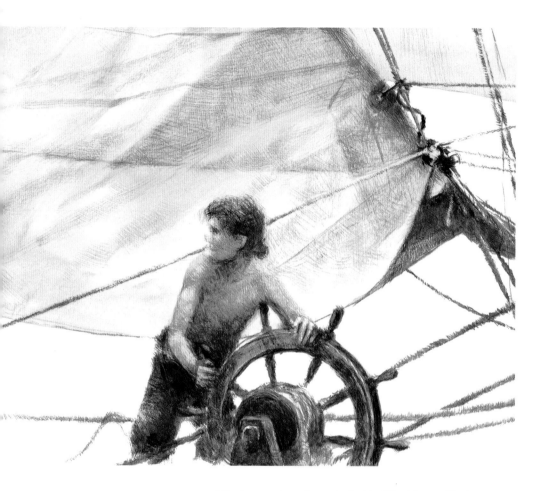

'The breeze served us admirably. We skimmed before it like a bird, the coast of the island flashing by and the view changing every minute... I was greatly elated with my new command...'

Robert Louis Stevenson, *Treasure Island*

Opposite:
'That was Flint's treasure that we had come so far to seek, and that had cost already the lives of seventeen men from the *Hispaniola*. How many it had cost in the amassing, what blood and sorrow, what good ships scuttled on the deep, what brave men walking the plank blindfold, what shot of cannon, what shame and lies and cruelty, perhaps no man alive could tell...'

Robert Louis Stevenson, *Treasure Island*

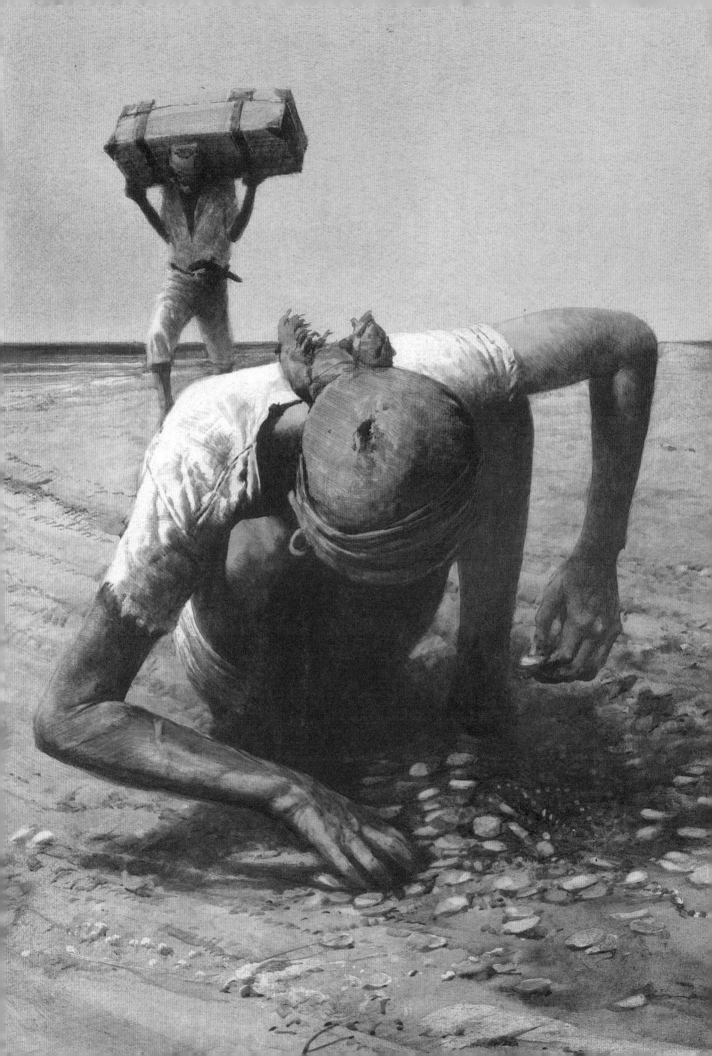

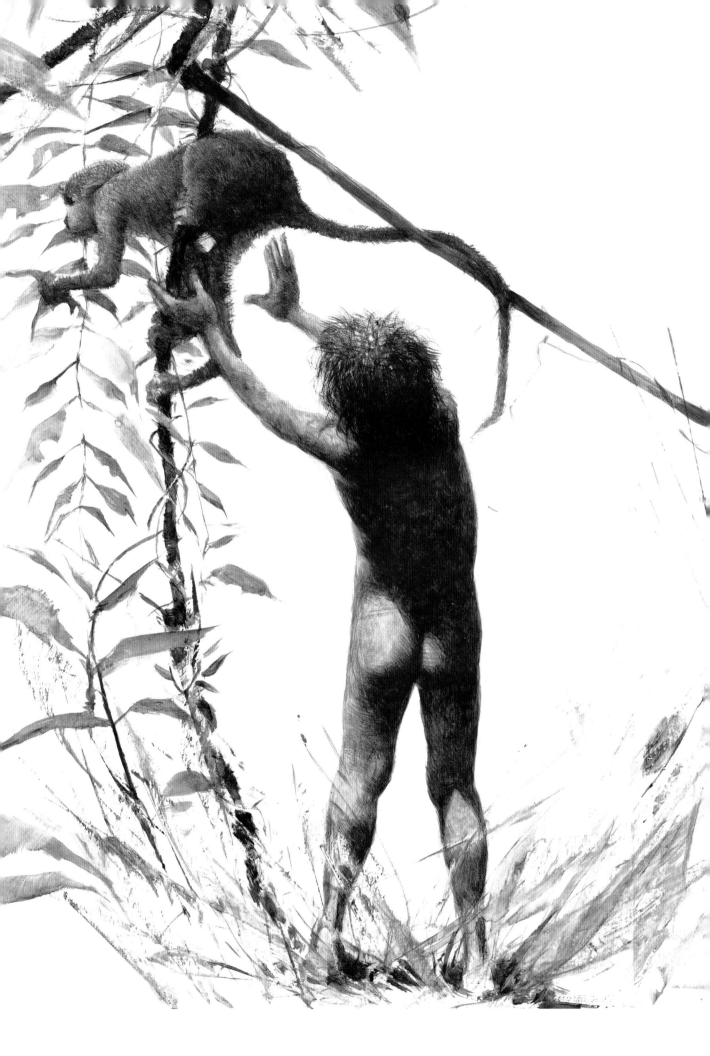

THE JUNGLE BOOK

by Rudyard Kipling
First published in 1894

To illustrate this famous collection of stories, first published over one hundred years ago, had its special problems. For example, I could not meet and talk with the man who called himself 'the Editor' – Rudyard Kipling. Nor could I meet Mowgli the boy raised by wolves in India's jungle, or Babadur Shah, baggage elephant 174 on the Indian Register, to help me make pictures. Without access to this help, the best I could do was to tread as lightly as I could with my pictures of the wild jungle creatures and their adventures, and to leave sufficient space for the reader to wonder at the words and thoughts that Kipling created for us during his time in India.

'"… Listen, Man-cub," said the Bear, and his voice rumbled like thunder on a hot night. "I have taught thee all the Law of the Jungle for all the peoples of the Jungle — except the Monkey-Folk who live in the trees. They have no Law. They are outcasts…"'

The Jungle Book, Rudyard Kipling

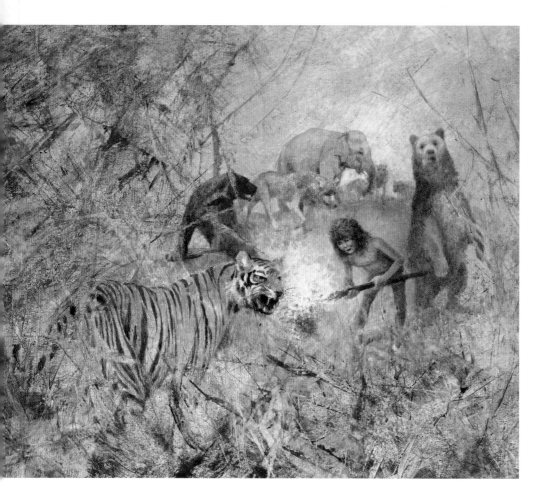

Mowgli is a boy, and as he grows up he learns that he must eventually take his place not with jungle animals but with his own kind. First, he must face his enemy the tiger, Shere Khan, in a battle of wits and strength to discover who is King of the Jungle.

Opposite:
Mowgli and Baloo
'All that is told here happened some time before Mowgli was turned out of the Seeonee Wolf-Pack, or revenged himself on Shere Khan the tiger. It was in the days when Baloo was teaching him the Law of the Jungle. The big, serious, old brown bear was delighted to have so quick a pupil, for the young wolves will only learn as much of the Law of the Jungle as applies to their own pack and tribe…'
Rudyard Kipling, *The Jungle Book*

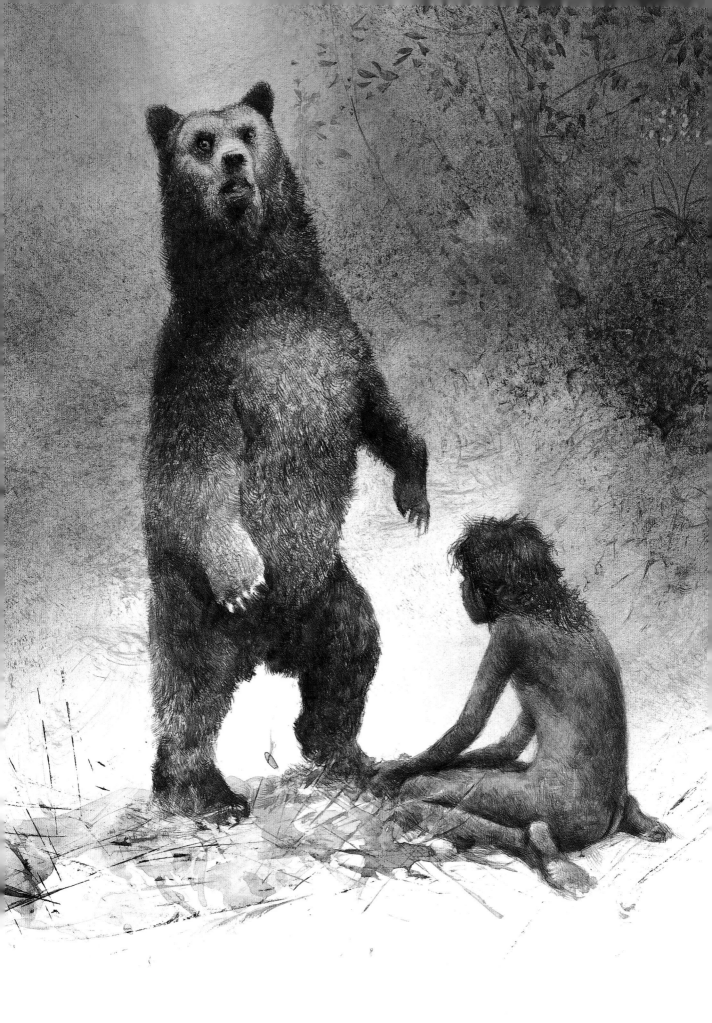

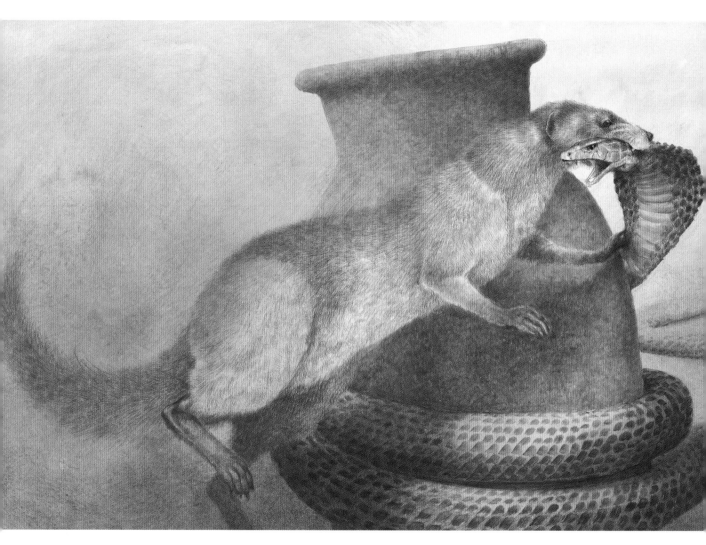

Rikki-tikki-tavi

'Then he jumped. The head was lying a little clear of the water-jar, under the curve of it, and, as his teeth met, Rikki braced his back against the bulge of the red earthenware to hold down the head. This gave him just one second's purchase, and he made the most of it. Then he was battered to and fro as a rat is shaken by a dog…'

The White Seal

'He landed close to old Sea Vitch – the big, ugly, bloated, pimpled, fat-necked, long-tusked walrus of the North Pacific, who has no manners except when he is asleep – as he was then, with his hind flippers half in and half out of the surf.

"Wake up!" barked Kotick [the White Seal]…"Isn't there any place for seals to go where men don't ever come?"'

Rudyard Kipling, *The Jungle Book*

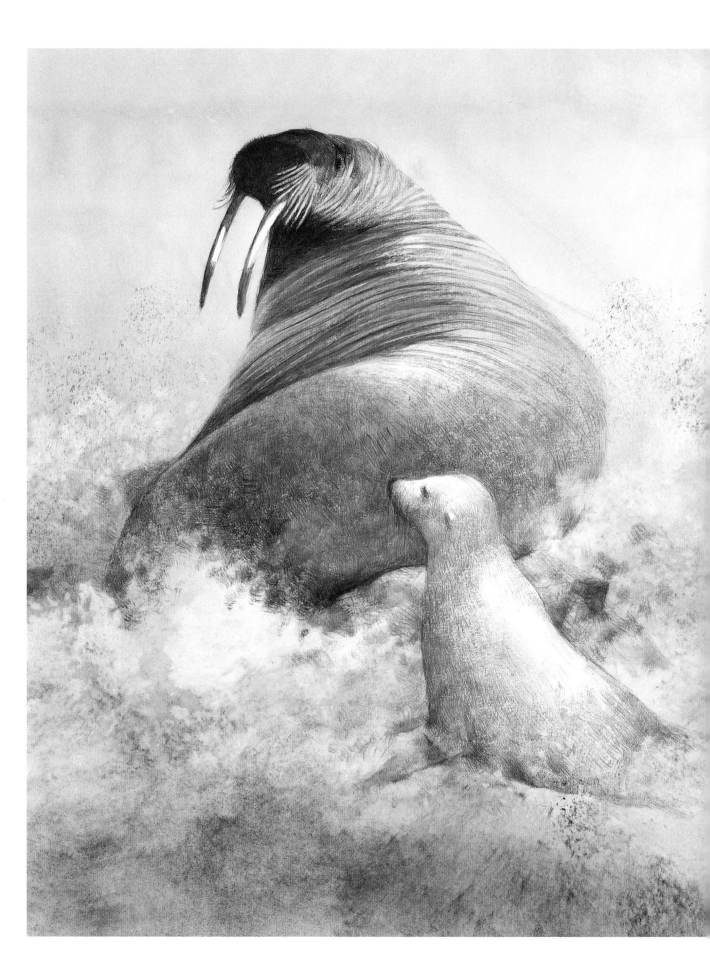

Kala Nag and Toomai

'Then Kala Nag reached the crest of the ascent and stopped
for a minute, and little Toomai could see the tops of the
trees lying all speckled and furry under the moonlight for
miles and miles, and the blue-white mist over the river in
the hollow. Toomai leaned forward and looked, and felt
that the forest was awake below him – awake and alive
and crowded. A big brown fruit-eating bat brushed past
his ear; a porcupine's quills rattled in the thicket; and in
the darkness between the tree-stems he heard a hog-bear
digging hard in the moist, warm earth, and snuffing as
it digged.'

Rudyard Kipling, *The Jungle Book*

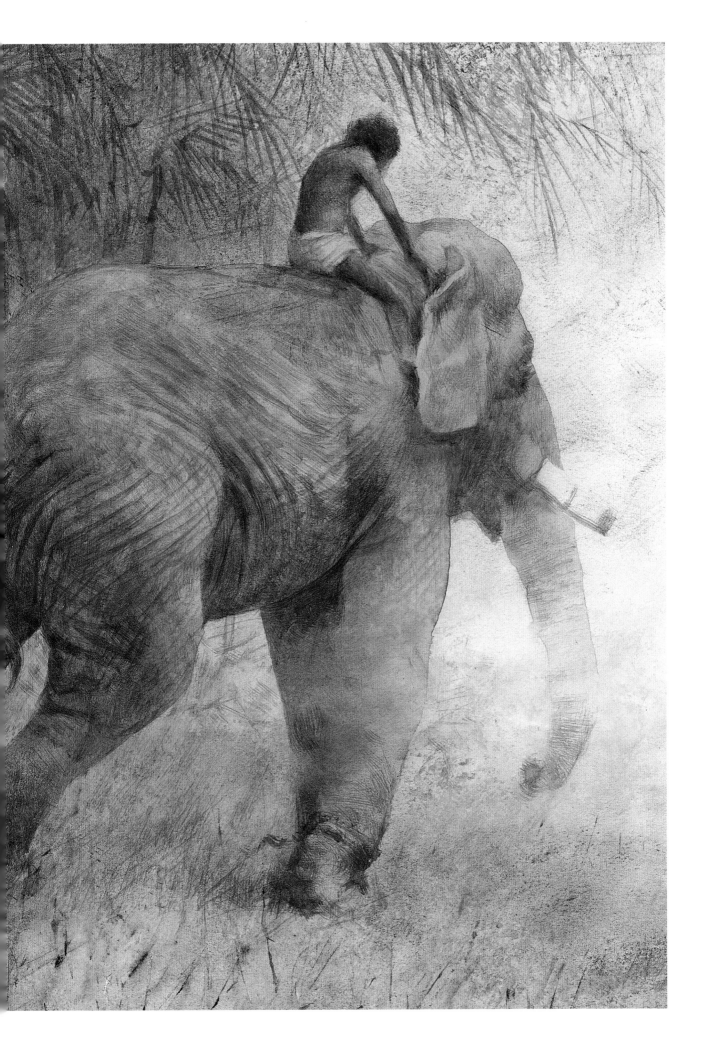

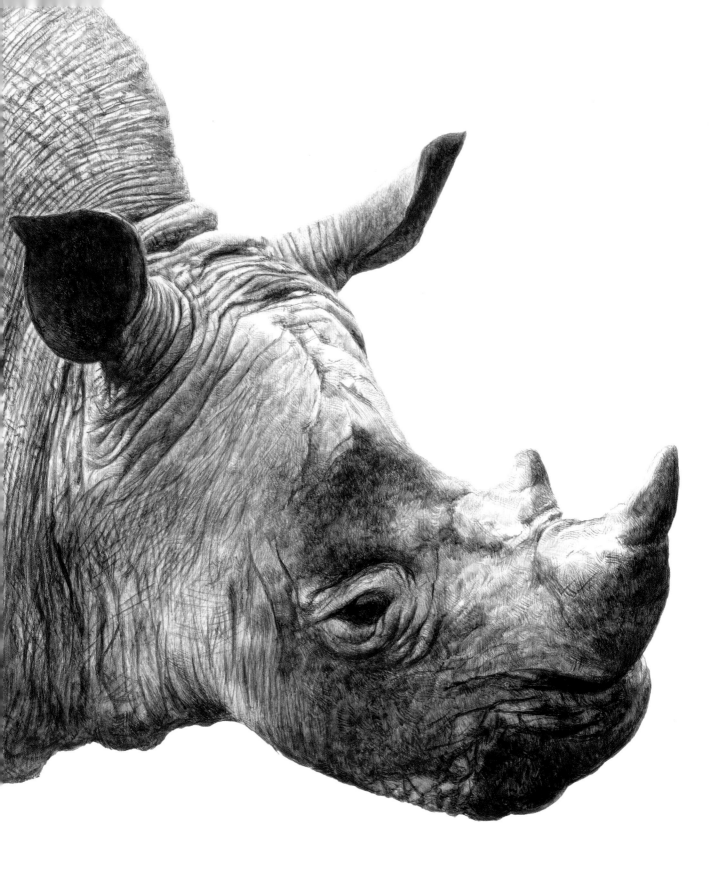

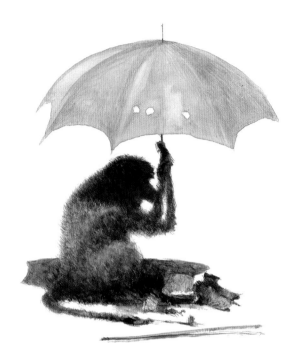

JUST SO STORIES

By Rudyard Kipling
First published in 1902

How did the whale get its throat? Why was the lazy camel lumbered with a hump? How did the elephant's insatiable curiosity earn it a trunk? And what about the rhinoceros's skin? Rudyard Kipling invented these wonderful stories about the beginning of the world and the first animals for his daughter Josephine, who tragically died when she was six. Devastated by her loss, he collated these stories and added his own illustrations into a treasury which was published in 1902.

My Children's Classics series edition in 2013 reproduced in its unabridged form each of these stories, and includes 'The Tabu Tale' which appeared later and is not often included. The new colour illustrations replace the rather surreal black and white ones made by Kipling, and try to include the substance of the very long captions he wrote to explain what he was trying to draw.

To find some way to illustrate the quirky *Just So Stories*, I needed to tread a path halfway between fact and fiction, and remember the lines of G.K. Chesterton written about the time of Kipling:

'It is one thing to describe an interview with a gorgon or a griffin, a creature who does not exist. It is another thing to discover that the rhinoceros does exist and then take pleasure in the fact that he looks as if he didn't.'

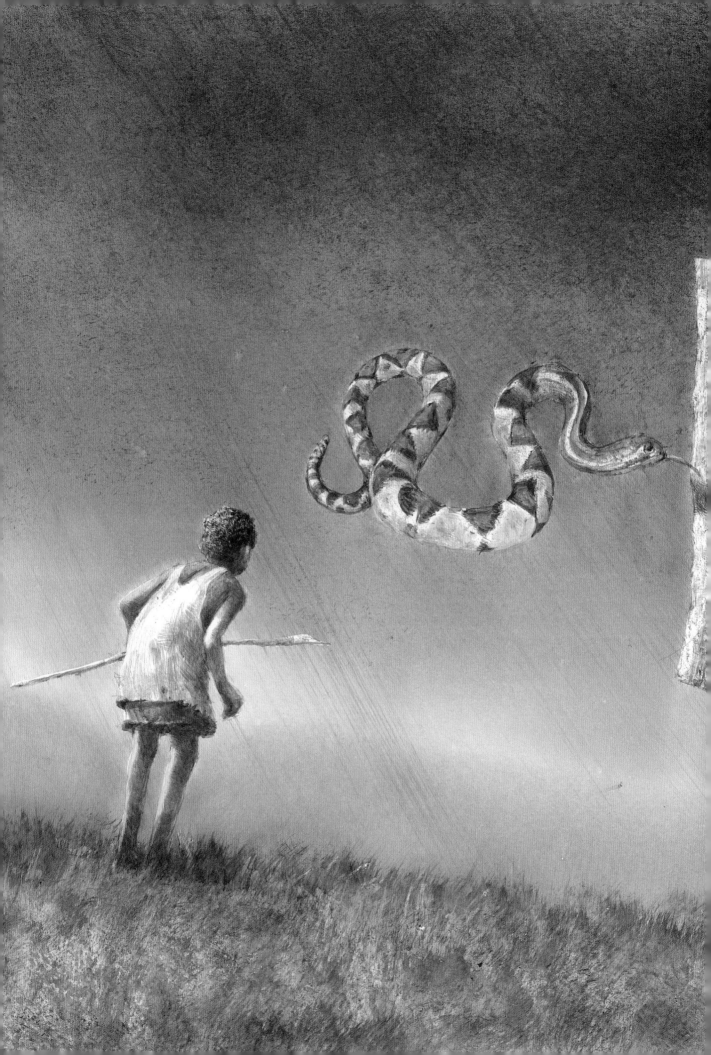

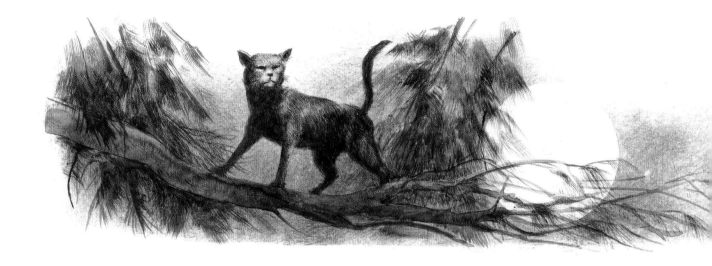

Above:

The Cat That Walked by Himself

'This is the picture of the Cat that Walked by Himself,
walking by his wild lone through the Wet Wild Woods
and waving his wild tail.'

Right:

The Crab Who Played with the Sea

'This is the picture of Pau Amma the Crab rising out of
the sea as tall as the smoke of three volca-noes. I haven't
drawn the three volcanoes, because Pau Amma was so
big. Pau Amma is trying to make Magic, but he is only a
silly old King Crab, and so he can't do anything. You can
see he is all legs and claws and empty hollow shell. The
canoe is the canoe that the Man and the Girl Daughter
and the Eldest Magician sailed from the Perak River in…
The Man is waving his curvy kris-knife at Pau Amma.
The Little Girl Daughter is sitting quietly in the middle
of the canoe. She knows she is quite safe with her Daddy.
The Eldest Magician is standing up at the other end of the
canoe beginning to make a Magic…'

Previous pages:

How the Alphabet Was Made

'"Snake – pole – broken-egg – carp-tail and carp-mouth,"
said Taffy. "*Shu-ya*. Sky-water (rain)" Just then a drop of
rain fell on her hand, for the day had clouded over. "Why,
Daddy, it's raining. Was that what you meant to tell me?"

 "Of course," said her Daddy, "And I told you without
saying a word, didn't I?"

 "Well, I think I would have known in a minute, but that
raindrop made me quite sure. I'll always remember it now.
Shu-ya means rain…"'

Rudyard Kipling, *Just So Stories*

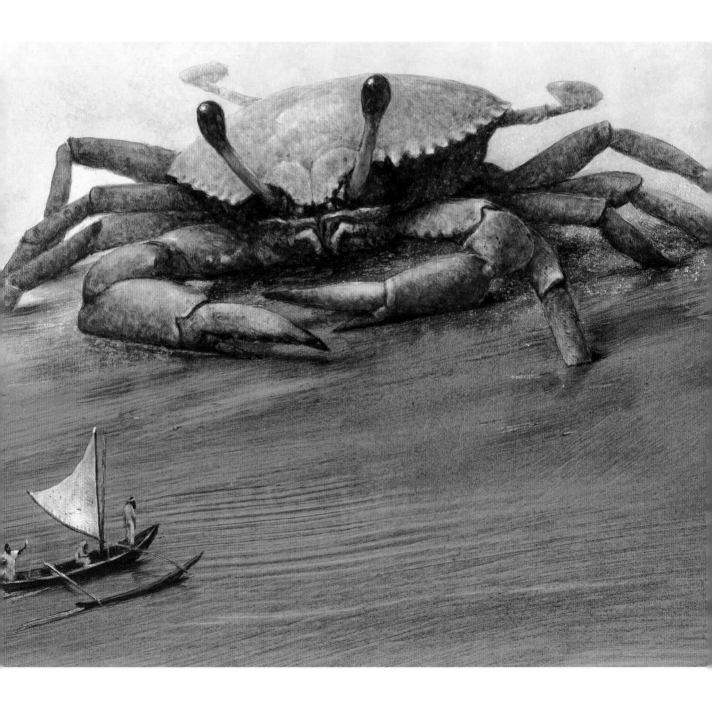

THE SECRET GARDEN
by Frances Hodgson Burnett
First published in 1911

This enchanting book is one of the best-loved children's books of the twentieth century and my illustrated edition was published in 2011 to mark the centenary of the first publication. The story is about poor Mary Lennox who is orphaned, sickly and spoiled when she arrives to live in her uncle's stately manor in the English countryside. After an uncomfortable start she gradually makes friends with chambermaid, Martha; the local animal-charmer Dickon; the gruff gardener Ben Weatherstaff; and the strange boy Colin.

When she finds a key to a secret garden that has been hidden for ten years, a new world of enchantment opens up to her.

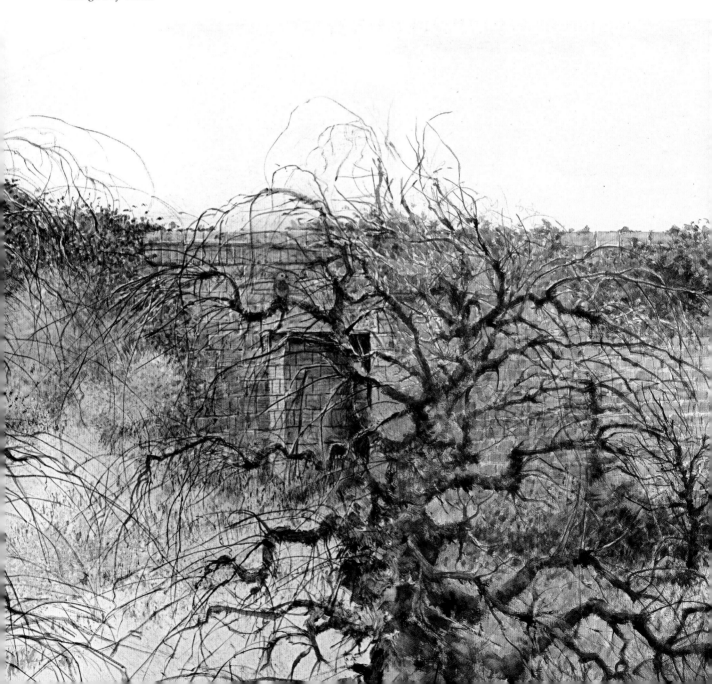

'The Secret Garden was what Mary called it when she was thinking of it. She liked the name, and she liked still more the feeling that when its beautiful old walls shut her in, no one knew where she was. It seemed almost like being shut out of the world in some fairy place.'
Frances Hodgson Burnett, *The Secret Garden*

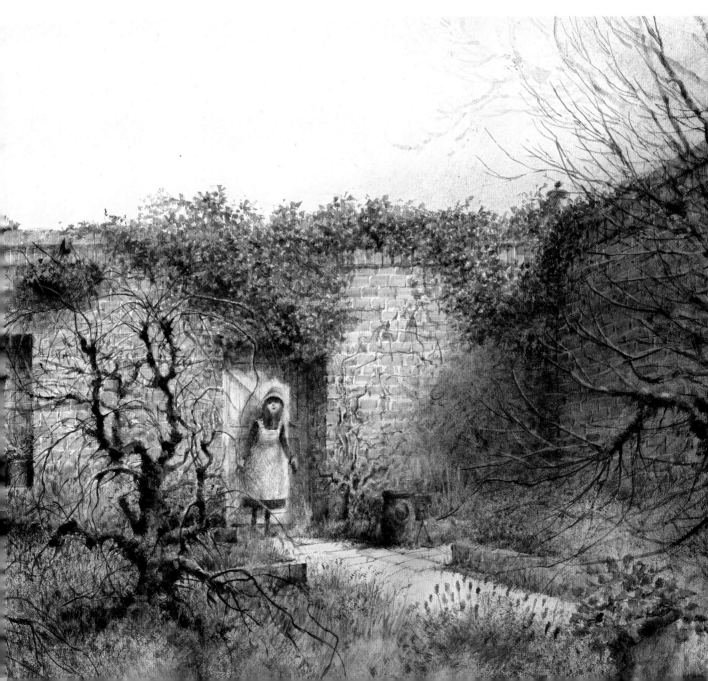

'It really did look like a procession. Colin was at its head with Dickon on one side and Mary on the other. Ben Weatherstaff walked behind, and the "creatures" trailed after them, the lamb and the fox cub keeping close to Dickon, the white rabbit hopping along or stopping to nibble and Soot following with the solemnity of a person who felt himself in charge.'

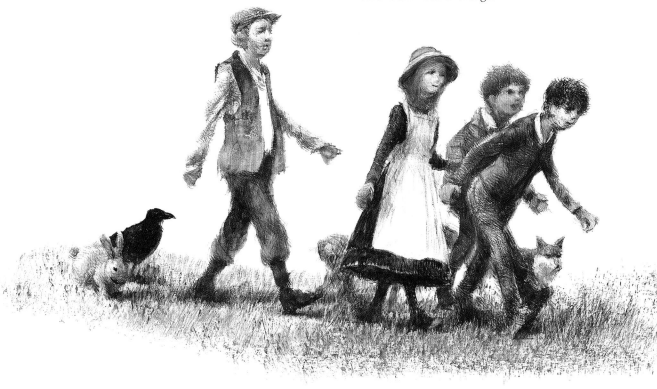

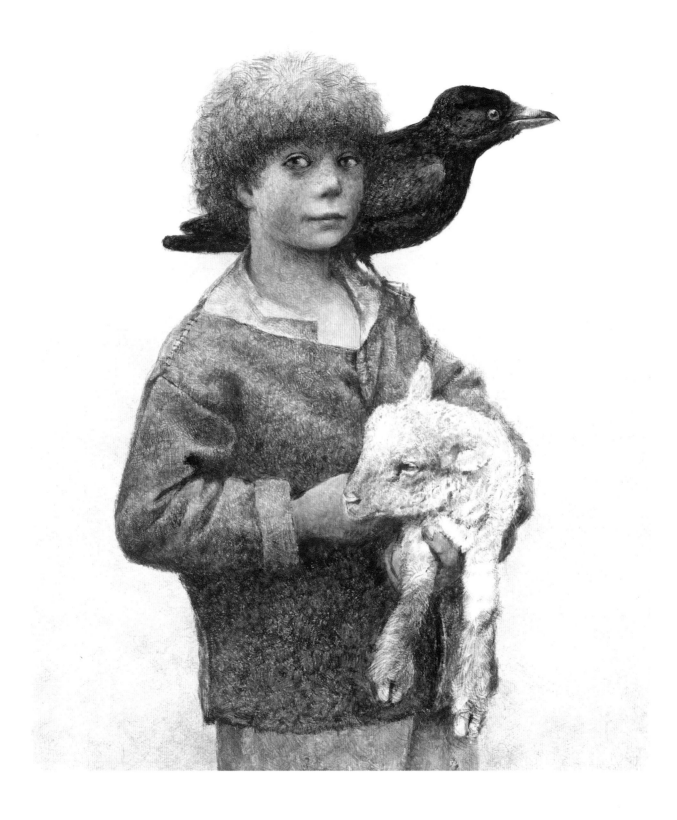

'He was a funny looking boy about twelve. He looked very clean and his nose turned up and his cheeks were as red as poppies and never had Mistress Mary seen such round and such blue eyes in any boy's face'

'"A boy, and a fox, and a crow, and two squirrels, and a new-born lamb are coming to see me this morning. I want them brought upstairs as soon as they come," he said…
"His name is Dickon and he is an animal charmer."'

Frances Hodgson Burnett, *The Secret Garden*

In designing the pages for *The Secret Garden* I made drawings of common English garden plants to decorate each of the twenty-seven chapter openings. For reference I used botanical drawings published in *The Frampton Flora*. This is a collection made in the 1840s by eight ladies of the Clifford family of Gloucestershire. Reading about this collection and how the artists teamed together suggested an affinity with the way Mary, Dickon and Colin went about rejuvenating their 'secret garden'.

The plant drawings reproduced here are
(*clockwise from top left*):
Common Poppy (*Papaver rhoeas*)
Rhubarb (*Rheum rhabarbarum*)
Rose 'Marchioness of Salibury' (*Rosa*)
Wild Turmeric (*Curcuma aromatica*)
Garden Pea (*Pisum sativum*)
Wild Strawberry (*Fragaria vesca*)

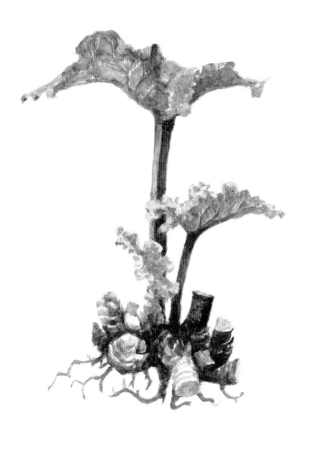

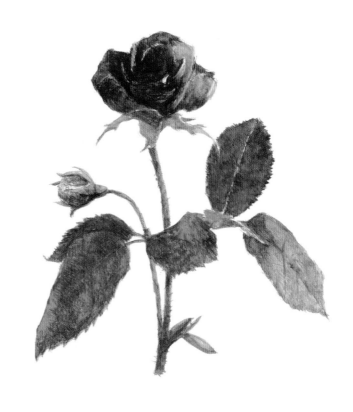

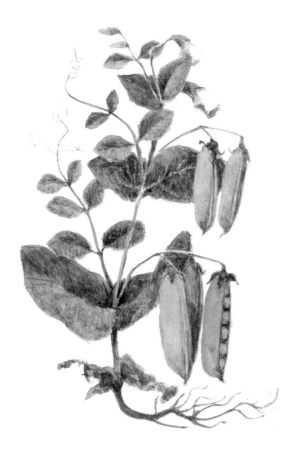

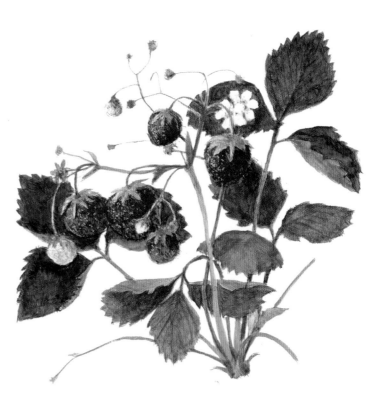

THE WIND IN THE WILLOWS

By Kenneth Grahame
First published in 1908

This overview illustration covers
the environs of all the events and
places in *The Wind in the Willows*. It
appears as the opening of chapter
one, 'The River Bank', in my version
of the great book published for
the centenary in 2008. It reads
like a map of this small corner of
the dreamy green countryside of
southern England. On one side of
the river are the homes of Mole and
Mr Toad of Toad Hall. Ratty's home
is on the near bank, and beyond the
water meadows lies the Wild Wood
where Badger has his house, and
where the Stoats, Weasels and other
wild things live. The river flows past
Pan Island and through the weir to
the Wide World that is all blue and
dim where the animals never go.

Kenneth Grahame appears here
surrounded by his story's main
characters – Badger, Mole, Ratty and
Mr Toad.

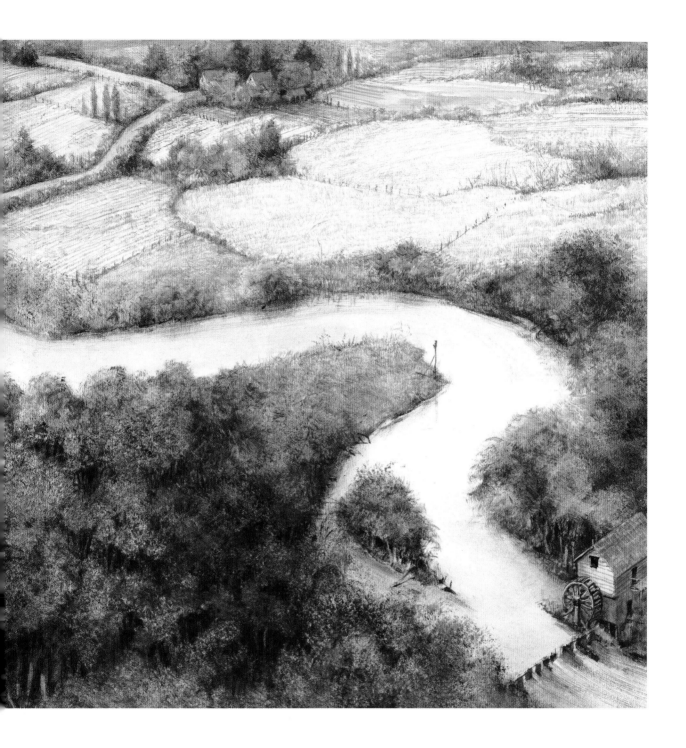

Badger's Kitchen (*overleaf*)

'It seemed a place where heroes could fitly feast after victory, where weary harvesters could line up in scores along the table and keep their Harvest Home with mirth and song, or where two or three friends of simple tastes could sit about as they pleased and eat and smoke and talk in comfort and contentment.

The ruddy brick floor smiled up at the smoky ceiling: the oaken settles, shiny with long wear, exchanged cheerful glances with each other; plates on the dresser grinned at pots on the shelf, and merry firelight flickered and played over everything without distinction.'

Kenneth Grahame, *The Wind in the Willows*

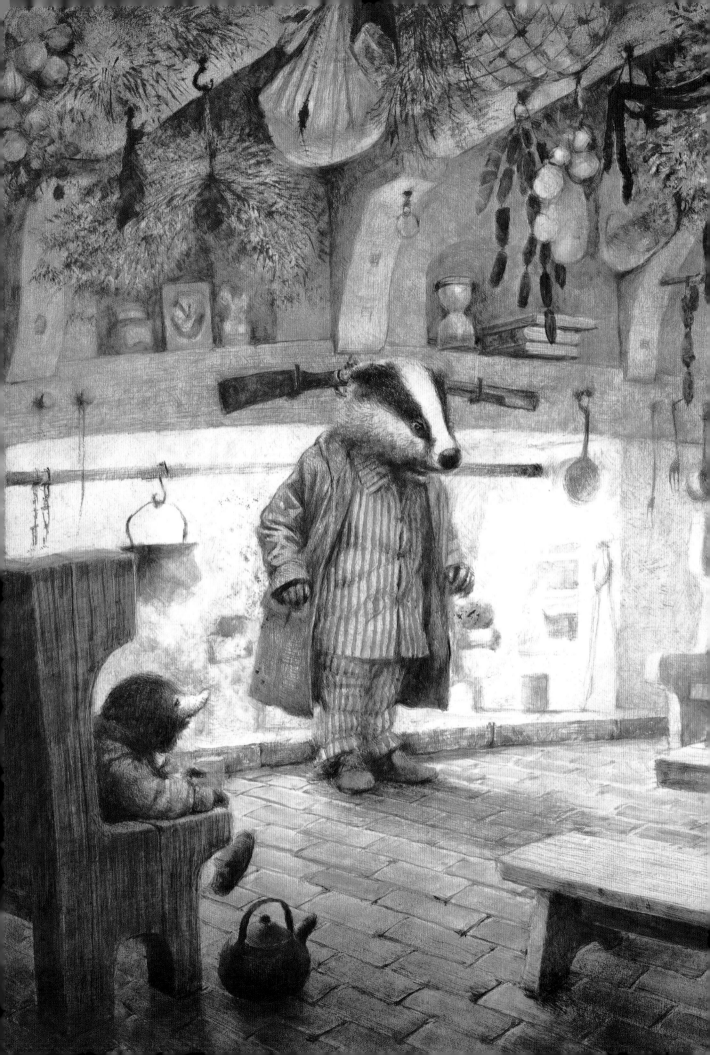

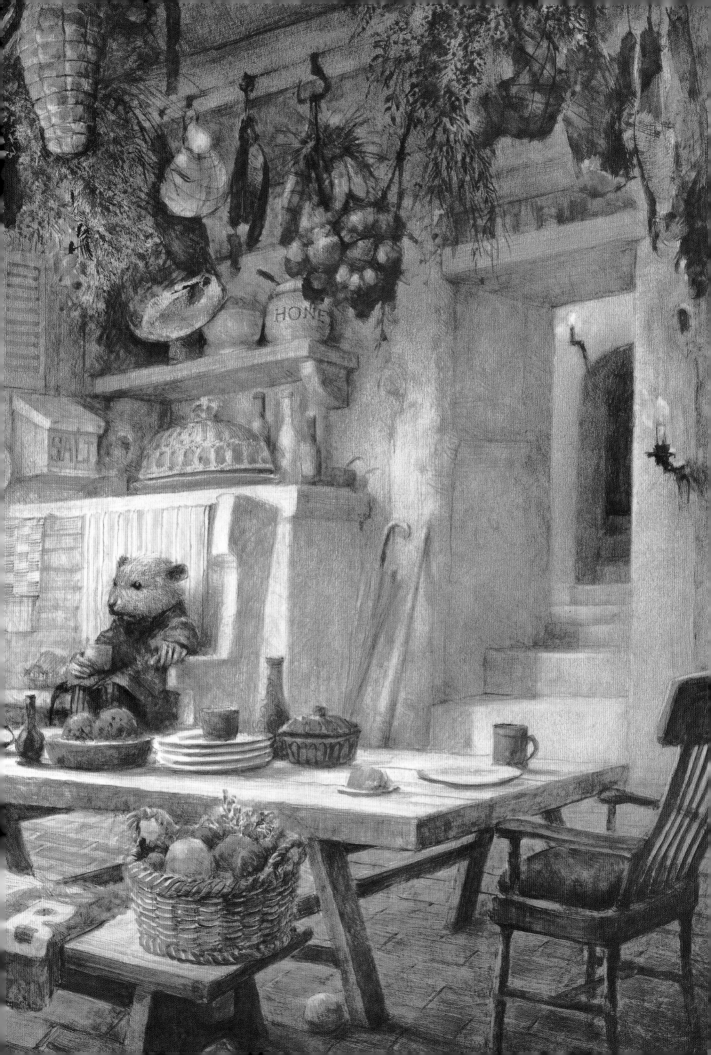

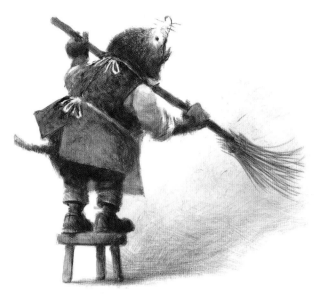

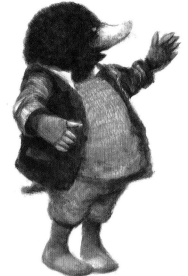

'As he hurried along, eagerly anticipating the moment when he would be at home again among the things he knew and liked, the Mole saw clearly that he was an animal of tilled field and hedgerow, linked to the ploughed furrow, the frequented pasture, the lane of evening lingerings, the cultivated garden-plot. For others the asperities, the stubborn endurance, or the clash of actual conflict, that went with Nature in the rough; he must be wise, must keep to the pleasant places in which his lines were laid and which held adventure enough, in their way, to last for a lifetime.'

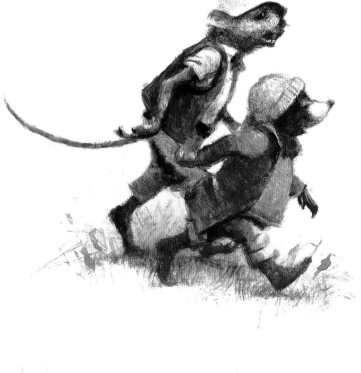

Opposite:
'The mole flung his sculls back with a flourish, and made a great dig in the water. He missed the surface altogether, his legs flew up above his head, and he found himself lying on the top of the prostrate rat. Greatly alarmed, he made a grab for the side of the boat, and the next moment —Sploosh!'

Kenneth Grahame, *The Wind in the Willows*

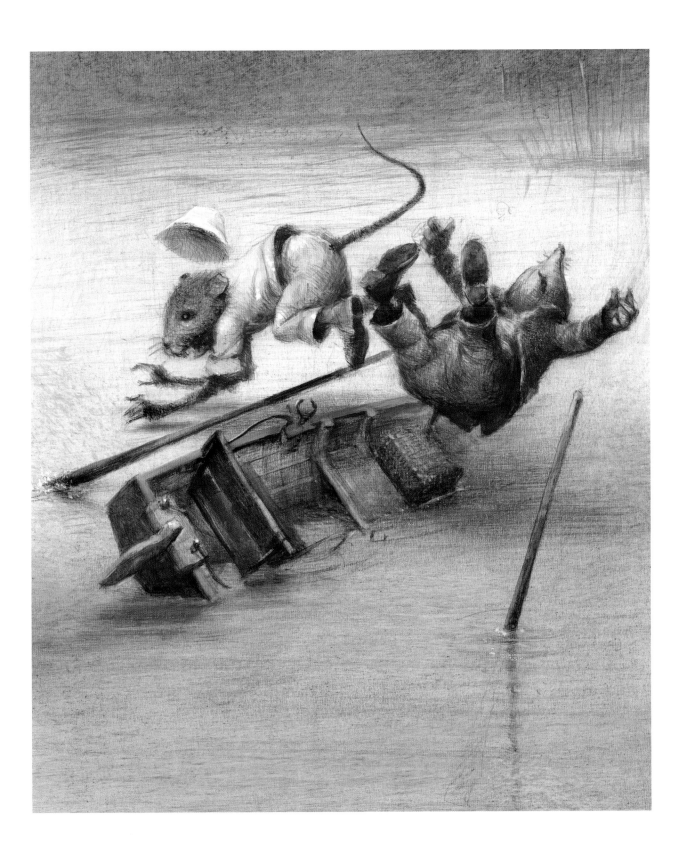

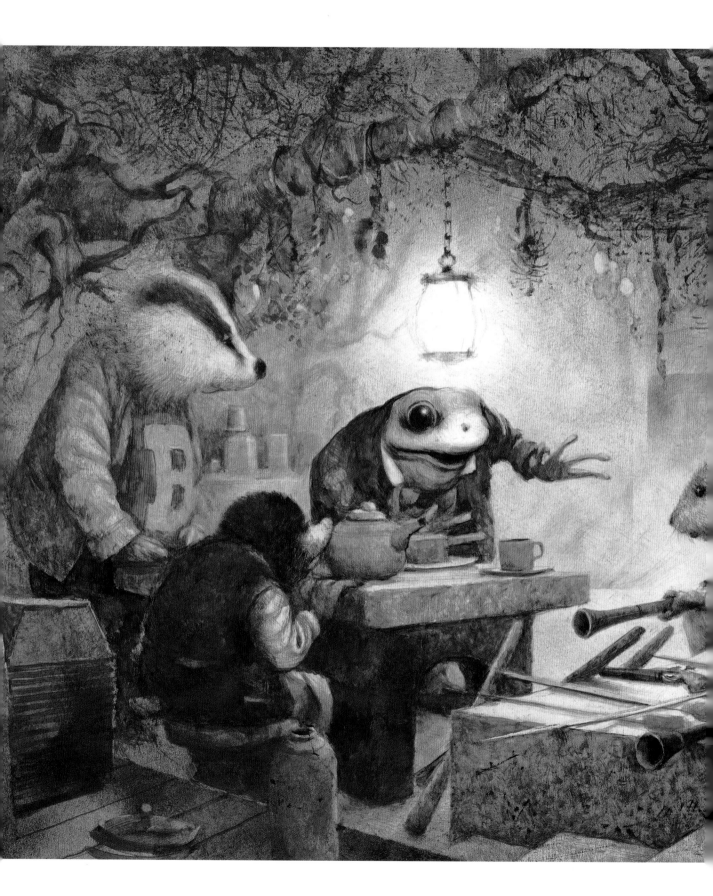

The Wild Wooders have occupied Toad Hall and the friends Rat, Mole and Badger meet with Mr Toad in Rat's house to plan an attack on Toad Hall to remove the squatters.

'"It's a very difficult situation," said the Rat, reflecting deeply. "But I think I see now, in the depths of my mind, what Toad really ought to do. I will tell you. He ought to –"

"No, he oughtn't!" shouted the Mole, with his mouth full. "Nothing of the sort! You don't understand. What he ought to do is, he ought to –"

"Well, I shan't do it anyway!" cried Toad, getting excited. "I'm not going to be ordered about by you fellows! It's my house we're talking about, and I know exactly what to do, and I'll tell you. I'm going to –"

By this time they were all three talking at once, at the top of their voices, and the noise was simply deafening, when a thin, dry voice made itself heard, saying, "Be quiet at once, all of you!" and instantly every one was silent.

It was the Badger…'

Kenneth Grahame, *The Wind in the Willows*

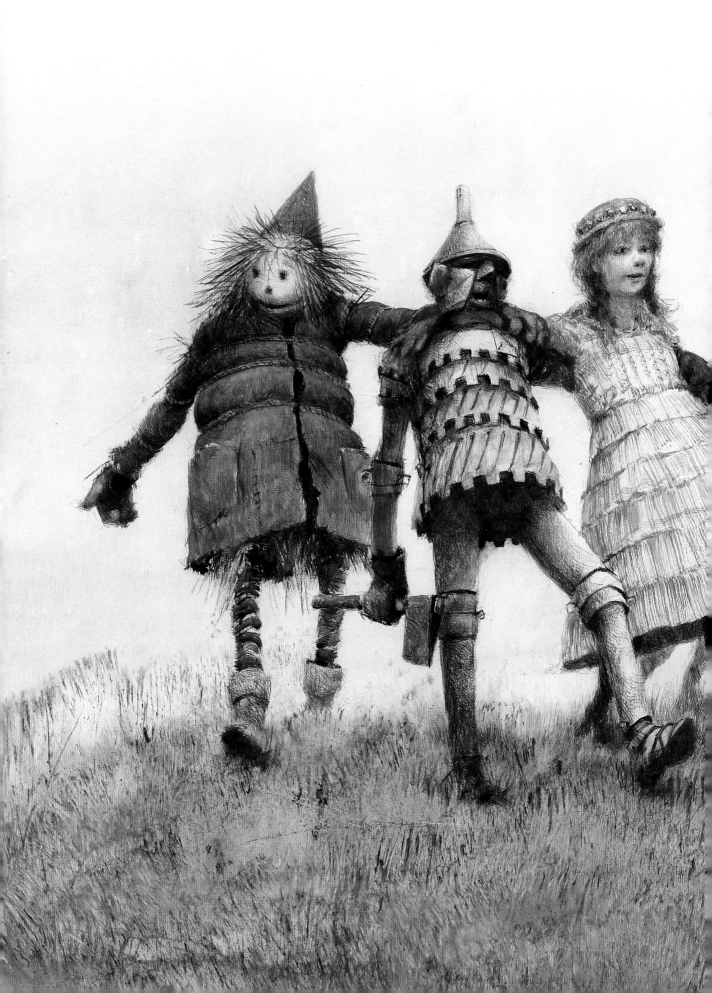

THE WONDERFUL WIZARD OF OZ

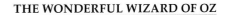

By L. Frank Baum
First published in 1900

The 1939 Hollywood film of *The Wizard of Oz* in which
Judy Garland played the role of Dorothy, was the first film
I remember being taken to by my parents in my hometown
of Geelong. Despite the thrill of the experience I was not
convinced by the movie casting of Dorothy's companions
– the Scarecrow, the Tin Man, and the Cowardly Lion –
I wanted them real like in the story, rather than being
merely human actors in fancy dress.

Seventy years later I had the privilege of illustrating the
'Oz' characters as imagined by L. Frank Baum to appear
as near to real as I have always wanted them to be. One
regret is that I could not make the illustrated map of
the journey to 'The Emerald City' and beyond taken by
Dorothy and her companions. That map remains in my
imagination and, I also hope, the imagination of those
who read this classic American fairytale.

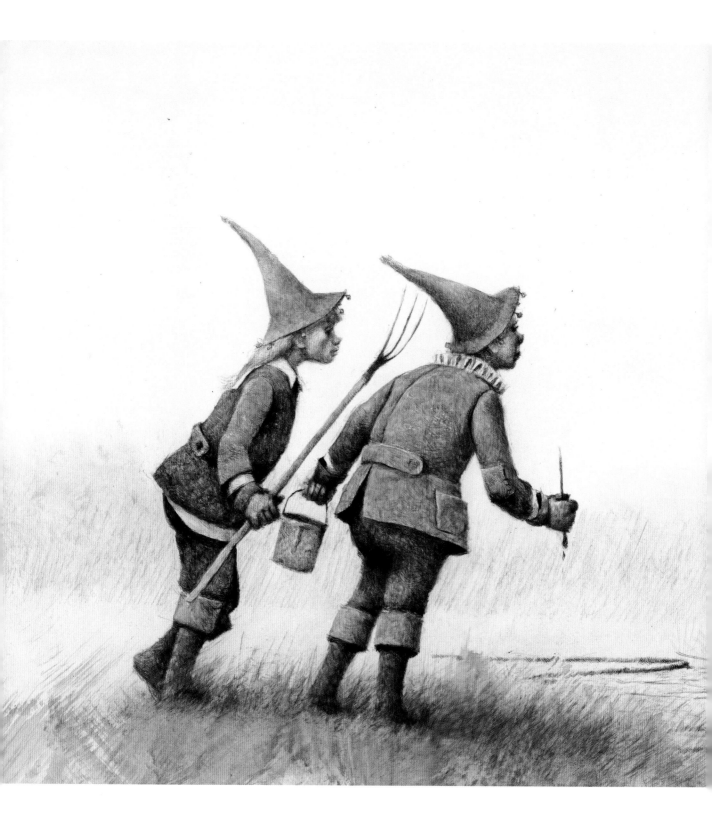

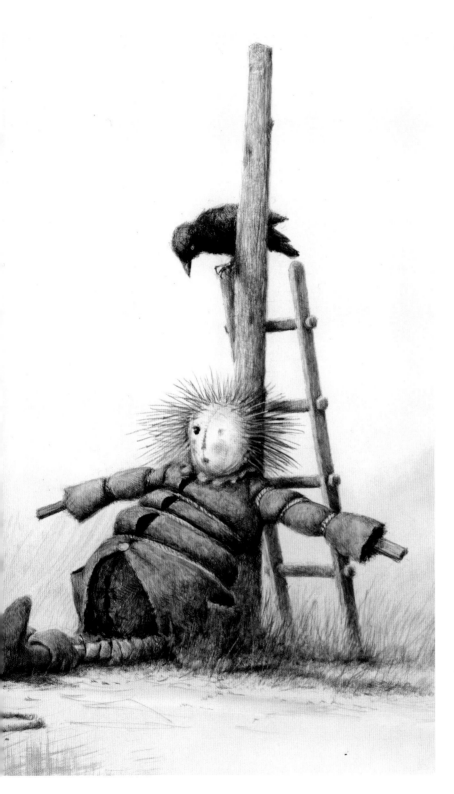

The Scarecrow

'"Won't you tell me a story, while we are resting?" asked the child.

The Scarecrow looked at her reproachfully, and answered: "My Life has been so short that I really know nothing whatever. I was only made the day before yesterday. What happened in the world before that time is all unknown to me. Luckily, when the farmer made my head, one of the first things he did was to paint my ears, so that I heard what was going on. There was another Munchkin with him, and the first thing I heard was the farmer saying, 'How do you like those ears?'

'They aren't straight,' answered the other.

'Never mind,' said the farmer. 'They are ears just the same,' which was true enough.

'Now I'll make the eyes,' said the farmer. So he painted my right eye, and as soon as it was finished I found myself looking at him and at everything around me with a great deal of curiosity, for this was my first glimpse of the world."'

L. Frank Baum, *The Wonderful Wizard of Oz*

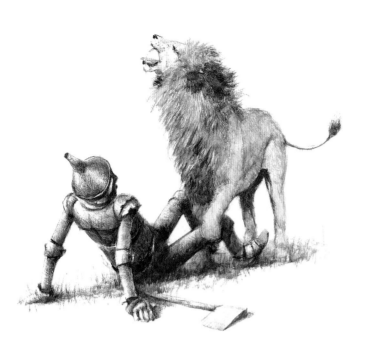

The Tin Woodman

The picture sequence here shows how a real Munchkin woodman evolved into the Tin Woodman following a series of accidents with his axe that had been enchanted by the Wicked Witch of the East to stop him marrying his Munchkin maiden. As each body part is cut off he has a tinsmith make replacements for legs, arms, head and finally body. But there is no heart… In the words of the Tin Woodman to Dorothy and the Scarecrow:

'While I was in love I was the happiest man on earth; but no one can love who has not a heart, and so I am resolved to ask Oz to give me one. If he does, I will go back to the Munchkin maiden and marry her.'

L. Frank Baum, *The Wonderful Wizard of Oz*

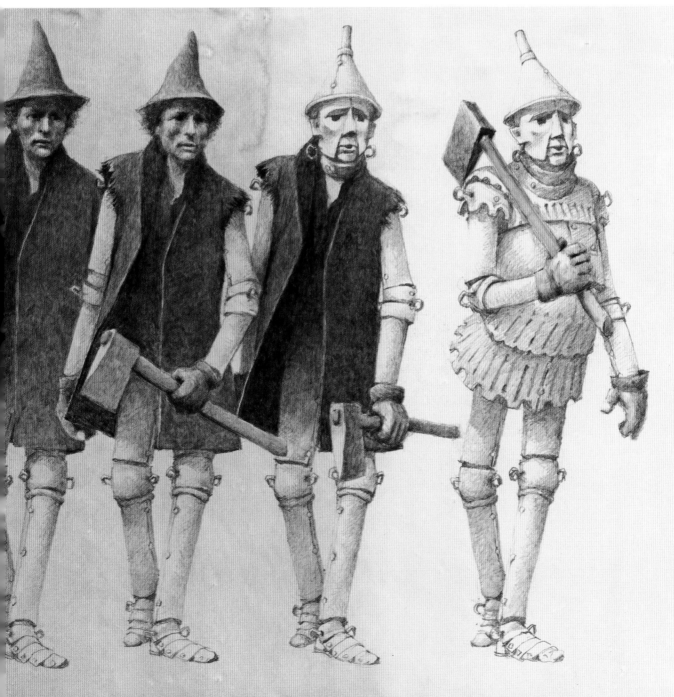

THE ADVENTURES OF TOM SAWYER

By Mark Twain
First published in 1876

Mark Twain grew up in Hannibal, Missouri, a place like the fictional town of St Petersburg where Tom Sawyer and his friends lived. The principal geographic feature, apart from the Mississippi River is Cardiff Hill, crowned by Widow Douglas's residence. Further away is Jackson's Island, some three miles downstream, and McDougal's Cave behind Cardiff Hill. All these places play a vital role in Tom Sawyer's adventures and inspired my edition published in 2010.

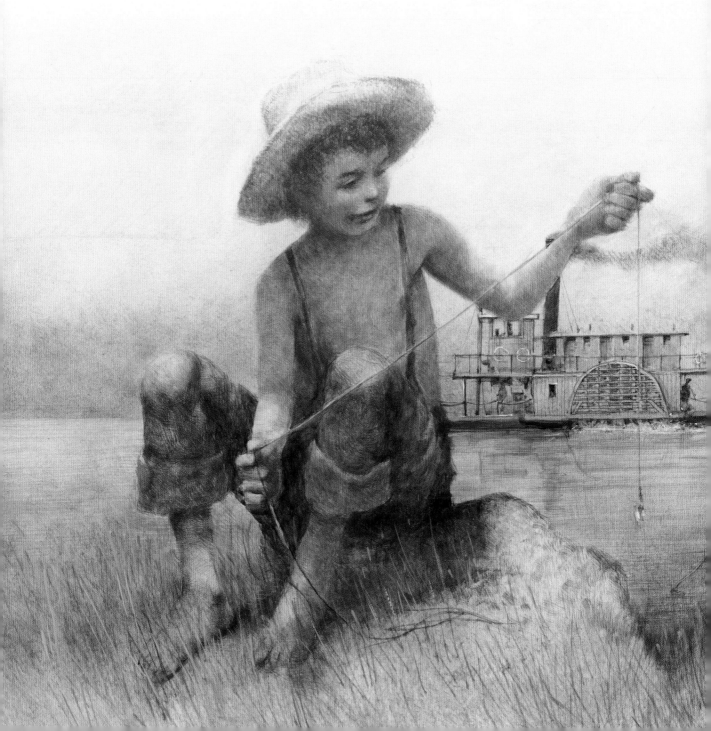

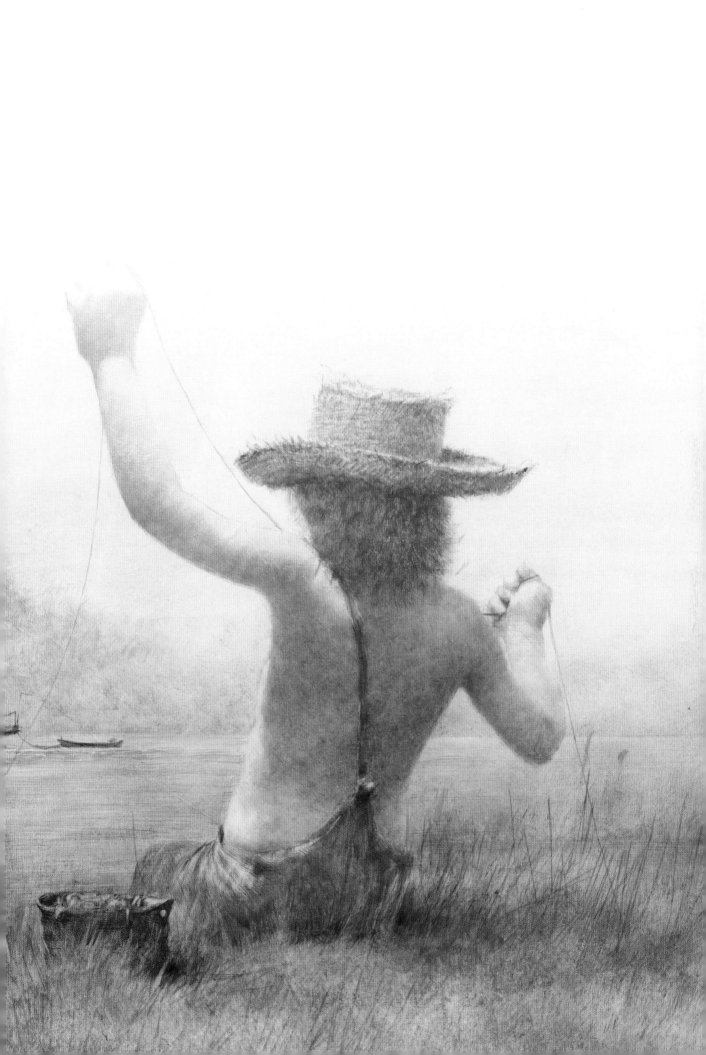

The town itself is comfortable but undistinguished, consisting largely of frame houses of one or two storeys. There is a Presbyterian church with a kind of pine-box on the top to serve as a steeple; a courthouse; the sheriff's office and town jail; three taverns; the schoolhouse; and a variety of stores, offices, livery stables and warehouses, all incorporated at various times in the typical Twain story. The dusty streets are mostly lined by high, whitewashed fences, and pleasantly shaded by locust trees that blossom in the spring. St Petersburg is one of the many small river-ports along the Mississippi but is not big enough to be the homeport of any of the side-wheel paddle steamers.

In this setting Tom and his friend Huckleberry Finn have terrifying adventures, many of which happen at night. Twain was probably not thinking about the future when illustrators might need to depict important moments in his story. The famous fence painting event happens during daylight on a Saturday morning, but much more takes place in the dark of McDougal's Cave, or rafting at night to Jackson's Island, or midnight in the graveyard. Drawing Tom and his friend Becky at their school desk was much less demanding.

'"Who goes there?"

"Tom Sawyer, the Black Avenger of the Spanish Main.
Name your names."

"Huck Finn the Red-Handed, and Joe Harper the Terror
of the Seas." Tom had furnished these titles, from his
favourite literature.'

Mark Twain, *The Adventures of Tom Sawyer*

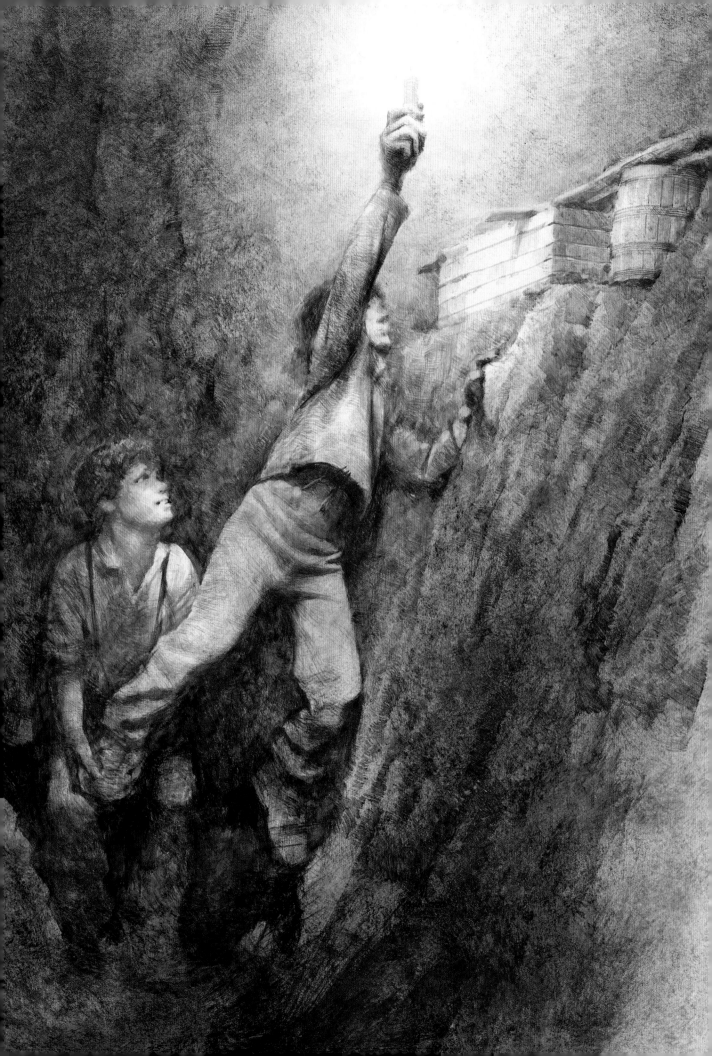

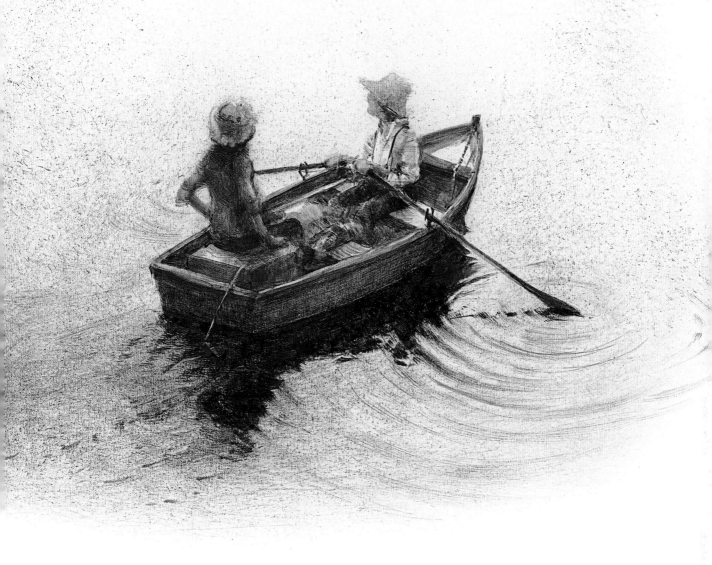

'A trifle after noon the boys borrowed a small skiff from a citizen who was absent, and got underway at once…'

In McDougal's Cave (*opposite*)

'"My goodness, Huck, lookyhere!"

It was the treasure-box, sure enough, occupying a snug little cavern, along with an empty powder-keg, a couple of guns in leather cases, two or three pairs of old moccasins, a leather belt, and some other rubbish well soaked with the water-drip.

"Got it at last!" said Huck ploughing among the tarnished coins with his hand. "My, but we're rich, Tom!"

"Huck, I always reckoned we'd get it. It's just too good to believe, but we have got it, sure! Say – let's not fool around here…"'

Mark Twain, *The Adventures of Tom Sawyer*

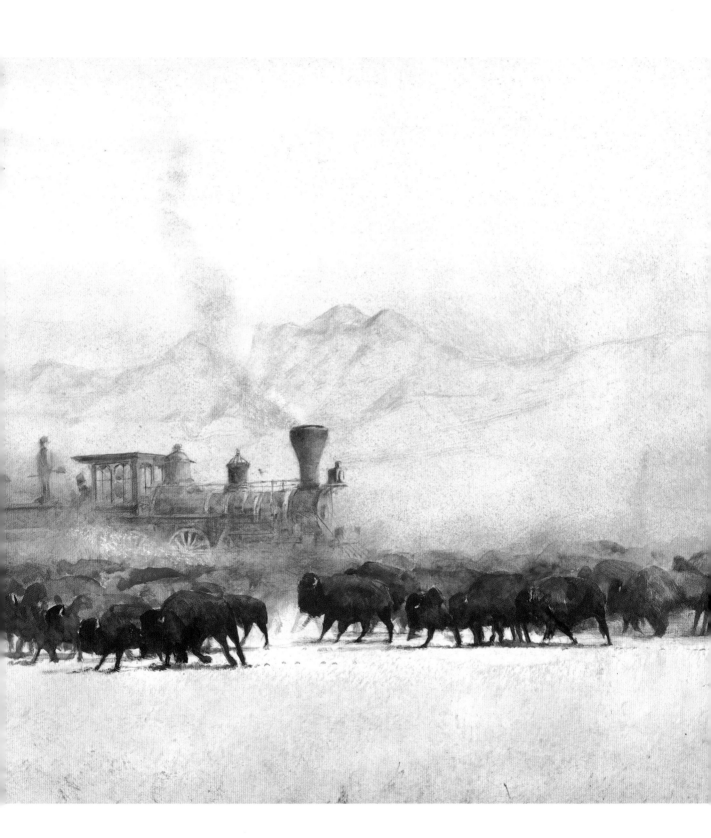

AROUND THE WORLD IN EIGHTY DAYS

By Jules Verne
First published in 1873

To fulfil a wager made at the Reform Club in London, Phileas Fogg and his manservant Passepartout embark on a mission to circumnavigate the world in eighty days. Travelling by train, steamboat, sledge and elephant, the unlikely pair rescue a young Indian woman from sacrifice, escape kidnap and survive hurricane winds. Along the way they are followed by the tenacious Detective Fix of Scotland Yard.

I remembered the widescreen film of the story produced by Michael Todd in 1956, mostly for the wonderful graphic credits by Saul Bass, which influenced my editions published in 2000 and revised in 2012. So memorable was the film that it continues to be difficult to convince people that there was no balloon travel over the French Alps in Verne's 'real' tale.

'Noon, December 4th (62 days into the journey)
… a troop of ten or twelve thousand head of buffalo encumbered the track. The locomotive, slackening its speed, tried to clear the way with its cow-catcher; but the mass of animals was too great. The buffaloes marched along with a tranquil gait, uttering now and then deafening bellowings…'

Overleaf:
Sledge Travel
'December 9th… What a journey!' The travellers, huddled close together could not speak for the cold, intensified by the rapidity at which they were going. The sledge sped on as lightly as a boat over the waves…'
Jules Verne, *Around the World in Eighty Days*

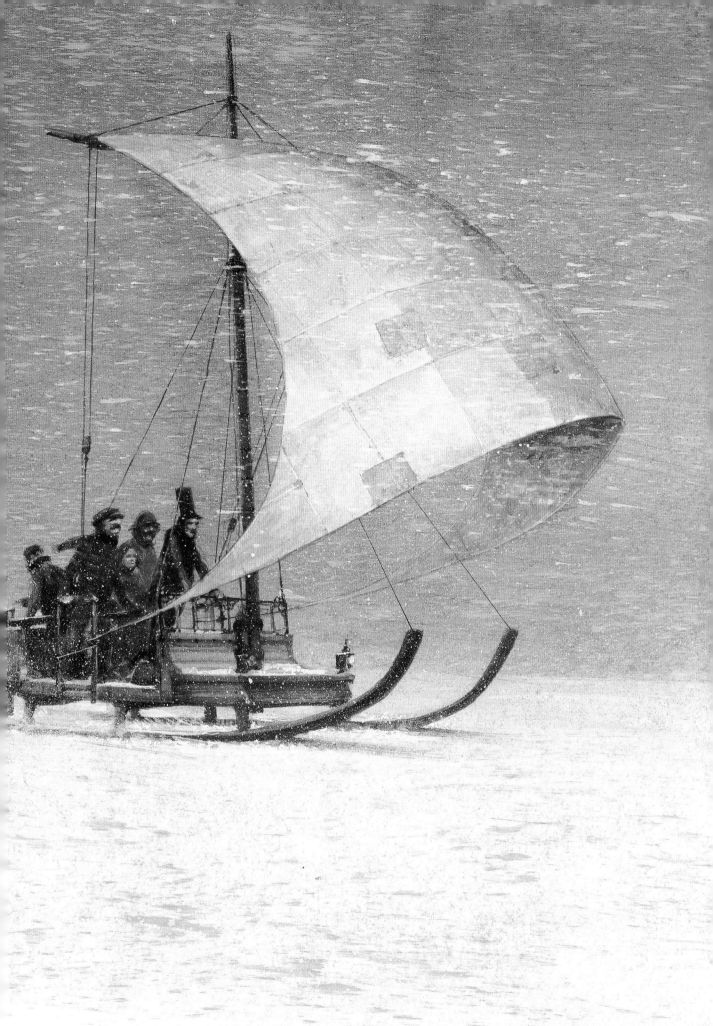

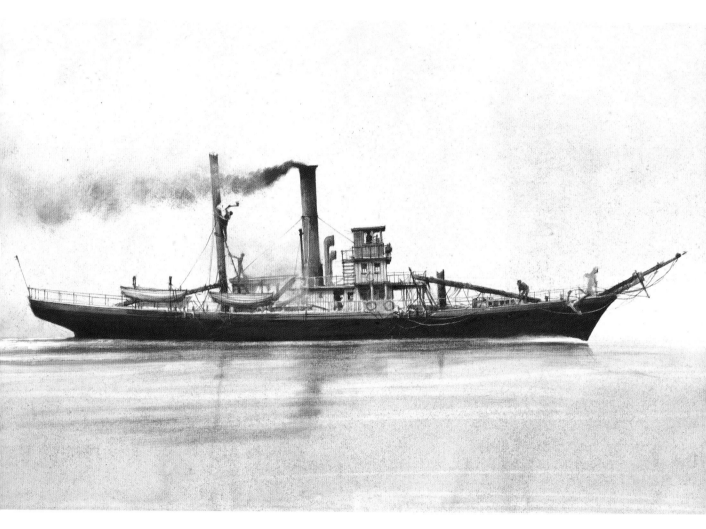

'December 18th…
"Burn the Henrietta!"

 "Yes; at least the upper part of her. The coal has given out."

 … It was necessary to have dry wood to keep the steam
up to the adequate pressure, and on that day the poop,
cabins and bunks, and the spare deck were sacrificed.
On the next day, the 19th of December, the masts, rafts
and spars were burned; the crew worked lustily, keeping
up the fires…

 The railings, fittings, the greater part of the deck, and
top sides disappeared on the 20th, and the 'Henrietta' was
now only a flat hulk. But on this day they sighted the Irish
coast and Fastnet Light.'

Jules Verne, *Around the World in Eighty Days*

Fogg and Passepartout

These are my studies of the two main characters in Jules Verne's adventure. They are described in the first chapter titled 'In which Phileas Fogg and Passepartout accept each other, the one as master, the other as man'.

THE ADVENTURES OF PINOCCHIO

By Carlo Collodi
First published in 1883

For today's readers, Collodi's *Pinocchio* may come as a surprise, and many will be startled to find that the original novel is greatly different to the famous Disney film of 1940. As each chapter was devised for a newspaper, Collodi had to keep his readers interested. He created a bizarre, topsy-turvy world that faintly resembles Tuscany, but in which anything is possible and where many dark and sinister characters lurk. Pinocchio lurches from one calamity to another; he endures much suffering, and his fate is never quite settled by the end of each chapter, leaving the reader dangling in suspense. Indeed, the author originally intended to end the story at chapter fifteen, in which Pinocchio is left hanging from an oak tree, apparently dead. But there came such an outcry from readers that Collodi was forced to continue the series.

When, in 2014, I illustrated the scene of Pinocchio hanging from the tree, a modern, if minor, outcry came from some publishers who considered this too gruesome. The consequence of this was that the rope connecting the limb of the oak and Pinocchio's wooden-puppet neck was digitally removed in the painting of the new edition, leaving Pinocchio running beneath the tree.

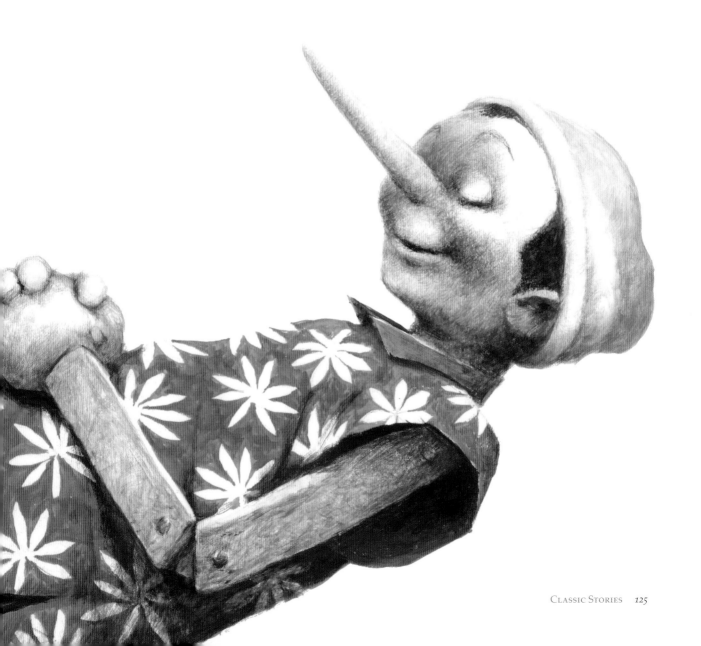

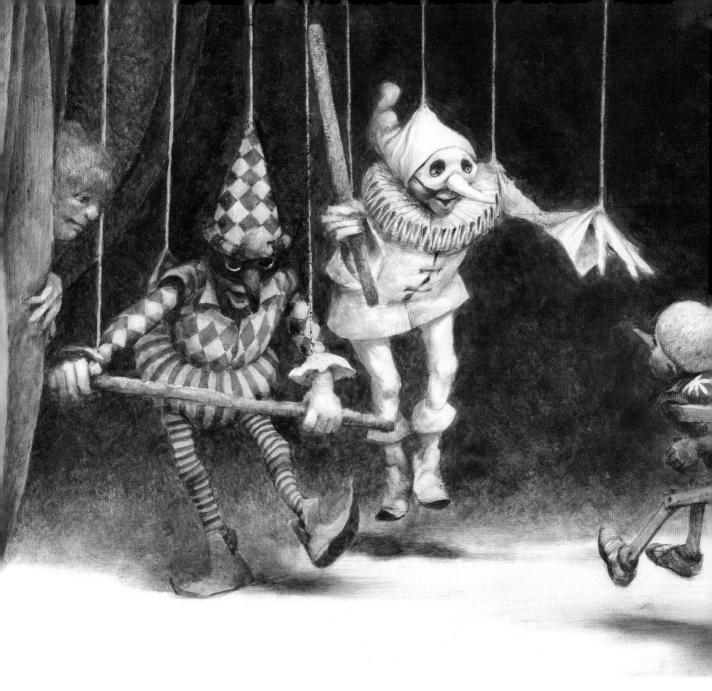

The Marionette Theatre

'"Pinocchio, come up to me!" shouted Harlequin. "Come to
the arms of your wooden brothers!'

At such a loving invitation, Pinocchio, with one leap
from the back of the orchestra, found himself in the front
rows. With another leap, he was on the orchestra leader's
head. With a third, he landed on the stage...'

Carlo Collodi, *The Adventures of Pinocchio*

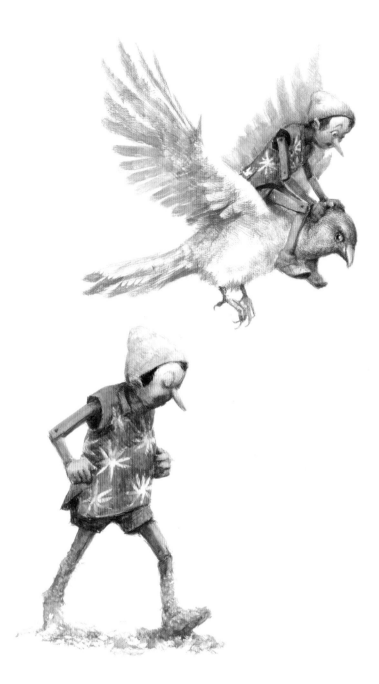

Top:
'Pinocchio jumped on the pigeon's back and, as he settled
himself, he cried out gaily, "Gallop on, gallop on, my
pretty steed! I'm in a great hurry!"'

Centre:
'It had rained for days, and the road was so muddy that, at
times, Pinocchio sank down almost to his knees. But he
kept on bravely.'

Right:
'"Don't you recognise me?" said the Snail.
 "Yes and no."
 "Do you remember the Snail that lived with the Fairy
with Azure Hair? Do you not remember how she opened
the door for you one night and gave you something to eat?"'

Carlo Collodi, *The Adventures of Pinocchio*

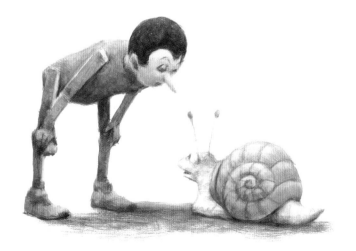

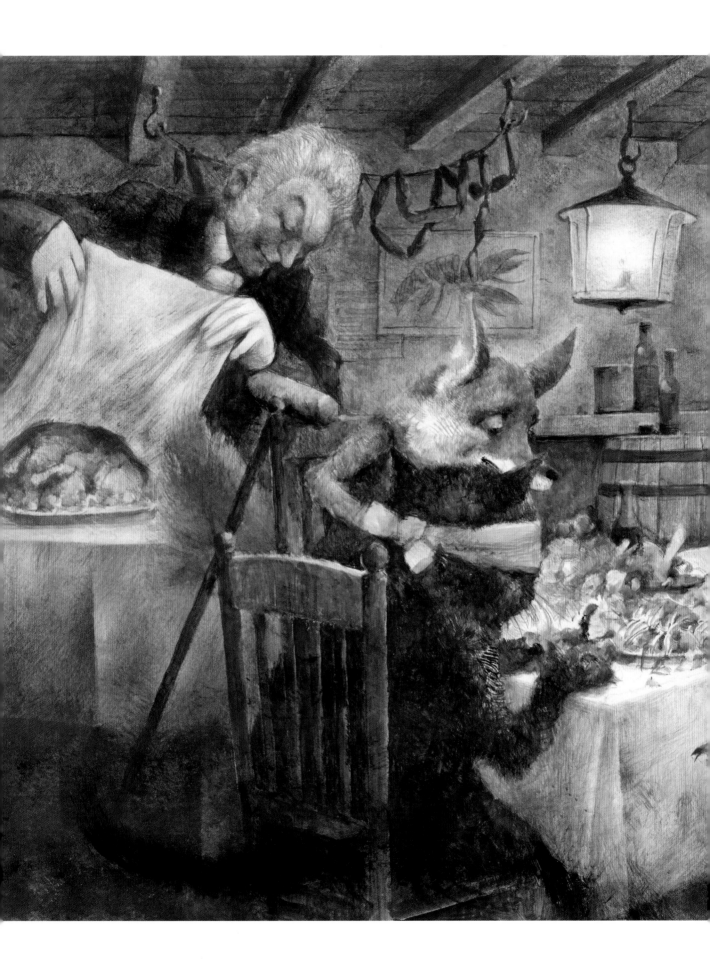

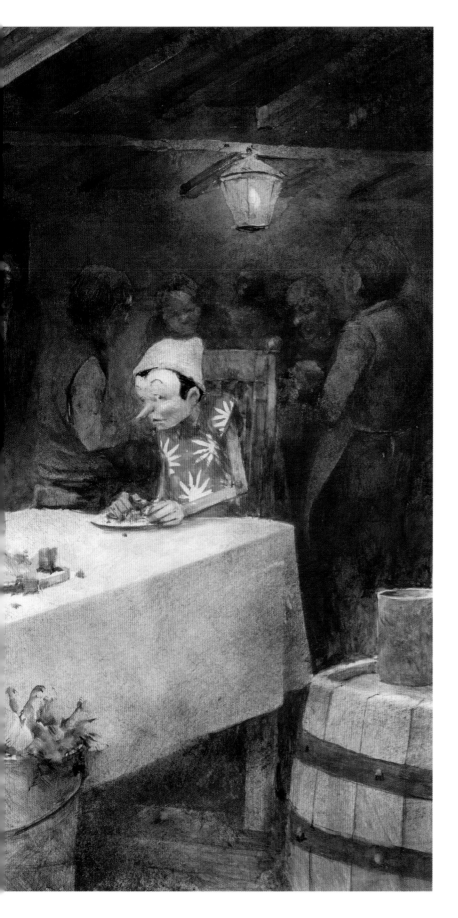

The Inn of the Red Lobster

Towards evening the Cat, Fox and Pinocchio come to the Inn of the Red Lobster and sit down at the same table. But none of them are hungry.

'… The poor Cat felt very weak, and he was able to eat only thirty-five mullets with tomato sauce and four portions of tripe and cheese… The Fox, after a great deal of coaxing… had to be satisfied with a small hare dressed with a dozen young and tender spring chickens. After the hare he ordered some partridges, a few pheasants, a couple of rabbits and a dozen frogs and lizards… Pinocchio ate least of all. He asked for a bite of bread and a few nuts and then hardly touched them. The poor fellow, with his mind on the Field of Wonders, was suffering from gold-piece indigestion.'

Carlo Collodi, *The Adventures of Pinocchio*

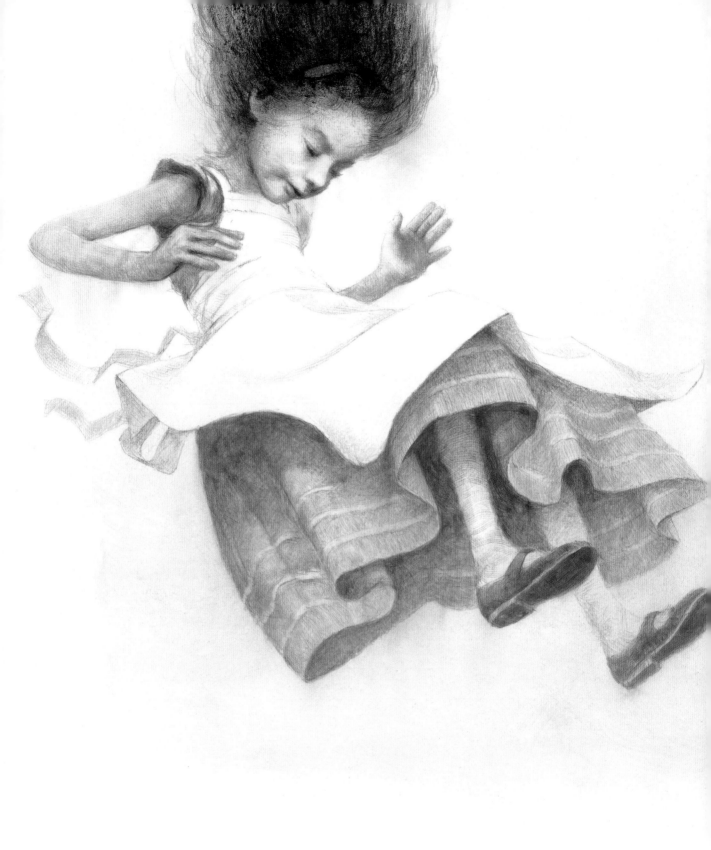

ALICE'S ADVENTURES IN WONDERLAND

By Lewis Carroll
First published in 1865

Lewis Carroll's extraordinary tale was first published on July 4th 1865, three years to the day from when he started telling it to young Alice Liddell and her sisters. A totally original work, quite unlike any previous children's book, it became an instant bestseller and has never been out of print in its 150 years.

John Tenniel was a celebrated illustrator of *Punch* magazine in London in the 1850s when Lewis Carroll invited him to make black and white pictures to appear in the first edition. Remarkably these Tenniel pictures continue to define the classic story. The book came out of copyright in 1907, which allowed illustrators other than Tenniel to interpret the story, one of whom, Arthur Rackham, depicted himself as the Mad Hatter. Some readers say that in my 2009 edition I do not look unlike the Mad Hatter that I have drawn. This was not my intention but it may be a subliminal way of paying homage to both Carroll and Tenniel, and later Rackham.

Opposite:
'The rabbit-hole went straight on like a tunnel for some way, and then dipped suddenly down, so suddenly that Alice had not a moment to think about stopping herself before she found herself falling down a very deep well.'
Lewis Carroll, *Alice's Adventures in Wonderland*

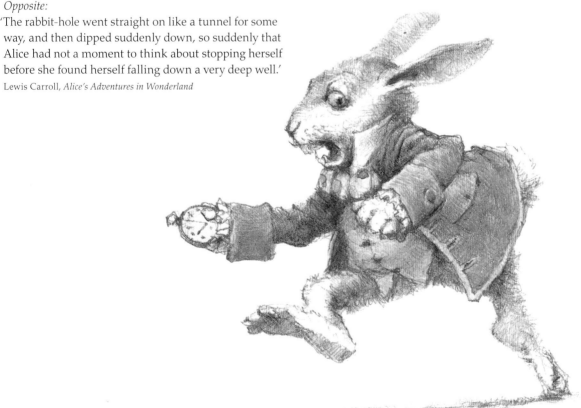

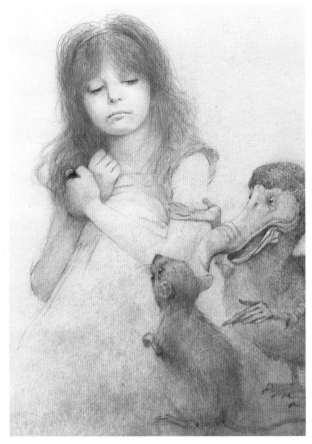

Illustrating Alice

Elizabeth Hammill, writing in *Books for Keeps*, talks about my interest in assisting modern children to 'read' Alice's mind through her body language:

'It is his close attention to authorial intent, to character psychology, to place and to other sensibilities and expectations of modern readers raised on video and cinematography that gives Robert's classic revisionings their power, immediacy and energy. Look at his Alice and her "amazed" yet "apprehensive" body language when faced with decisions about "unknown substances" inviting her to "Eat me" or "Drink me".

The social issue of "substance abuse" was not part of Lewis Carroll's Victorian times as it is today. So he quietly made a study of how ten year olds – Alice's age – responded when they became apprehensive but did not want to draw attention to themselves.

One common action, it seemed, was to first draw your hand up to your face and draw away, then, as if to mask the action, to cover it with your other hand. Alice does this when she approaches a moment when she rightly becomes uncertain.'

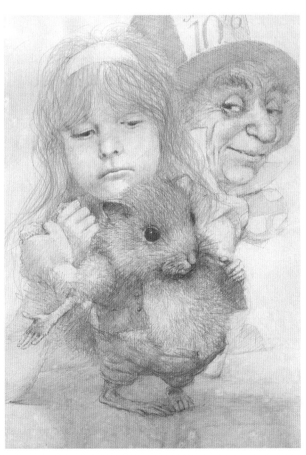

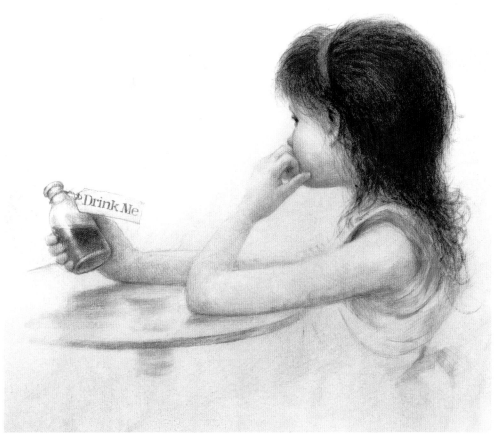

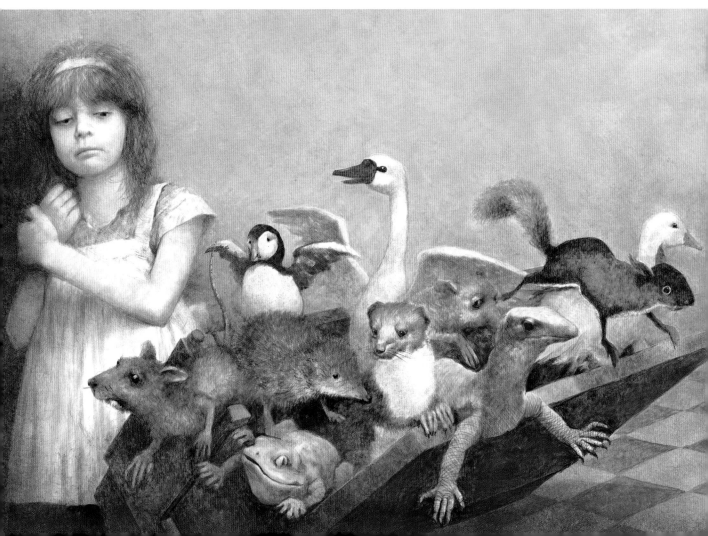

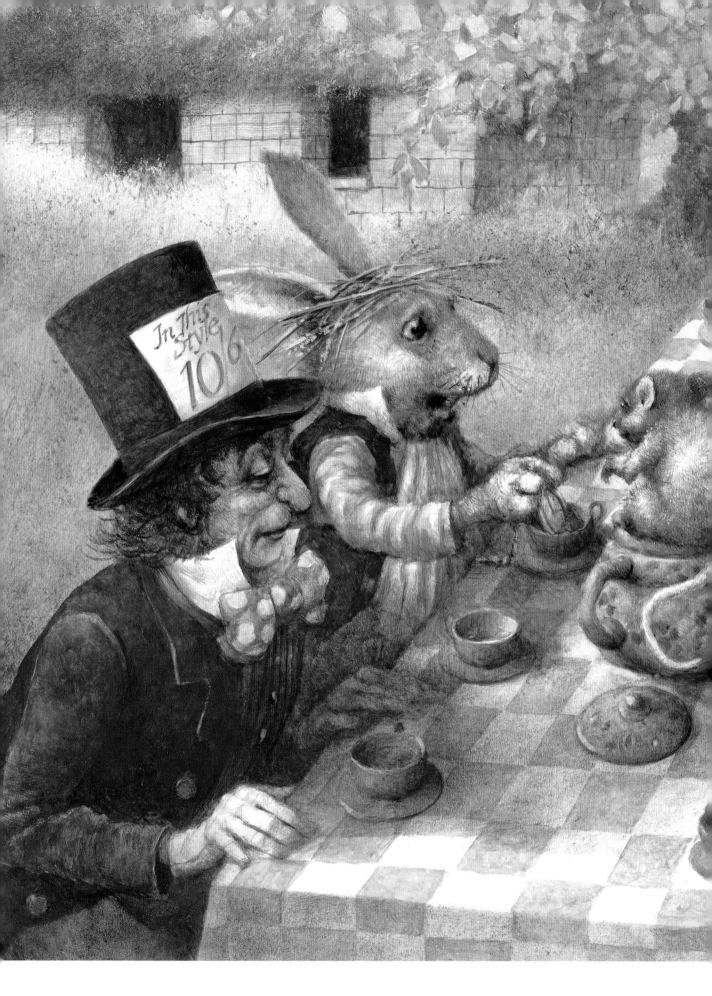

The hat bears a note reading "In This Style 10/6".

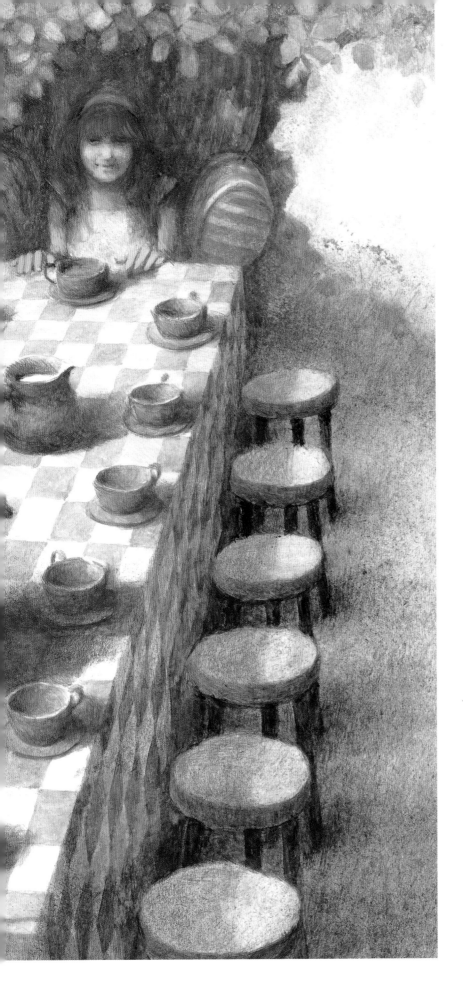

A Mad Tea-Party

'There was a table set out under a tree in front of the house, and the March Hare and the Hatter were having tea at it: a Dormouse was sitting between them fast asleep… The table was a large one, but the three were all crowded together at one corner of it:

 "No room! No room!" they cried out when they saw Alice coming.

 "There's plenty of room!" said Alice indignantly, and she sat down in the large armchair at one end of the table.'

Overleaf:
Advice from a Caterpillar

'The Caterpillar and Alice looked at each other for some time in silence: at last the Caterpillar took the hookah out of its mouth, and addressed her in a languid sleepy voice.

 "Who are you?" said the Caterpillar.

 This was not an encouraging opening for a conversation. Alice replied, rather shyly, "I – I hardly know sir, just at present – at least I know who I was when I got up this morning, but I think I must have been changed several times since then."'

Lewis Carroll,
Alice's Adventures in Wonderland

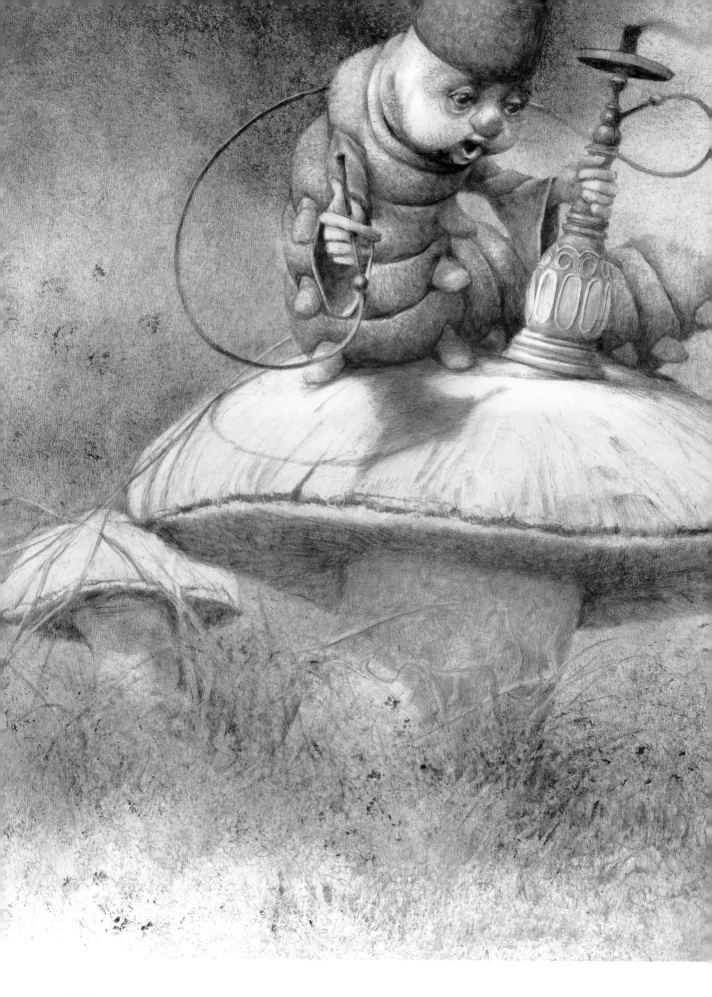

136 WONDERLANDS

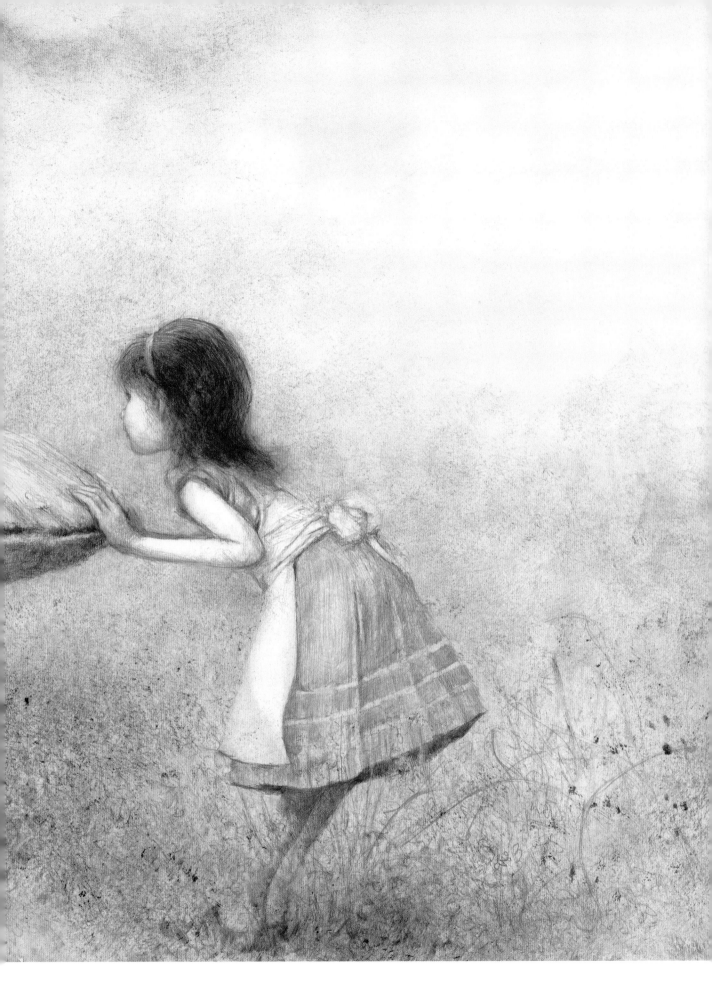

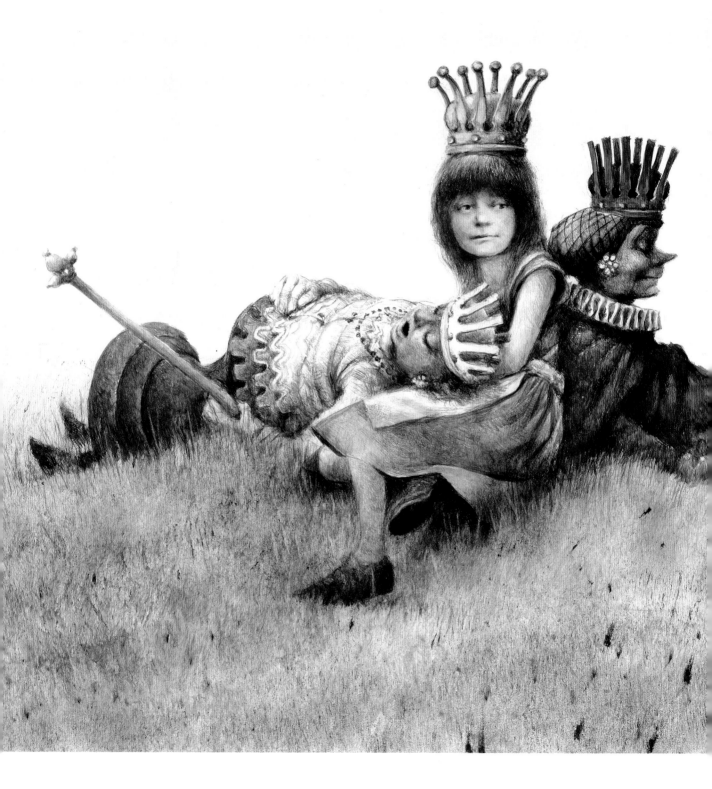

ALICE THROUGH THE LOOKING-GLASS

By Lewis Carroll
First published in 1871

Following *Alice's Adventures in Wonderland*, Carroll provides a perfect counter-point with this sequel, and it is every bit as wonderful. This time Alice steps through a mirror above the mantelpiece into a reverse and topsy-turvy world where chess pieces lead her on a journey, flowers talk and nothing is quite as it seems. A wrong-way-round theme runs through the story as it seemed to do through Lewis Carroll's life: he liked to write letters in mirror writing, and to draw pictures which changed into something else when turned upside down.

In illustrating two Alice books – the first in 2009 and the second in 2015 – I tried to 'get to know' Carroll by reading as much as I could about him. But I was still left as a poor student is to a master when trying to interpret him with pictures seen 'through the looking-glass.'

Queen Alice

'"Well this is grand!" said Alice. "I never expected I should be a Queen so soon – and I'll tell you what it is, your Majesty," she went on, in a severe tone (she was always rather fond of scolding herself), "it'll never do for you to be lolling about on the grass like that! Queens have to be dignified, you know!"'

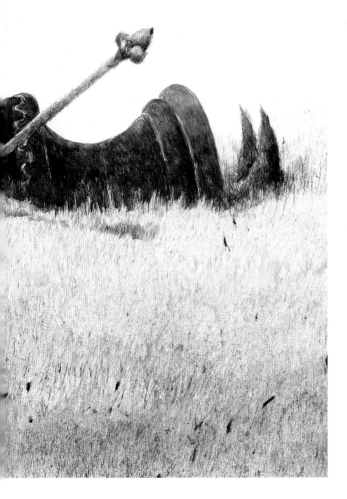

Overleaf:

'Jabberwocky'

'"Beware the Jabberwock, my son!
The jaws that bite, the claws that catch!
Beware the Jubjub bird, and shun
The frumious Bandersnatch!"

He took his vorpal sword in hand;
Long time the manxome foe he sought –
So rested he by the Tumtum tree
And stood awhile in thought.

And, as in uffish thought he stood,
The Jabberwock, with eyes of flame,
came whiffling through the tulgey wood,
And burbled as it came!'

Lewis Carroll, *Alice through the Looking-Glass*

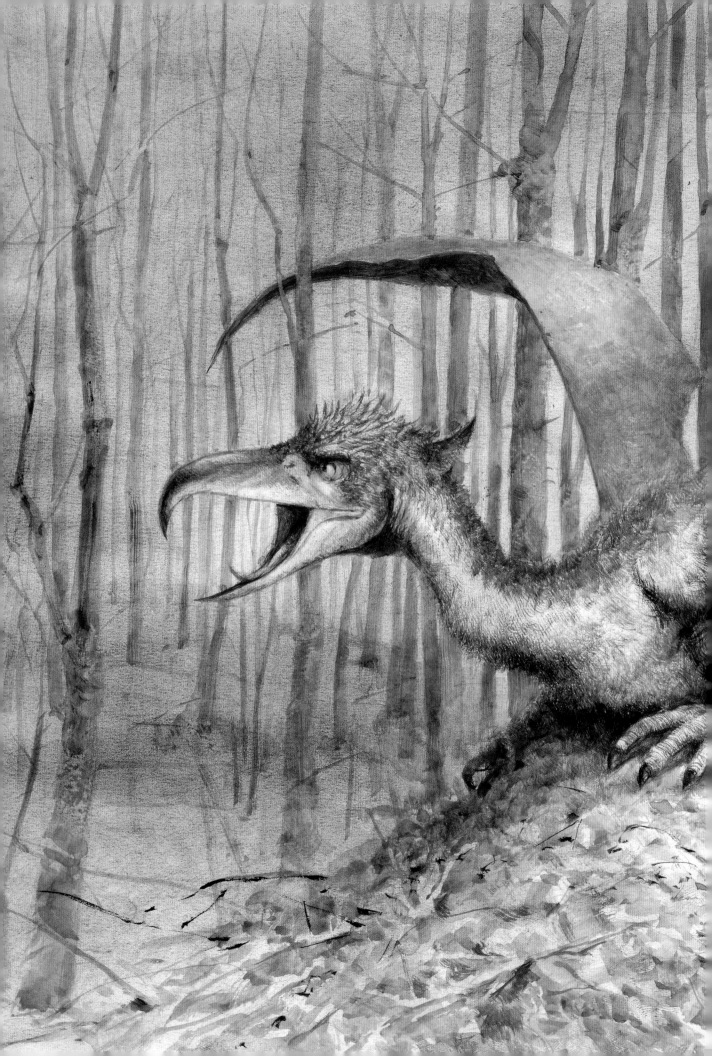

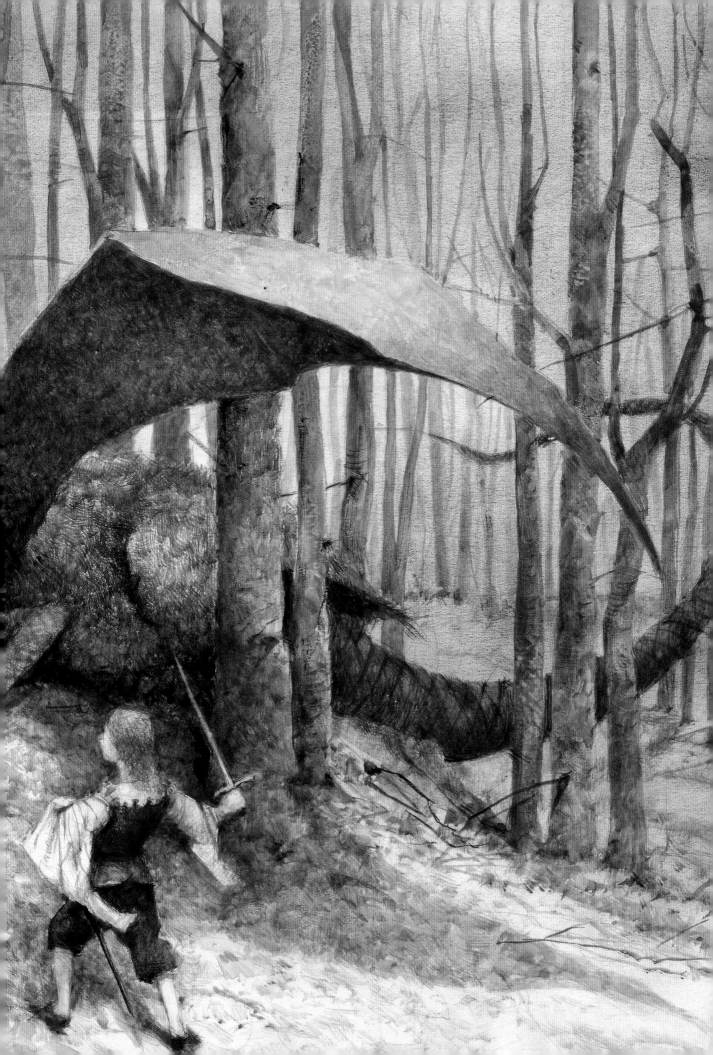

Alice Meets Tweedledum and Tweedledee

'They were standing under a tree, each with an arm around the other's neck, and Alice knew which was which in a moment, because one of them had "DUM" embroidered on his collar, and the other had "DEE".

"I suppose they've each got 'TWEEDLE' round at the back of the collar," she said to herself.'

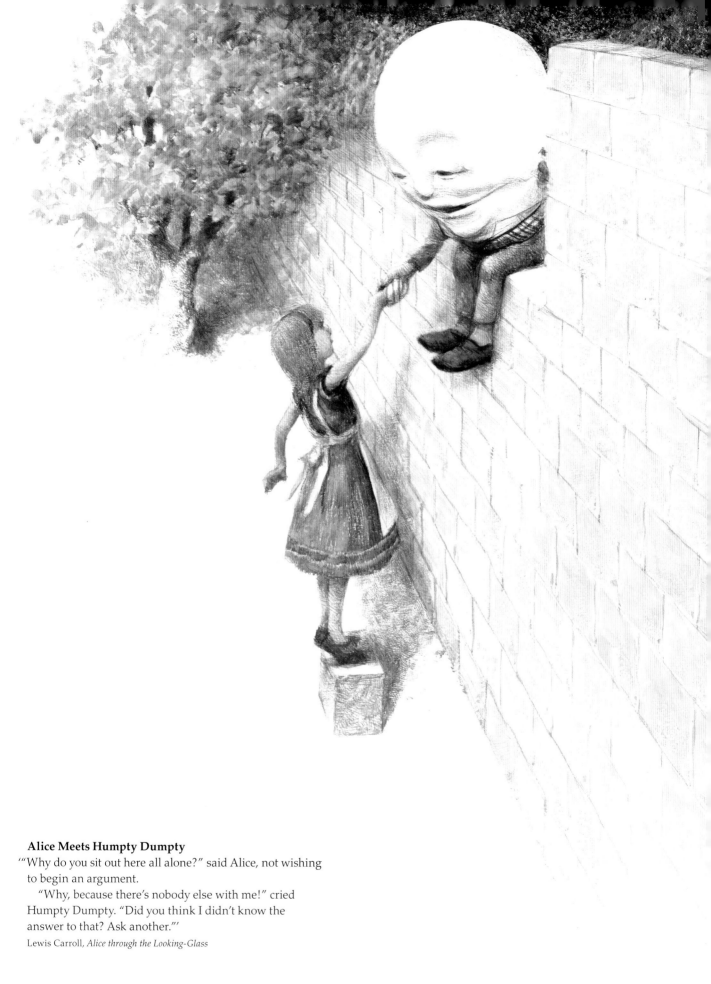

Alice Meets Humpty Dumpty

'"Why do you sit out here all alone?" said Alice, not wishing
to begin an argument.

"Why, because there's nobody else with me!" cried
Humpty Dumpty. "Did you think I didn't know the
answer to that? Ask another."'

Lewis Carroll, *Alice through the Looking-Glass*

Finding Wonderlands
MAGIC AND DREAMING

'There is a world just around the corner of your mind where reality is an intruder and dreams come true. You may escape into it at will. You need no password, no magic wand or Aladdin's lamp; only your own imagination and curiosity about things that never were.'

In 1985 Michael Page and I introduced our book, the *Encyclopaedia of Things That Never Were* with the above thought. Every people, of every time, have known the importance of dreaming. When our dreams have been recorded we call them myths, or legends, or fairy stories. They are part of the treasury of our secret world, able to transport us instantly to wonderlands. They explain to us everything we long to know, and give substance to our instinct that there are worlds beyond our world.

This third section of my art of illustration is related to four books that explore in words and pictures some realms of magic and dreaming. They are:

Encyclopaedia of Things That Never Were, 1986
The Dreamkeeper, 1995
Halloween Circus, 2002
The Wizard's Book of Spells, 2003

Right:
The Dreamkeeper
The creatures of our dreams often escape to find reality, and it is the job of The Dreamkeeper to catch them and return to The Great Dreamtree where they belong.

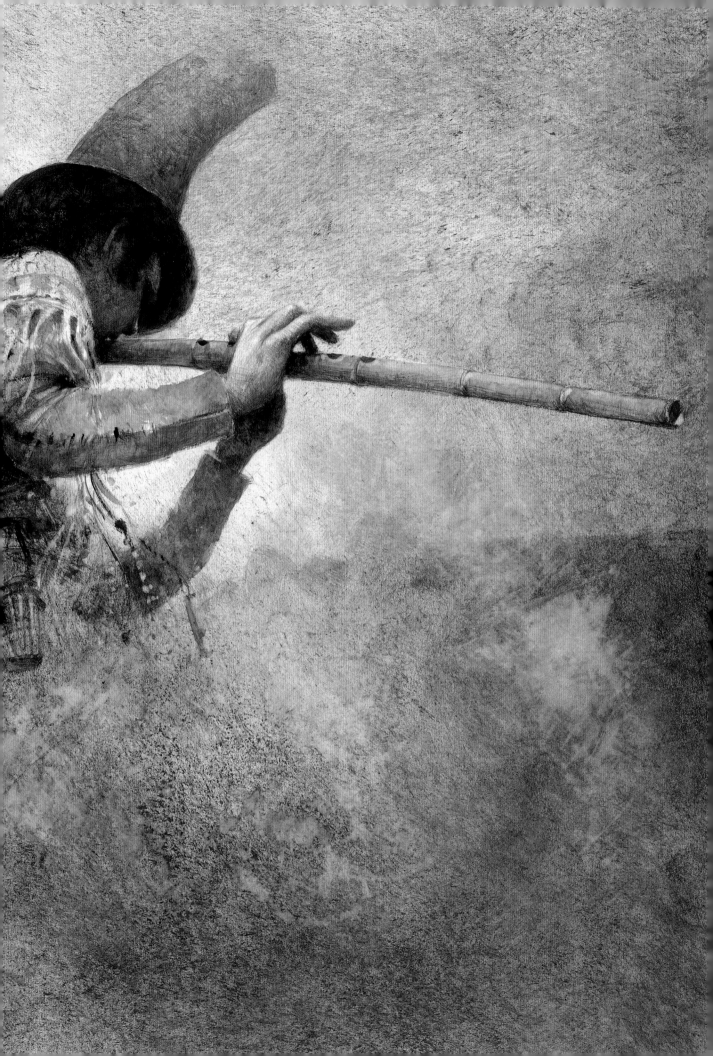

THE WIZARD'S BOOK OF SPELLS

By Beatrice Phillpotts and Robert Ingpen

Wizards are as ancient as the human race. As mighty magicians, they possess the power to do what the rest of us can only dream of – to wave a wand and control the path of destiny. History, myth and legends are rich in stories of extraordinary individuals, gifted with the awesome ability to shape our world for good and evil.

Wizards are as popular now as ever. Our favourite modern spellcasters, like Harry Potter, may be confined to fiction, but the dream lives on. A wizard is often regarded as the male equivalent of a witch, but this is not totally correct. Witches rely on evil spirits or demons to assist them, whereas wizards usually call on benevolent forces to activate their spells or at least to employ both good and evil spirits.

Wizards belong to a numerous class of magic workers, which includes sorcerers, magicians, thaumaturgists, conjurers, witches, lamias, warlocks, mages, enchanters and mystics.

SATOR
AREPO
TENET
OPERA
ROTAS

CIRCE

Circe the Sorceress

The beautiful magician Circe is best known for transforming Odysseus's crew into pigs during their visit to her enchanted island. Odysseus himself successfully resisted Circe's spell with the help of a magical herb, *Allium moly*, prescribed for him for the purpose by the Greek god Hermes.

Doctor John Dee

The last royal magician, John Dee was an astrologer to Queen Elizabeth I, and a powerful figure at the English court in the late sixteenth century. A gifted mathematician and map-maker, Dee was respected as the most learned man in Europe, but his fascination with astrology, alchemy, and angel magic made him widely feared. William Shakespeare used John Dee as inspiration for his wizard Prospero in *The Tempest*.

JOHN DEE

HALLOWEEN CIRCUS

By Charise Neugebauer and Robert Ingpen

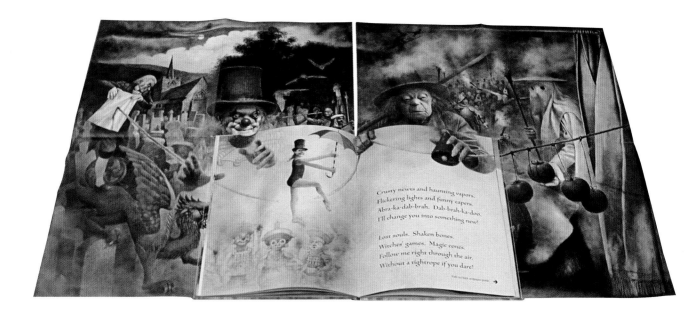

The publisher and I planned and experimented with making this special book to attempt to capture the spirit of Halloween with surprises beyond just the words and pictures.

To achieve a novel way of folding the pages of the book (shown above), we had special 'rag based' paper manufactured. Then an Italian printer devised a way of machine folding, collating and binding the book. The 16-page book measured 230 x 285mm, and opened out to display a poster-like image (900 x 570mm) that interacted with the book pages. The original plans, artwork, and story of how this was produced was gifted to the Eric Carle Museum of Picture Book Art in Massachusetts, USA.

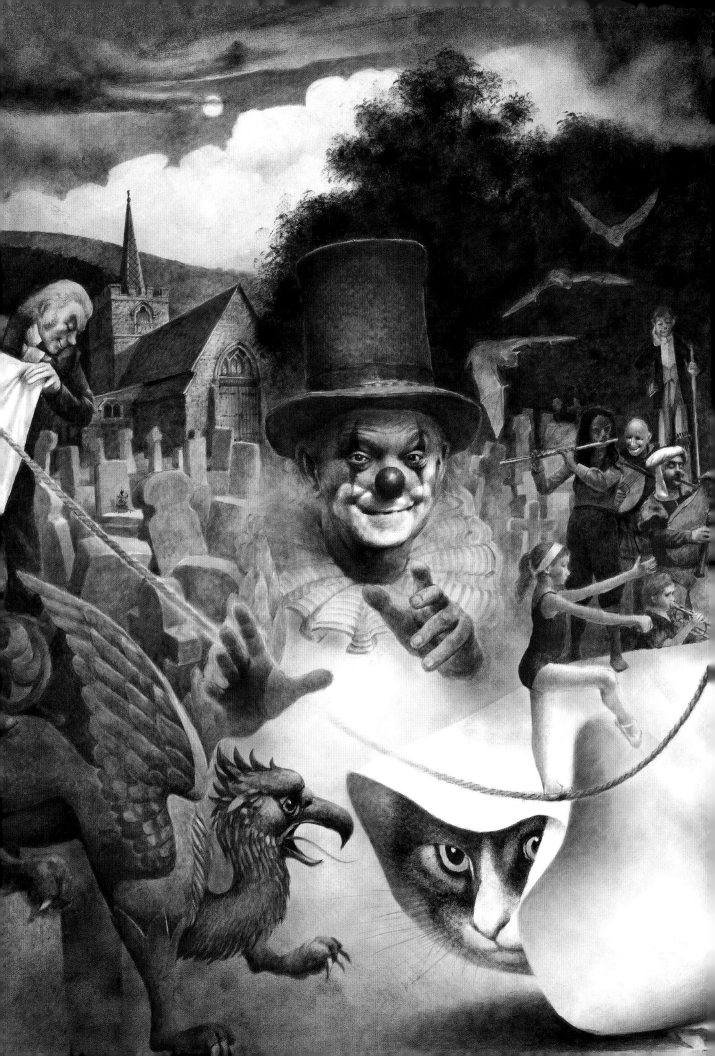

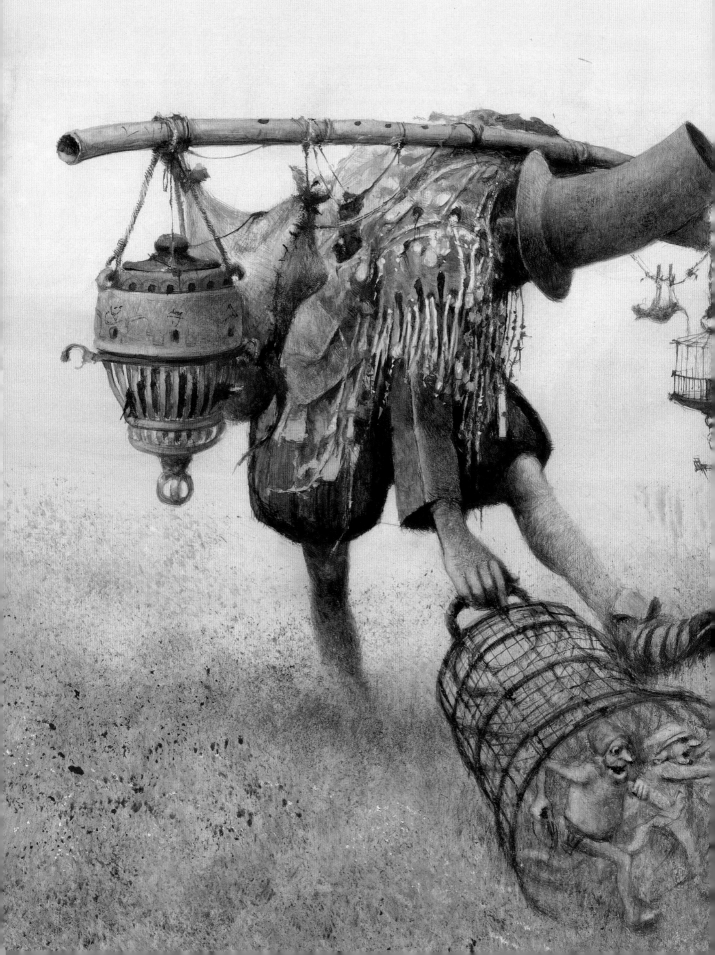

THE DREAMKEEPER
by Robert Ingpen

With regard to the character of The Dreamkeeper, I wrote
a letter to my granddaughter Alice Elizabeth in 1995:

Dear Alice

*This is a story about a man who collects
dreams and keeps them safe. He is called The
Dreamkeeper.*

*Nobody I know has ever seen him. We can
only imagine what he looks like, although we do
know a few things about him.*

*We know he wears strange clothes which
belong to earlier times, so he is probably quite
old. He has charms and lures, all sewn or
pinned or tied to his coat.*

*Over his shoulder he carries a long bamboo
pole with strange markings, which he uses to
carry cages and traps he needs for collecting the
dream creatures he finds. Sometimes he plays
the bamboo pole as a flute.*

Until recently people believed that The
Dreamkeeper worked alone with no helpers.
This is not so; Tally is with him at all times
unless he is contracted to do special projects for
other council members. He keeps 'tally' of all The
Dreamkeeper's tricks, captures and conquests.

He has a memory as long as his white beard,
which he has to tuck into his belt to stop tripping
over himself. Once he used to carry a sword
to cut up his food and defend himself, but now
he makes do with his ingenious belief-powered
remote control.

For centuries pigeons have lived in pigeonhouses, and they still do. People think they are kept there to be hunted, or to make droppings in order to fertilize the surrounding vineyards. But they really carry messages for The College of Great Belief which has its offices in this building. The president of the College is The Dreamkeeper, and when he is not travelling he lives there with his sister and a useful goblin called Tally...

... The College of Great Belief operates for the well-being of all storybook characters, and sometimes for real people who appear in stories.

Inside the pigeonhouse Tally has a small room with a bed for sleeping, a box for keeping and a desk for for recording and reporting. His room has two doors: one that leads to the kitchen where Belief Syrup and other magic potions are made, and another that leads to the library and meeting chambers where The Dreamkeeper bunks down when he needs to sleep. A small window high in the room leads to the wider world outside.

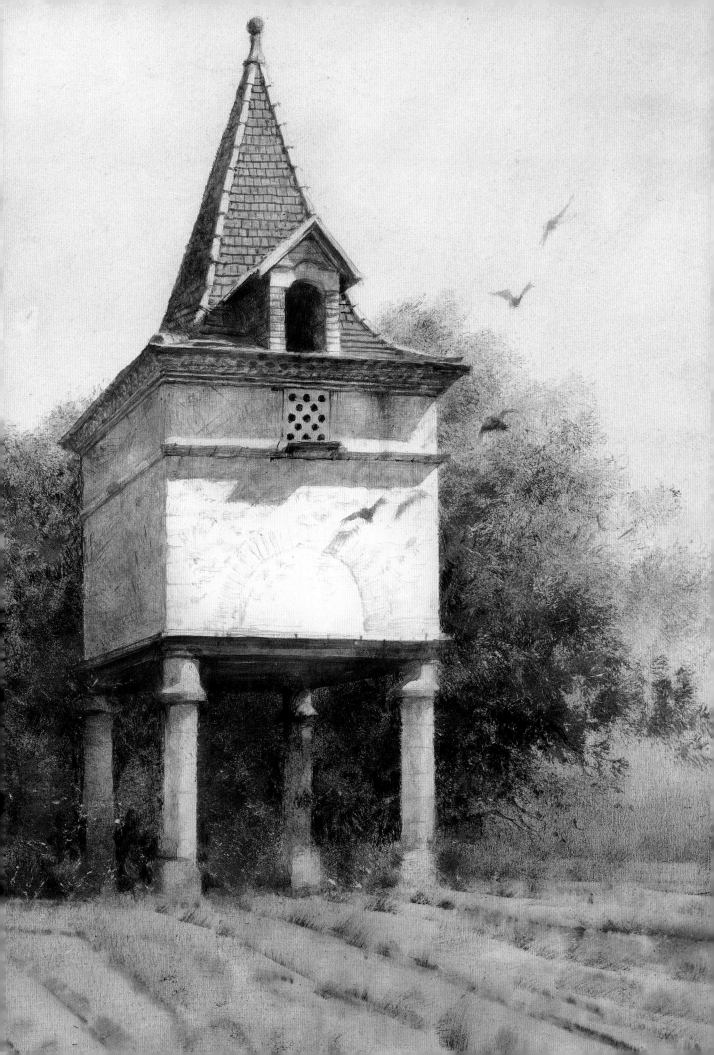

ENCYCLOPAEDIA OF THINGS THAT NEVER WERE
By Michael Page and Robert Ingpen

This is a book that lets your mind float free through all the dimensions of fantasy and shows that everyone, since the dawn of time has travelled the pathways and tracks through the Forest of Imagination.

Michael Page and I spent two years or so assembling and describing in text and illustrations a huge range of make-believe persons, places, creatures and objects – or, more simply, 'Things That Never Were'.

The Cosmos
The mystic creators of the world and those who influence our thoughts and activities. They include the Creatures of the Zodiac and mighty Zeus of Olympus.

The Ground and Underground
The magical and mysterious creatures who live in our homes, in the ground beneath us, and in the forest, hills and wilderness. Creations like Centaurs, Satyrs and Leprechauns.

Wonderland
A travelog to many wondrous places of legend, myth and literature. Among them are the undersea empire of Atlantis, the mines of King Solomon, the castle-city of Camelot and Lilliput.

Magic, Science and Invention
Frankenstein, flying carpets, Jekyll's Potion, masks and moon shots and many other strange things, creatures and monsters.

Water, Sky and Air
The Argo, Bunyips, Dragons, Griffins, Moby Dick, mermaids, rainbow serpents and Poppykettles that inhabit the boundless atmosphere and watery places.

The Night
A host of shuddersome creatures that emerge at night: the banshee, vampires, witches, ghosts and zombies.

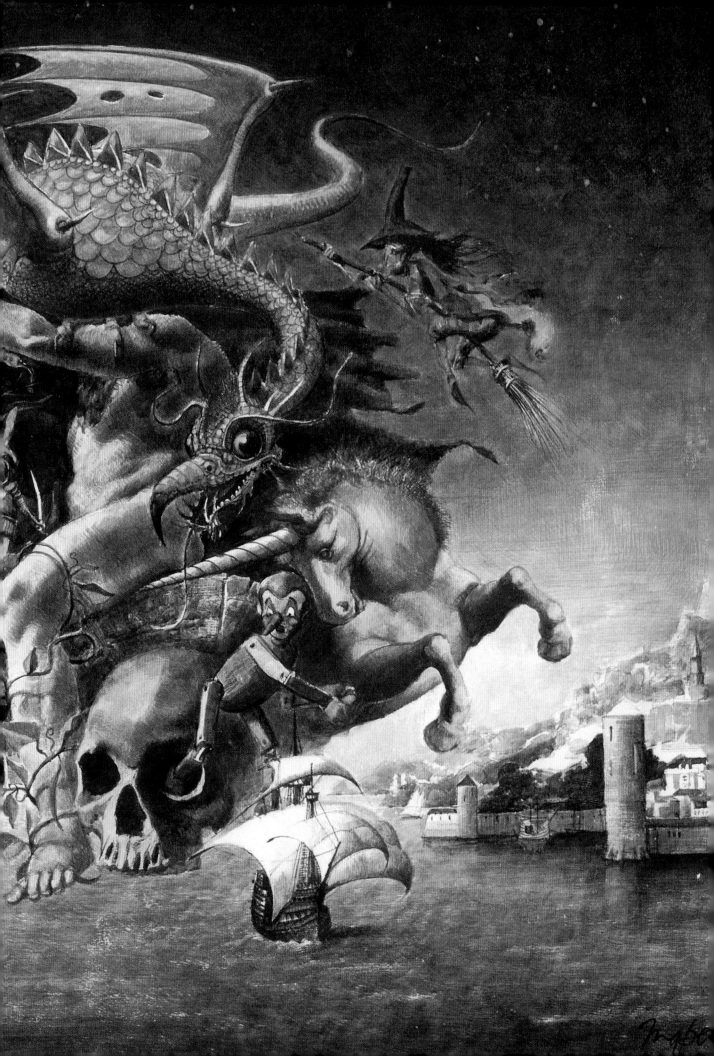

The Lost Empire of Atlantis

Legend tells us that when the gods divided up the universe, Poseidon, god of the oceans, established a beautiful state and a central city of Atlantis for himself. Built around concentric circles of water and land, it became a world centre to visit for culture and science. Even philosopher Plato wrote much about it. But when the people of Atlantis stopped obeying Poseidon's laws, the city was long ago swallowed up by the ocean and lost forever. At least, this map I made for the *Encyclopaedia of Things That Never Were* shows, not where it is, but what one might be looking for if a journey was made to find the remains of this fabled wonderland.

Many people have asked me how I came to do this map in such detail if the place lies far beneath the sea. Knowing that I am probably dealing with an unbeliever, I usually say that after consulting tidal charts for the west of Ireland in the Atlantic, I calculated that during 1983 the lowest tide ever to be was to happen at midday on February 30th. I borrowed cod fisherman's waders and headed out through the Atlantic mud to make the drawing you see here. Since I was not believed by some, I signed the drawing at the bottom right and dated it as 1996, when there really was a very low tide!

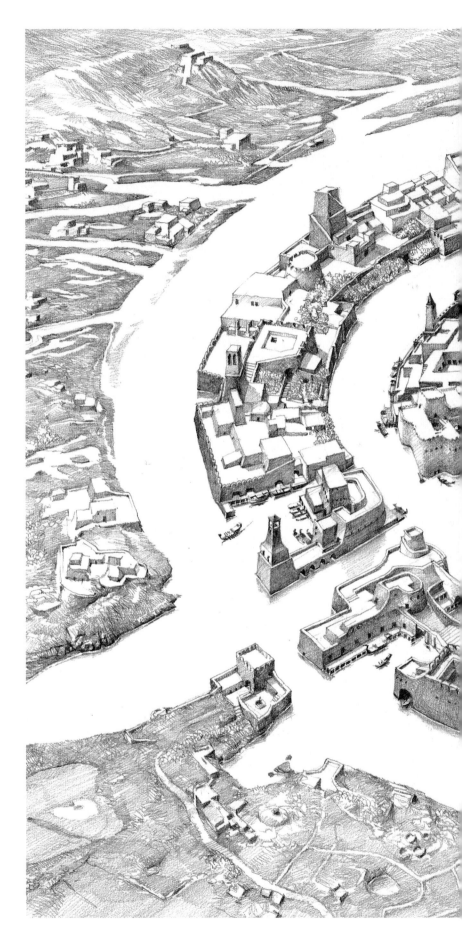

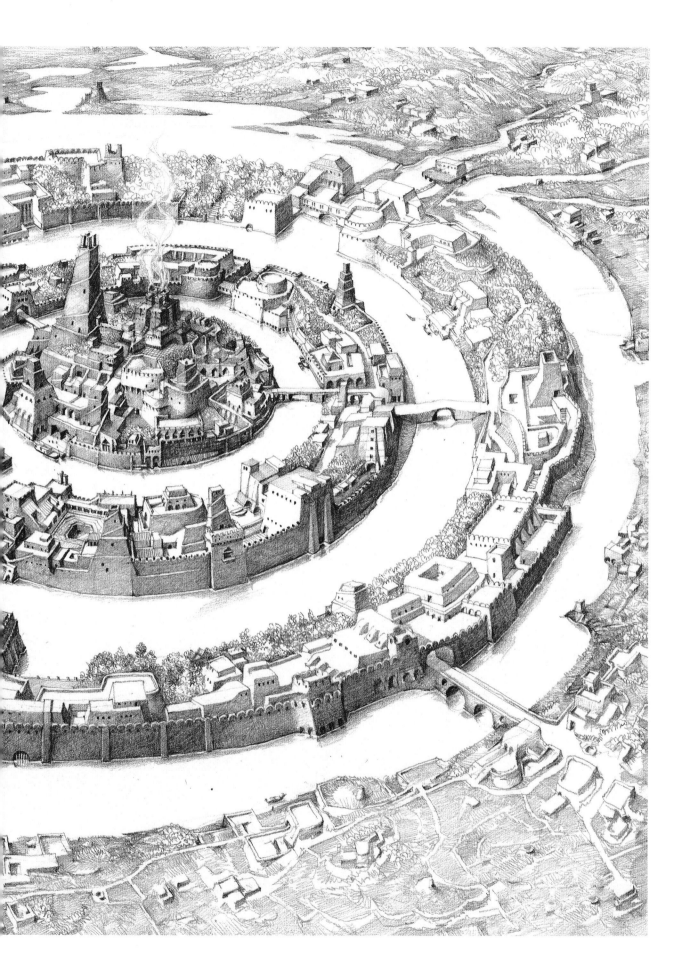

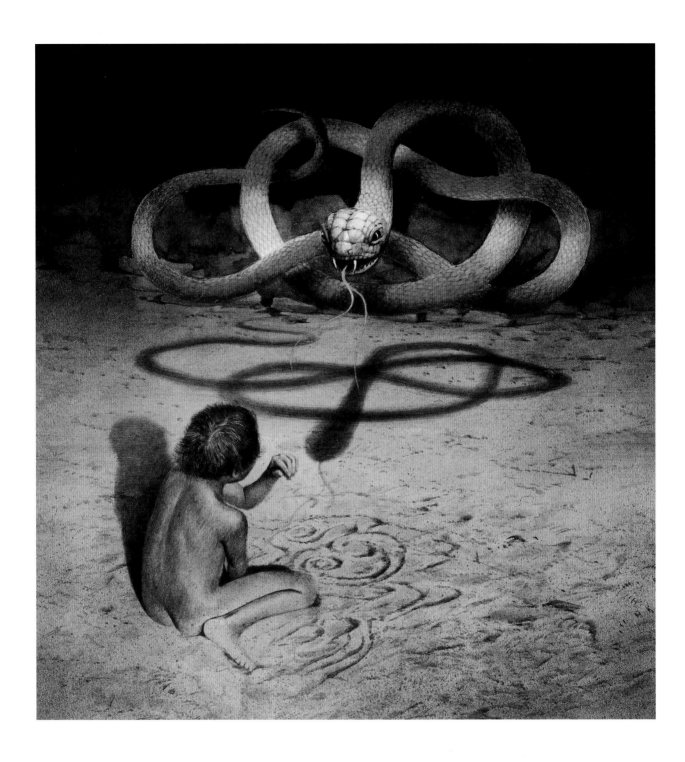

The First Australian Dreamtime

Long ago Australia was occupied by the spirit ancestors of all the people, plants and animals still living there today. During their timeless occupation of the land, these creation ancestors formed everything into its present shape.

At creation the Rainbow Serpent dug out the riverbeds and the billabongs and waterholes as it writhed across Australia (as above). The first people were created in wonderful ways in different parts of the land. In one place, an old woman rose miraculously out of the ground accompanied by two girls and a boy. In another place, the spirit Bunyil fashioned the first men out of clay. The Aboriginal people now see everything in their country as a reminder of their Dreamtime ancestors.

Finding Wonderlands
NATURE

THE NARGAN AND THE STARS

By Patricia Wrightson
First published in 1973

It is written that Patricia Wrightson's classic and mystical story *The Nargan and the Stars* (1973) is a 'spiritual investigation of the land, of the Aboriginal people and imagination'. The illustration reproduced here is from a 1988 edition, published to mark the occasion in 1986 when Patricia Wrightson and I jointly won the international Hans Christian Andersen Medal, the only Australians to have done so, so far.

BEGINNINGS AND ENDINGS WITH LIFETIMES IN BETWEEN

By Bryan Mellonie and Robert Ingpen

This small but enduring book, published in 1983, begins with a drawing of a bird's nest with two speckled eggs, and the words:

'There is a beginning and ending for everything that is alive. In between is living.'

Above is a drawing of the remains of a butterfly, which illustrates the words:

'Sometimes living things become ill or they get hurt. Mostly, of course, they get better again but there are times when they are so badly hurt or they are so ill that they die because they can no longer stay alive. This can happen when they are young, or old, or anywhere in between.'

CONSERVATION

By Robert Ingpen and Margaret Dunkle

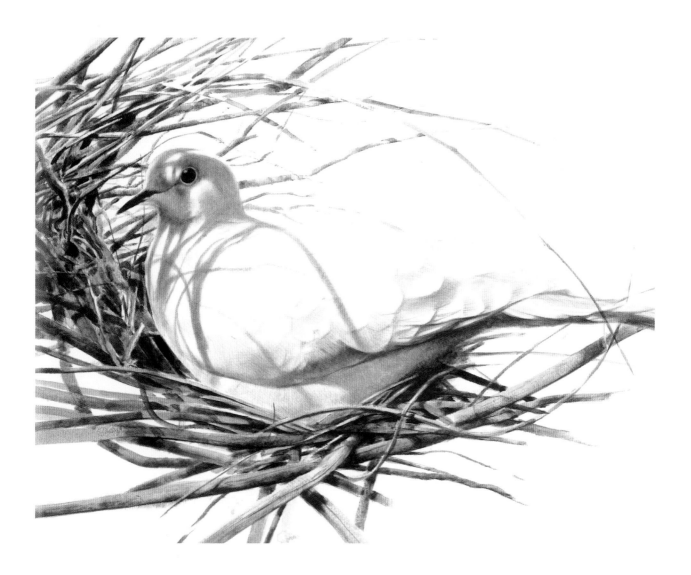

Conservation was intended as a companion to *Lifetimes* and published in 1987. Here I illustrated the words of Margaret Dunkle who shared similar thoughts with me about conservation and how we should inform children.

This illustration of 'one bird at home' has a text that reads:

'Conservation is our way of looking after our world, just as we would look after our homes. Using our intelligence and common sense to keep it safe, to make it comfortable and beautiful, to repair any damage and upset, to preserve it for the future.'

CHIEF SEATTLE

Great Names series, 2000
Illustrated by Robert Ingpen

Included in this book was the famous speech by Chief Seattle, the Native American Duwamish tribal leader. It was first spoken in 1854 at Puget Sound, Washington Territories, and he was reported to have said, in part only:

'… The bear, the great condor, are our brothers,
The rocky crests, the meadows, the ponies and man
All belong to our family.
Now the white men have come.
Our ways are different from your ways,
And we do not understand what living becomes
When all buffalo are slaughtered,
The wild horses tamed, the forests plundered.
Where is the thicket? Gone.
Where is the eagle? Gone.
What is there to living if man cannot hear the cry
Of the thrush or the arguments of the frogs
Around the pond at night?'

THE MARGINAL WORLD

Many times through my working life I have been drawn
to the shoreline – that 'Marginal World' between high
and low tide, along beaches and to rock pools – to make
studies and find treasures.

As a student at the Art School of the Royal Melbourne
Institute of Technology in the mid 1950s, I attended
classes in graphic printmaking. From many drawings
I had made along the coastline near Anglesea on the
Great Ocean Road, I produced a set of hand-drawn
lithographs called *The Dance of the Periwinkles*. These
six prints were sold as a limited edition.

1980
Coral Rock Community *(right)*
Around 1980 I was a consultant to the Great Barrier Reef
Marine Park Authority which at the time was preparing to
submit a proposal for World Heritage recognition for the
Great Barrier Reef. I made these two watercolour studies
of the upside and underside of a piece of living coral rock,
to be part of the folio of documents presented to UNESCO.

2012
Homage to a Storyteller *(opposite)*
Opposite is one of my many recent egg tempera paintings
of 'treasures' found on the shoreline of Mission Beach,
Queensland. This painting hangs in our living room at
Barwon Heads, and is dedicated to my hero, Robert Louis
Stevenson. He was known to Pacific Islanders as 'Tusitala'
– 'The Storyteller' and is buried on a mountain top in
Western Samoa. On his grave, his epitaph concludes:
'Home is the sailor home from the sea,
and the hunter home from the hill.'

OME IS THE SAILOR HOME FROM THE SEA
AND THE HVNTER HOME FROM THE HILL

THE IDLE BEAR

Written and illustrated at the birth of our first
grandchild, Sarah, in 1986

This book was thoughtfully described by Dr Maurice Saxby, the eminent Australian authority on children's literature, in a review he wrote years after many editions had been published in different languages:

'When Robert Ingpen's poster of a Teddy Bear upside down on a pile of books prepared for International Children's Book Day, 2 April 1988, was displayed in Munich and at the annual Children's Book Fair in Bologna it became the talking point for people from all around the world. Many of them recognised the Bear at once. He first appeared in *The*

Idle Bear as a pragmatic Ted who "stood on his head as best he could" to prove to his more laconic companion Teddy, that his growl would still work – occasionally.

It was when Robert Ingpen's first grandchild, Sarah Louise, was born that Ted and Teddy were taken out of their boxes and sat on a chair to engage the heart of a new generation. "What would the bears be thinking", "What would they say to one another." So *The Idle Bear* came into being: in words, and distinctive pencil and chalk illustrations which perfectly catch the lightness and vulnerability yet tough endurance of early childhood. Nothing sentimental here. But a direct line back to the imagination when it is at its freest and most untrammelled. A passport to the philosopher inherent in every infant. For we all have to think and feel our way through the thorny questions of "Where do I come from?", "Who am I?", "What are the realities of my world?"… The sceptics labelled it a picture book for adults and claimed that small children couldn't cope with the question which is answered in the text: "What is an Idle Bear?" Experience has shown that children enjoy the story, when it is read to them, on different levels. Pre-school children find the non-sequiturs and puns in the conversation between the two bears amusing, without knowing exactly why. Older children enjoy differentiating the distinctive characters of Ted, the Worldly Bear of good brain, and the less loquacious Teddy Idle who, nevertheless, knows exactly how he got his name. The talk of being put away in a box and being taken out, of worn out growls and bandaged paws may be inconsequential, or it may have deep psychological reverberations. What matter? Children respond to it; and the more thoughtful and imaginative construct their own meaning. Which is exactly what educationists say children should be doing every time they read. The trouble is, most texts for young children are so closed in that there is no space for reader exploration.'

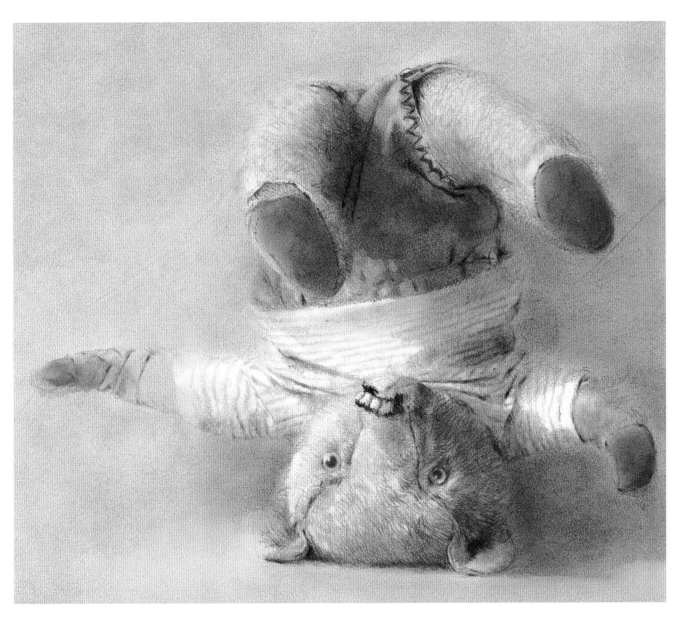

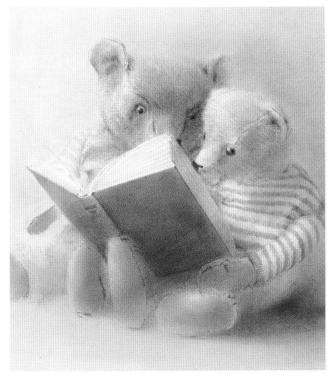

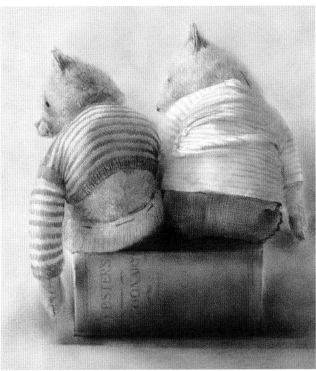

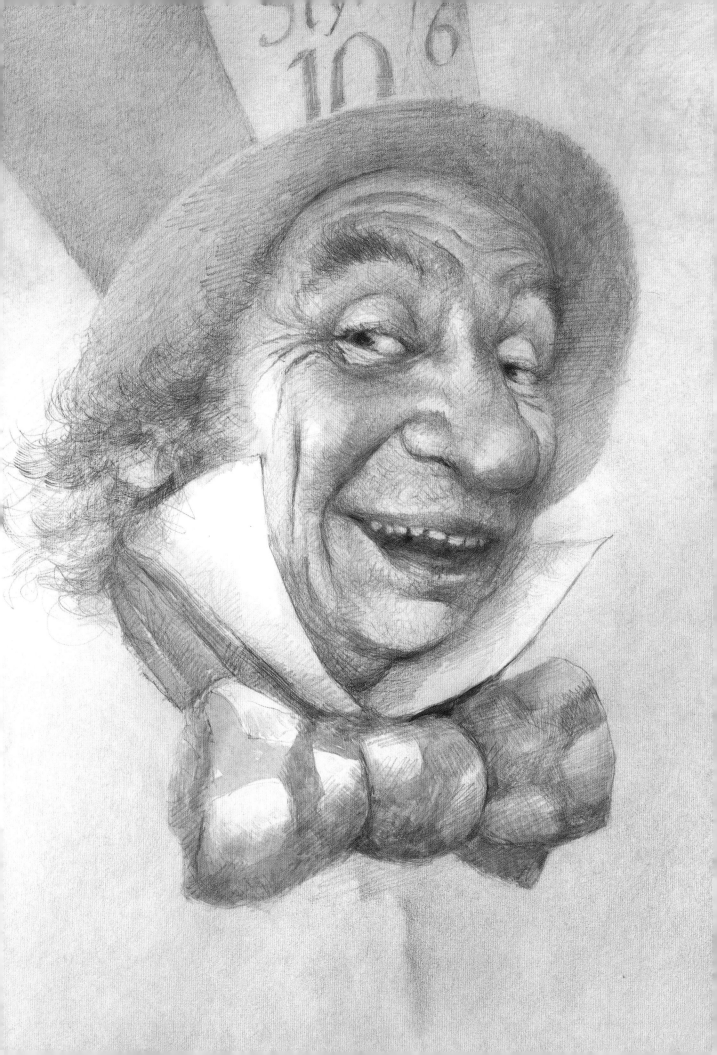

CHRONOLOGY

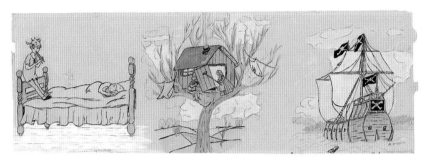

Above: Peter Pan and Wendy, a frieze by Robert Ingpen, aged seven.

PUBLISHED BOOKS 1972–2016

This chronological list indicates the book title, the nature of the collaboration with the respective writer, publisher and country of first publication.

1972
Pioneers of Wool, written and illustrated (Rigby, Adelaide).

1973
Pioneer Settlement in Australia, written and illustrated (Rigby, Adelaide).

1974
Storm Boy, with Colin Thiele (Rigby, Adelaide).

1975
Robe: A Portrait of the Past, written and illustrated (Rigby, Adelaide).

Western Portrait, designed and illustrated (Victorian Government Ministry for Conservation).

1976
The Runaway Punt, with Michael Page (Rigby, Adelaide).

Surprise and Enterprise (50 years of CSIRO), designed and illustrated, written by Andrew McKay (CSIRO, Canberra).

1977
The Commercial Fish of Australia, illustrated (Department of Primary Industry, Canberra).

1978
Paradise and Beyond (Tasmania), with Nick Evers (Rigby, Adelaide).

Lincoln's Place, with Colin Thiele (Rigby, Adelaide).

1979
Australian Gnomes, written and illustrated (Rigby, Adelaide).

River Murray Mary, with Colin Thiele (Rigby, Adelaide).

Marking Time: Australia's Abandoned Buildings, written and illustrated (Rigby, Adelaide).

1980
Turning Points in the Making of Australia, with Michael Page (Rigby, Adelaide).

The Voyage of the Poppykettle, written and illustrated (Rigby, Adelaide).

1981
Australia's Heritage Watch, written and illustrated (Rigby, Adelaide).

The Unchosen Land, written and illustrated (Rigby, Adelaide).

Night of the Muttonbirds, with Mary Small (Methuen, Sydney).

1982
Aussie Battlers, with Michael Page (Rigby, Adelaide).

Australian Inventions and Innovations, with students of The Geelong College (Rigby, Adelaide).

Clancy of the Overflow, poem by A.B. Paterson, introduction and illustrations (Rigby, Adelaide).

1983
Lifetimes: Beginnings and Endings, with Bryan Mellonie (Hill of Content, Melbourne).

1984
Click Go the Shears, a traditional Australian song, introduction and illustrations (William Collins, Sydney).

The Great Bullocky Race, with Michael Page (Hill of Content, Melbourne).

1985
Religious Worlds, with Max Charlesworth (Hill of Content, Melbourne).

Colonial South Australia, with Michael Page (J.M. Dent, Melbourne).

1986
The Encyclopaedia of Things That Never Were, with Michael Page (Rigby, Adelaide).

The Idle Bear, written and illustrated (Lothian, Melbourne).

1987
Conservation, with Margaret Dunkle (Hill of Content, Melbourne).

Folk Tales and Fables of the World, with Barbara Hayes (David Bateman, Auckland), republished in 2007.

The Stolen White Elephant, Mark Twain (Scholastic, Sydney).

The Making of Australians, with Michael Page (J.M. Dent, Melbourne).

1988
The Nargan and the Stars, with Patricia Wrightson (Hutchinson, Melbourne).

Worldly Dogs, with Michael Page (Lothian, Melbourne).

The Age of Acorns, written and illustrated (Lothian, Melbourne).

A Christmas Tree and *The Child's Story*, Charles Dickens (Scholastic, Sydney).

A Strange Expedition, Mark Twain (Scholastic, Sydney).

1989
The Great Deeds of Superheroes, Maurice Saxby (Millenium, Sydney).

Peacetimes, with Katherine Scholes (Hill of Content, Melbourne).

1990
The Great Deeds of Heroic Women, with Maurice Saxby (Millenium, Sydney).

The Encyclopaedia of Mysterious Places, with Philip Wilkinson (Dragon's World, London).

1991
Encyclopaedia of World Events, with Philip Wilkinson (Dragon's World, London).

1992
Ragazzi Felici (Celebrating International Rights for Children), with Elisabeth Stockli (Pro Juventute/UNICEF).

Treasure Island, Robert. L. Stevenson (Dragon's World, London).

1993
Encyclopaedia of Ideas That Changed the World, with Philip Wilkinson (Dragon's World, London).

River through the Ages, with Philip Steele (Eagle Books, London).

1994
A Celebration of Customs and Rituals, with Philip Wilkinson (Dragon's World, London).

1995
The Dreamkeeper, written and illustrated (Lothian, Melbourne) – later edition in 2006 by Minedition, Hong Kong).

1996
The Afternoon Treehouse, written and illustrated (Lothian, Melbourne and Pavilion, London).

1997
The Drover's Boy, a song by Ted Egan (Lothian, Melbourne).

Jacob: The Boy from Nuremburg, with Ejnar Agertoft (Agertoft Verlag, Denmark).

1998
Fabulous Places of Myth, with Michael Cave (Lothian, Melbourne).

1999
Great Name Series *Scott of the Antarctic, Captain Cook, Marco Polo, Xuan Zang*, design and illustration (Grimm Press, Taiwan).

Once Upon a Place, written and illustrated (Lothian, Melbourne).

Around the World in Eighty Days, Jules Verne (Arena Verlag, Germany, and Pavilion, London).

The Poppykettle Papers, with Michael Lawrence (Pavilion, London).

2000
Great Names Series *Gandhi, Mother Theresa, Chief Seattle*, design and illustration (Grimm Press, Taiwan).

Hans Christian Andersen, with Villy Sorenson (Agertoft Verlag, Denmark).

A Bear Tale, written and illustrated (Lothian, Melbourne).

Who Is the World For?, with Tom Pow (Walker Books, London).

2001
Shakespeare: His Work and His World, with Michael Rosen (Walker Books, London).

Robinson Crusoe, Daniel Defoe (Grimm Press, Taiwan).

2002
Pinocchio, Carlo Collodi (Grimm Press, Taiwan).

Halloween Circus, with Charise Neugebauer (North South Books, Zurich – Michael Neugebauer).

2003
The Wizard's Book of Spells, with Beatrice Phillpotts (Palazzo Editions, Bath).

The Magic Crystal, with Brigitte Weninger (Minedition, Hong Kong).

Broken Beaks, with Nathaniel Lachenmeyer (Michelle Andersen, Melbourne).

2004
The Rare Bear, written and illustrated (Lothian, Melbourne).

In the Wake of the Mary Celeste, with Gary Crew (Lothian, Melbourne).

The Tapestry Story: Documenting the 150 years of the Melbourne Cricket Ground, with Keith Dunstan (Lothian, Melbourne).

Peter Pan and Wendy, J.M. Barrie (Produced by Palazzo Editions, Bath).

Pictures Telling Stories (The art of Robert Ingpen), with Sarah Cox (Minedition/Lothian).

2005
Dickens: His Work and His World, with Michael Rosen (Walker Books, London).

Treasure Island, Robert. L. Stevenson (Produced by Palazzo Editions, Bath).

The Ugly Duckling, H.C. Andersen (Minedition, Hong Kong).

The Voyage of the Poppykettle, written and illustrated, with some new illustrations (Minedition, Hong Kong).

2006
Silent Night, Holy Night, with Werner Thuswalder (Minedition, Hong Kong).

Mustara, with Rosanne Hawke (Lothian, Melbourne).

Imprints of Generations, written and illustrated (Lothian, Melbourne).

The Jungle Book, Rudyard Kipling (Produced by Palazzo Editions, Bath).

2007
The Wind in the Willows, Kenneth Grahame (Produced by Palazzo Editions, Bath).

Ziba Came on a Boat, with Liz Lofthouse (Penguin/Viking, Melbourne).

2008
The Boy from Bowral (The Story of Don Bradman), written and illustrated (Palazzo Editions, Bath).

A Christmas Carol (with A Christmas Tree), Charles Dickens (Produced by Palazzo Editions, Bath).

2009
Alice's Adventures in Wonderland, Lewis Carroll (Produced by Palazzo Editions, Bath).

If You Wish, with Kate Westerlund (Minedition, Hong Kong).

2010
The Adventures of Tom Sawyer, Mark Twain (Produced by Palazzo Editions, Bath).

The Secret Garden, Frances Hodgson Burnett (Produced by Palazzo Editions, Bath).

The Night before Christmas, Clement C. Moore (Palazzo Editions, Bath).

2011
The Wonderful Wizard of Oz, L. Frank Baum (Produced by Palazzo Editions, Bath).

2012
Around the World in Eighty Days, Jules Verne (Produced by Palazzo Editions, Bath).

The Owl and the Pussycat (and Other Rhymes), Edward Lear (Palazzo Editions, Bath).

2013
Just So Stories, Rudyard Kipling (Produced by Palazzo Editions, Bath).

Looking for Clancy, written and illustrated (National Library of Australia, Canberra).

2014
The Adventures of Pinocchio, Carlo Collodi (Produced by Palazzo Editions, Bath).

Tea and Sugar Christmas, with Jane Jolly (National Library of Australia).

2015
Alice through the Looking-Glass, Lewis Carroll (Palazzo Editions, Bath).

2016
The Nutcracker, E.T.A. Hoffmann (Produced by Palazzo Editions, Bath).

Radio Rescue, with Jane Jolly (National Library of Australia).

ART AND DESIGN COMMISSIONS (1954–2009)

Mural Paintings

1954
'The Nuclear Era', 6m x 2.5m (now demolished), Geelong College – painted as final year art assignment.

1956
'The Coffee Society, Ninos Cafe', 8m x 3m (now demolished) - commissioned when an art student, Ninos Cafe, Chapel Street, Melbourne.

1963
'The Land Research Mural', *fresco secco*, 8m x 3m (restored and Heritage Listed) at entrance to CSIRO Division of Land Research, Black Mountain, Canberra.

1968
'Clunies Ross Memorial Mural', Science House, Melbourne (100 square feet on timber pieces, now relocated to Geelong) – commissioned by the Australian Veterinary Association.

1969
'The Geelong City Mural', Geelong City Hall, egg tempera on panels, 6m x 2.5m.

1970
'The Conservation Mural', (egg tempera on four panels) – commissioned by Victorian Government for the entrance to The Rylah Institute for Environmental Research.

1976
'The Geelong Wool Mural', egg tempera on three 2m x3m panels – commissioned by Bank of Australasia and relocated to The National Wool Museum, Geelong.

1977
'The Geelong Water Mural', egg tempera on board, 8m x 3m on 5 panels – commissioned by The Geelong Water Trust for the entrance of their offices.

1979
'The Computer Mural', egg tempera on board – commissioned by ACI Computer Division, Melbourne.

1985
'Jupiters Mural', egg tempera on panels, 4m x 6m – commissioned by architects, Buchan Laird, for the entrance to Conrad Hilton/Jupiters Casino, Broadbeach, Queensland.

Tapestries

2002
'The Melbourne Cricket Ground History', 7m x 2m, woven in wool by the Australian Tapestry Workshop, South Melbourne – commissioned by MCC to celebrate 150 years of the ground and hangs in the entry hall to the Long Room.

2009
'Children's Games Tapestry', 6.5m x 3m, woven in wool by the Australian Tapestry Workshop – commissioned by Royal Children's Hospital, Melbourne as a memorial to Dame Elisabeth Murdoch, and hangs in the atrium of the new hospital, Parkville, Victoria.

Bronze Sculptures

1980
'The Poppykettle Fountain', lost wax bronze caste by Bucek Family, Moolap, Geelong, now demolished – commissioned by the McAlister Family, Geelong and originally located on the Geelong foreshore to Corio Bay.

1981
'The Dromkeen Medal', The Magic Key of Dromkeen was designed and cast in lost wax bronze – commissioned by the Dromkeen Literature Foundation, and presented annually for achievement in Australia in children's literature (now displayed at The State Library of Victoria).

1988
'The Bronze Doors' Members Entrance to the Melbourne Cricket Ground, seven doors, 2.7m x 1.05 m with bronze panels, at various sizes – commissioned by the MCG to mark the 150 years of the Melbourne Cricket Club. (Now relocated to the entry hall near the Long Room in the Members Stand.)

Communication Design

1958–1968
CSIRO Agricultural Liaison Section Based with head office, East Melbourne. Graphic design and illustration interpreting and communicating the research of rural scientists.

1966
'Representation of Relations in Biotic Systems', with G.L. Kesteven. (*Proceedings of the Ecological Society of Australia*, vol.1, 79–83).

1969
Development and planning of The Swan Hill Pioneer Settlement, for Victorian Government.

1970
'Cook Bicentenary' Postage Stamps.

1971
Communication consultant to FAO/UNDP, based in Mexico for various periods to advise on communication within the fishing industry.

1972
Communication consultant to FAO/UNDP, based in Lima, Peru to advise on communication for the management of the Anchovy Fishery.

1976–77
Coat of arms and flag design Commissioned by The Northern Territory for the Self Government, 30 June, 1978.

1978
Concept design for the Zoological Park, Werribee, Victoria – commissioned by the Zoological Board of Victoria.

1980
Consultant to The Great Barrier Reef Marine Park Authority, for planning conservation strategy and zones.

1980–81
Consultant to the Geelong Regional Commission, for the concept and planning of The National Wool Centre, to become in 1988, The Geelong Wool Museum.

1984
Designed the 'Resources for Life', a poster series to communicate the Australian National Conservation Strategy.

Photograph by Darren Dunkley-Smith

Whether drawing, watercolour painting, or larger tempera painting, my work has always begun with carefully recording ideas in pencil in sketchbooks. When I feel ready, or the design is approved by a publisher, I begin final drawing, again in HB pencil on my 'special' paper. I have used this paper almost exclusively for at least forty years. The paper surface is hard, very smooth and very expensive, and imported from Germany in blocks of twenty sheets: Schoellershammer – Airbrush Paper No. 4 professional quality (white, chemical pulp, containing rags, acid-free and smooth, 35 x 50cm).

For my watercolour work I use Winsor & Newton finest sable – series 7 in sizes ranging from 2 to 5. For washes I have an old faithful sable brush, so much used that all the markings have worn off the handle. I expect it will see me out. For special effects I use sea or cosmetic sponges, very worn-down bristle brushes, even a toothbrush for creating falling or blowing snow. My paints are in tubes made also by Winsor & Newton, and, for those children who are always asking, my favourite colour is Quinacridone Gold.

My thanks to Colin and Pamela Webb, Victoria Walters and Claudia Kennerley; to Bernard Higton for his skill and patience in applying my design and illustrations for this book; to Elizabeth Hammill for her introduction; to Susan Hall, publisher at the National Library of Australia.

Robert Ingpen AM

Robert Ingpen was born in 1936, and lived in Geelong where he went to school at The Geelong College. In 1955 he went to Melbourne where he studied art and design at The Royal Melbourne Institute of Technology (now RMIT University). After graduation he was employed in 1958 as a graphic designer and illustrator with the CSIRO (Commonwealth Scientific and Industrial Research Organisation). In 1968 he began his long career as an illustrator and author which has resulted in well over one hundred published books.

He became the first Australian to receive the Hans Christian Andersen Medal (for illustration) in 1986, and has been honoured with a Doctor of Arts from RMIT University, and with Membership of the Order of Australia.

He and Angela were married in 1959 and, after many homes and adventures, have settled not far from Geelong at Barwon Heads. They have four children, Katrina, Susan, Sophie and Tom; six grandchildren and three great grandchildren.

For further information regarding Robert Ingpen and his work, including requests for loans of pictures for exhibition and the purchase of copyright to reproduce selected works, visit www.robertingpen.com

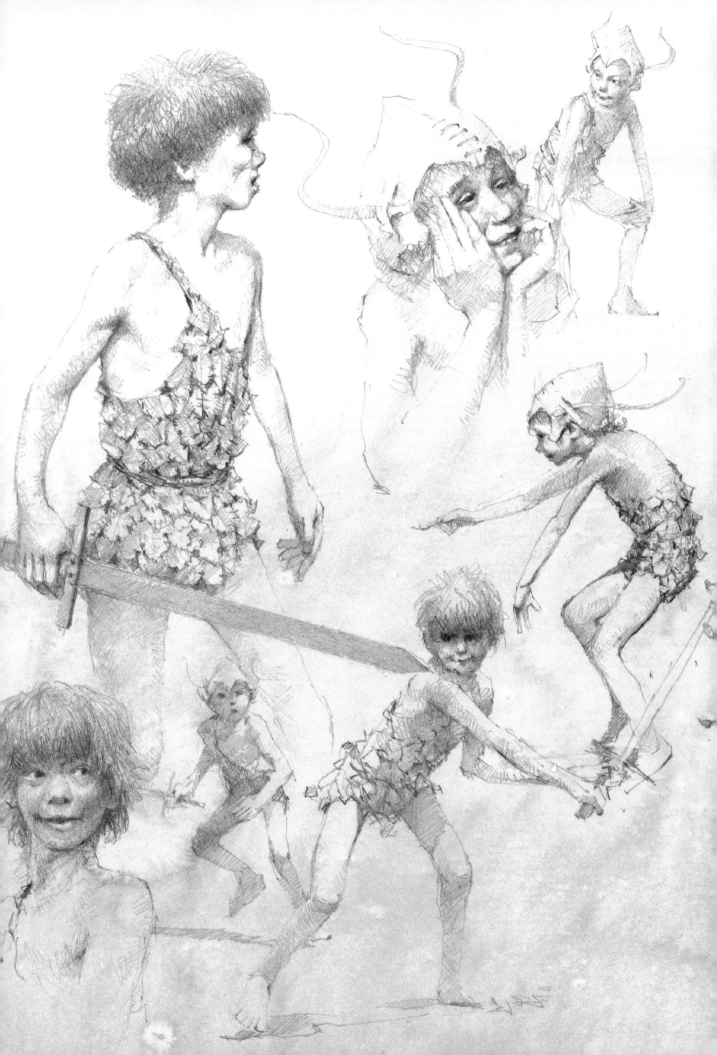

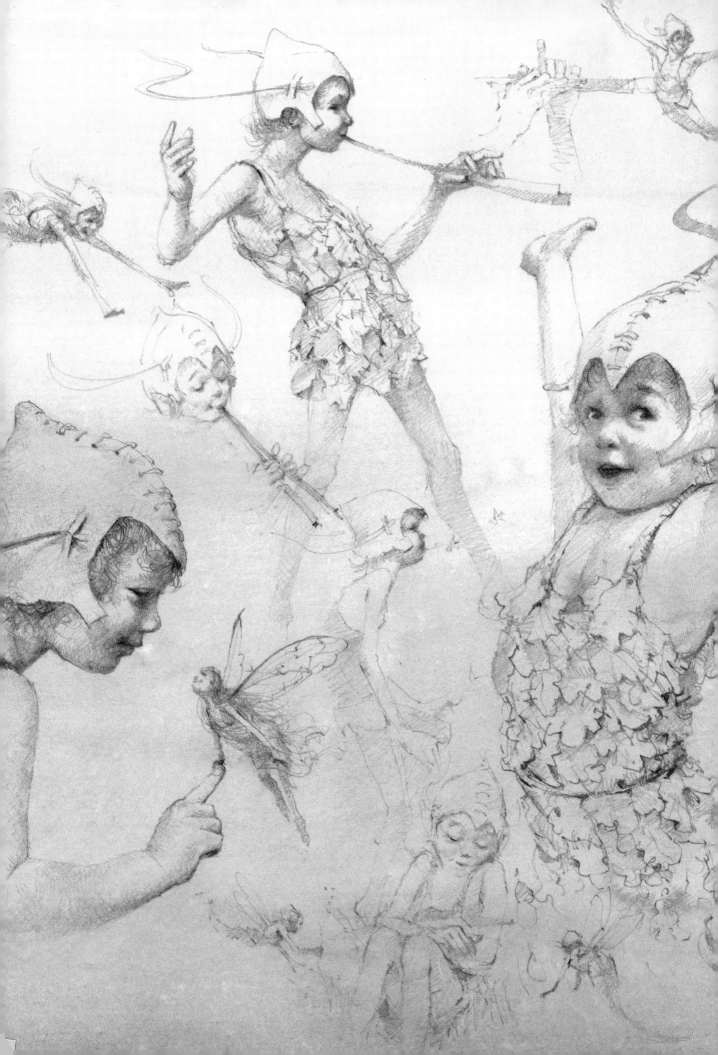